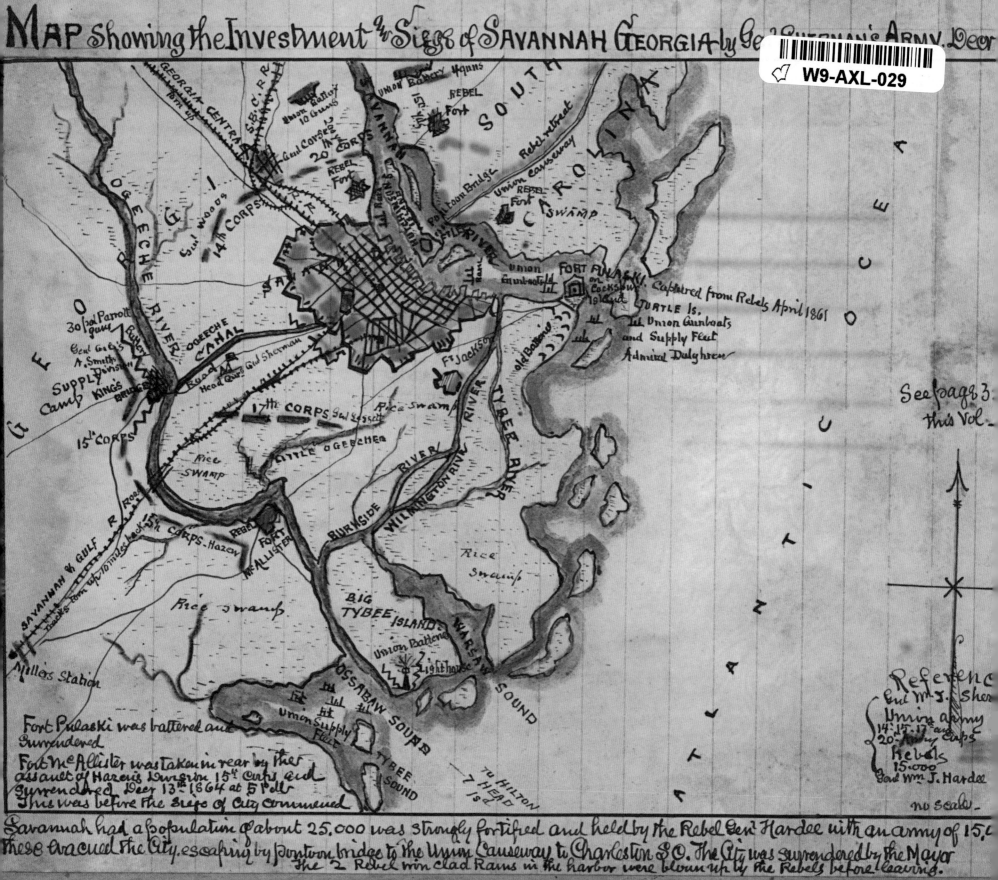

MAP Showing the Investment & Siege of SAVANNAH GEORGIA by Genl Sherman's Army. Decr

SOUTH CAROLINA

OCEAN

ATLANTIC

GEORGIA

GEORGIA CENTRAL R.R.

S.C. R.R.

SAVANNAH

Union Battery 4 guns

REBEL Fort

Union Battery 10 Guns

Genl Corps 14th 20th CORPS

REBEL Fort

Rebel retreat

Union causeway

Pontoon Bridge

REBEL Fort

C SWAMP

SAVANNAH RIVER

Union Gunboat

FORT PULASKI on Cockspur Island

Captured from Rebels April 1861

TURTLE Is.

Union Gunboats and Supply Fleet

Admiral Dahlgren

See page 3 this Vol.

OGEECHE RIVER

OGEECHE CANAL

30 pd Parrott guns

Genl Corps A. Smith Division

Battery

SUPPLY Camp KINGS BRIDGE

Road

Head Qurs Genl Sherman

Ram

Ft Jackson

Old Battery

TYBEE RIVER

15th CORPS

17th CORPS Genl Bassett

Rice Swamp

LITTLE OGEECHEE

WILMINGTON RIVER

Rice SWAMP

Rice swamp

SAVANNAH & GULF R. ROAD

Tracks torn up to midway back 17th CORPS - Hazen

REBEL FORT McALLISTER

BURNSIDE

Rice Swamp

Millers Station

BIG TYBEE ISLAND

Union Battery

Lighthouse

WARSAW SOUND

OSSABAW SOUND

Union Supply Fleet

TYBEE SOUND

To HILTON HEAD IsId

Fort Pulaski was battered and Surrendered

Fort McAllister was taken in rear by the assault of Hazens Division 15th Corps and Surrendered Decr 13th 1864 at 5 PM This was before the Siege of City Commenced

Reference

Genl W. T. Sherman

Union army 14-15-17 and 20 Army Corps

Rebels 15,000

Genl Wm. J. Hardee

no scale

Savannah had a population of about 25,000 was strongly fortified and held by the Rebel Genl Hardee with an army of 15,000 These evacued the City. escaping by Pontoon bridge to the Union Causeway to Charleston S.C. The City was surrendered by the Mayor The 2 Rebel iron clad Rams in the harbor were blown up by the Rebels before leaving.

Savannah

THEN AND NOW

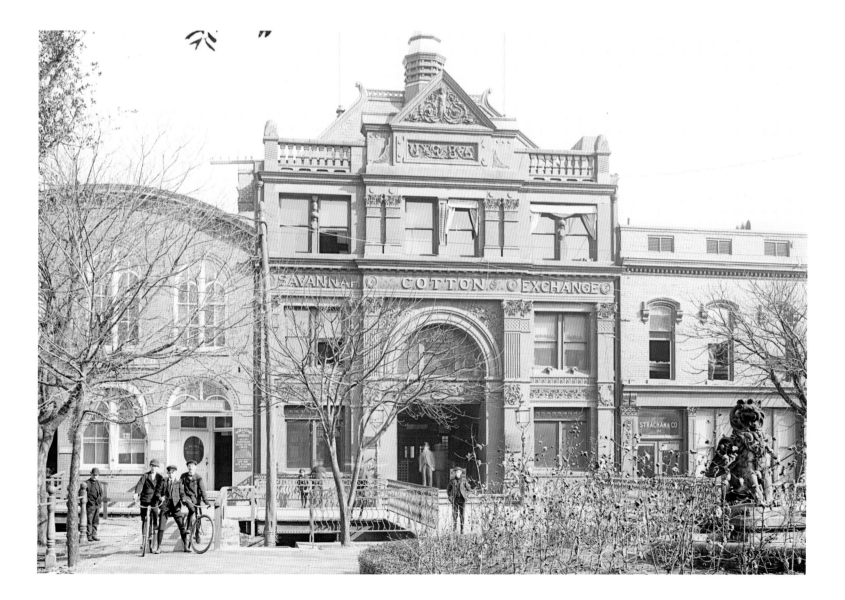

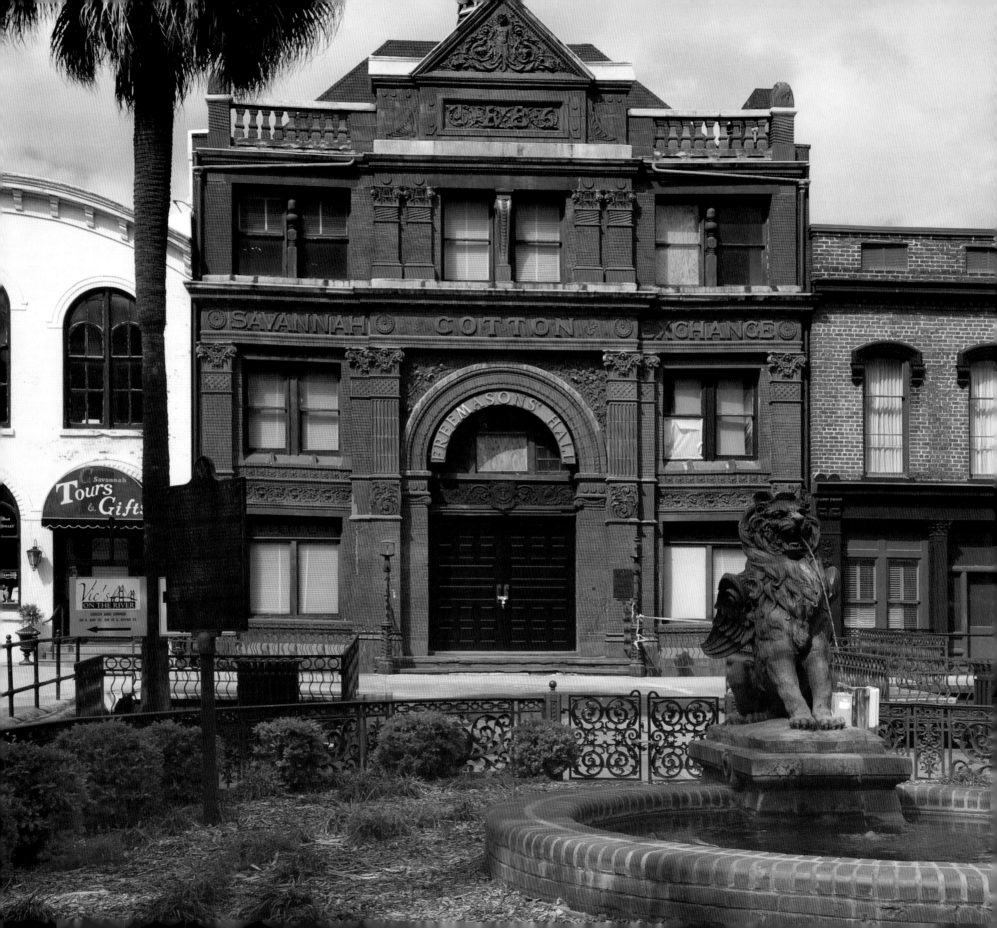

Savannah

THEN AND NOW

Polly Cooper and
Ted Eldridge

THUNDER BAY
P·R·E·S·S

San Diego, California

Thunder Bay Press
An imprint of the Baker & Taylor Publishing Group
10350 Barnes Canyon Road, San Diego, CA 92121
www.thunderbaybooks.com

Produced by Salamander Books,
an imprint of Anova Books Ltd.
10 Southcombe Street, London W14 0RA, UK

"Then and Now" is a registered trademark of Anova Books Ltd.

© 2010 Salamander Books

ISBN-13: 978-1-60710-127-7
ISBN-10: 1-60710-127-0

Library of Congress Cataloging-in-Publication Data available on request.

1 2 3 4 5 14 13 12 11 10

Printed in China

ACKNOWLEDGMENTS

For allowing us on top of tall buildings for photos, for consenting to being interviewed, for offering
encouragement and support, and for tolerating our blunders, we sincerely thank a long list of
patient and helpful friends. As the list would stretch around the block, it is impossible to name
everyone, but we know who you are and are eternally grateful. The following are just a small
handful: Laura Lawton, Tim Cooper, David Watts, David Salmo, Jay Self, Frank Hopkinson, Nora
Lewis, Honorable William T. Moore Jr., Emma and Lee Adler, Big Polly Brooks, Scott L. Poff, the
seven Savannah ladies who formed Historic Savannah Foundation, Inc., in 1955, and the late
Emmeline King Cooper whose *Visitor's Guide to Savannah* was a gold mine of well-researched
facts.

PICTURE CREDITS

The publisher wishes to thank the following for kindly supplying the photographs that appear in
this book:

"Then" photographs:
All "Then" images in the book were supplied courtesy of Library of Congress, except for the
following:
Corbis: page 136.
Georgia Historical Society: page 18 (GHS 35:04-1375-177), page 36 (GHS 35:1375-285-005) and
(GHS 35:Oddfellows), page 38 (GHS 35:1375-175[437]), page 44 (GHS 35:1361-07-08-1273), page 48
(GHS 35:1361PH-08-16-1561), page 50 (GHS 35:1361-28-10-5392), page 54 (GHS 35:1360-04-01-
08A), page 60 (GHS 35:1360-10-23-01) page 62 (GHS 35:1375-192[454]), page 64 (GHS 35:1360-22-
20-01), page 66 (GHS 35:1360-09-25-07), page 70 (GHS 35:1361PH-13-14-2797) and (GHS
35:1361PH-13-14-2796), page 72 (GHS 35:1361PH-07-23-1414), page 80 (GHS 35:1360-12-16-05a),
page 82 (GHS 35:1360-11-02-12), page 86 (GHS 35:1360-08-22-02), page 88 (GHS 35:1361PH-04-
07-0624), page 92 (GHS 35:1361PH-06-15-1216) and (GHS 35:1361PH-14-17-2944), page 94 (GHS
35:1502-01-03-03), page 96 (GHS 35:1374-01-18-01), page 98 (GHS 35:1374-01-18-04), page 100
(GHS 35:1375-183[445]), page 102 (GHS 35:1375-196[458]), page 106 (GHS 35:1360-05-13-05), page
108 (GHS: 35:1360-01-05-02), page 110 (GHS 35:1360-04-19-08) and (GHS 35:1361-07-12-1311),
page 118 (GHS 35:1361-11-03-05), page 120 (GHS 35:1360-11-18-04), page 122 (GHS 35:1360-13-
10-05), page 128 (GHS 35:1360-03-02-10), page 132 (GHS 35:1361-18-10-3682), page 134 (GHS
35:1374-01-32-06).
Vann E. Hettinger, Lane Library, Armstrong Atlantic State University: page 66 (inset).
Andrew Lynch: page 124.
The Collection of Alvin W. Neely Junior: page 122.

"Now" photographs:
All "Now" images were taken by David Watts.

Introduction

Savannah was founded in February 1733, when thirty-six-year-old James Edward Oglethorpe arrived on the ship *Anne*, along with 114 other settlers, to begin a new life in the New World. On a high, windy bluff above the Savannah River, he was greeted by Tomochichi, chief of the Yamacraw Indians, who welcomed these tired English settlers with gifts of deerskins and venison. Tomochichi gave Oglethorpe permission to settle lands between the Savannah and the Altamaha rivers, plus several offshore islands. From the beginning, there was mutual respect between the young Englishman and the elderly Indian. In 1734 Oglethorpe invited his new friend Tomochichi and the chief's family to travel with him to London for a visit. This goodwill trip delighted the trustees, as well as King George ll and Queen Caroline.

Oglethorpe was aided in his mission by Colonel William Bull, a surveyor from South Carolina. Today, the main street running through the Historic District is named Bull Street in the colonel's honor.

Oglethorpe paced off four squares, or little parks, and sketched a design of streets and lanes around these squares. His original town plan within this unique grid of streets, squares, and lanes has been faithfully followed throughout the years and is recognized today by the American Society of Civil Engineers as a National Civil Engineering Landmark. The city today proudly claims twenty-two of its grand total of twenty-four squares, or as locals call them, "outdoor living rooms." Elbert and Liberty squares were sacrificed in the questionable name of progress. Standing in Chippewa Square on Bull Street is a large bronze statue of General Oglethorpe, sculpted by Daniel Chester French. Many squares here have monuments, elegant fountains, or gazebos.

The American Revolution began on August 10th, 1779. The settlers were weary of England's control, and in 1783 they triumphed, but the town was still a straggle of wooden houses on sandy streets. The invention of the cotton gin by Eli Whitney sped up cotton production and Savannah boomed. "King Cotton" made many families wealthy, as evidenced by the numerous Georgian mansions lining the streets of what is now the Historic District.

Visitors to Savannah can admire the Greene-Meldrim House, which served as Union General William T. Sherman's headquarters after the city was captured during the Civil War. Savannah was the last point of resistance in Sherman's 1864 March to the Sea. Once Fort Pulaski's walls had succumbed to the rifled artillery shells of the Union army, Colonel Charles Olmstead surrendered his city in a bid to escape the wanton destruction wrought across so many cities of the South by Sherman's flaming torch.

Though business flourished again once the conflict was over, the impact of the cotton-eating boll weevil across the southern states ensured that the cotton trade was doomed to fade and die. River Street, once flourishing in the prosperous days of King Cotton, fell into disrepair. The large historic houses were vacated, leaving them subdivided into tenements or demolished for their precious Savannah gray bricks. Lady Astor visiting the city in 1946 famously described Savannah as "a beauttful woman with a dirty face."

The city lost its colorful City Market in Ellis Square in 1954 after plans were approved to construct a multistory parking garage, which obliterated the square. Tempers flared, and the following year, when the Davenport House on Columbia Square was threatened by the wrecking ball, seven bold Savannah ladies stopped the demolition and established the Historic Savannah Foundation (HSF), Inc. In 1959 a powerful preservation tool, the "revolving fund," was started. This method enabled HSF to purchase old homes in danger of demolition and offer them up for sale to buyers committed to restoration. HSF recovers the original purchase price and buys another. Since then, HSF has saved countless buildings from destruction, making Savannah's Historic District of 2.5 square miles the largest in the United States. Fifty years later, when the lease on the parking garage expired, this monument to the internal combustion engine was demolished in a satisfying cloud of dust, and the city returned Ellis Square to an open, green space, as Oglethorpe had intended.

Today, the city is celebrated for its Georgian and Victorian architecture and its gardens. The Park and Tree Commission was established in 1896 to protect the already existing magnificent tree cover and support its urban forest. The manicured squares, filled with azaleas, camellias, and wisteria, live oaks, palmettos and cedar trees, are a testimony to the hard work of this dedicated commission.

Millions of visitors enjoy the historic houses such as the Wayne-Gordon House (birthplace of Juliette Gordon Low, the founder of the Girl Scouts), Telfair Academy of Arts and Sciences, Central of Georgia Railway Roundhouse Complex, and the new Jepson Center for the Arts. These are but a mere sampling of what makes Savannah so rich in heritage and architecture.

The Savannah College of Art and Design was started in 1978 and has rehabilitated more than sixty historic buildings, many in challenged neighborhoods. The college's cultural influence has enriched Savannah's quality of life. Its historic preservation school has lured many professionals, interns, and volunteers for Savannah's strong preservation movement.

Tourism brings in over six million visitors a year, aided by movies such as *Forrest Gump* and *Midnight in the Garden of Good and Evil*—a movie based on a book that entertained many outsiders but horrified some Savannahians.

Even though progressive local government supports technology, growth, innovation and a dynamic film industry, the city combines the pluses of living in a big city with desirable small-town charm and Southern hospitality, the seed of which was sown so many years ago on that high windy bluff with that first handshake between Oglethorpe and Tomochichi.

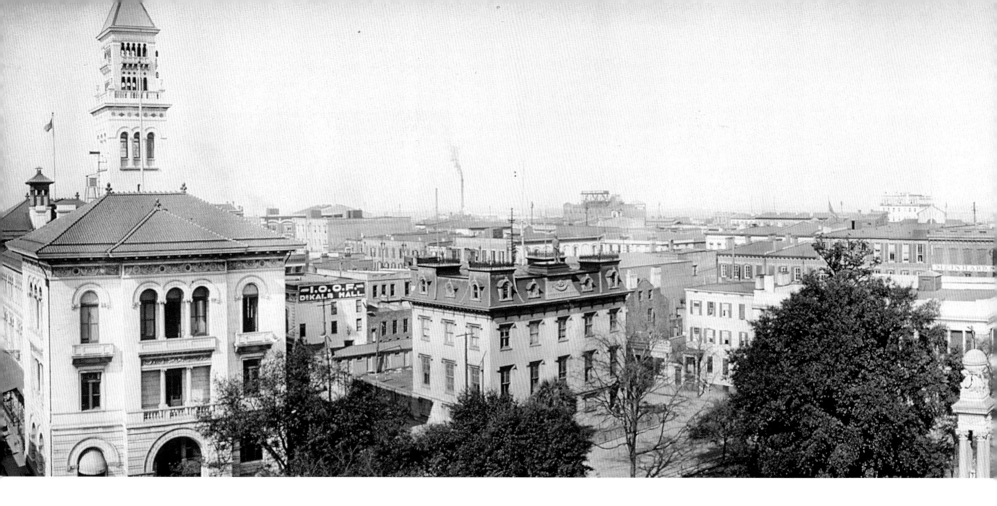

WRIGHT SQUARE PANORAMA

At the heart of historic Savannah

Above: By 1906 the skyline of Savannah boasted a three-story marble post office (far left), which was completed in 1899, with a magnificent tower behind it in matching second Renaissance Revival style. The granite foundation levels were complemented by white marble above. Decorative circles and diamonds of marble quarried from the northern Georgia mountains were set under the red tiles of the roofs, adding a regional element to the stately structures on Wright Square. To the right of the post office sits the Chatham Artillery armory, home to Savannah's distinguished first militia unit, founded by James Edward Oglethorpe in the 1730s. In the distance are the National and Germania banks, the tallest buildings in town at the time. To their right is the city hall building, completed in 1906 at the head of Bull Street, the first north-south road built in the settlement in 1733. In the foreground can be seen the tops of the trees of Wright Square, the German Lutheran Church of the Ascension and, at the far right, the Chatham County Courthouse, completed in 1889.

Right: Any modern aerial photograph of Savannah is dominated by a canopy of green with far-reaching limbs of live oak. The Chatham Artillery armory was razed in 1933 to extend the post office north to State Street, effectively closing President Street between the two blocks. The twin structures were connected with a recessed third section, creating the Federal Courthouse Complex. While the Gordon Monument still anchors the center of Wright Square, two three-story SunTrust Bank buildings have replaced the Liberty National and Germania banks to the north, which were demolished in the mid-twentieth century. City Hall, at the head of Bull Street (center), has been preserved, other than for the covering of the copper dome with brilliant gold leaf. Both the Lutheran Church of the Ascension and the Chatham County Courthouse have been beautifully maintained through the years.

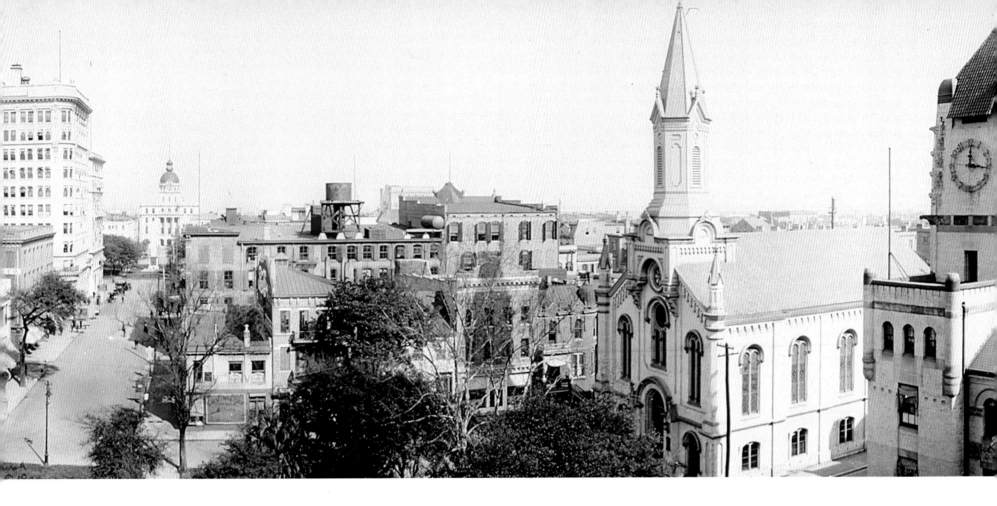

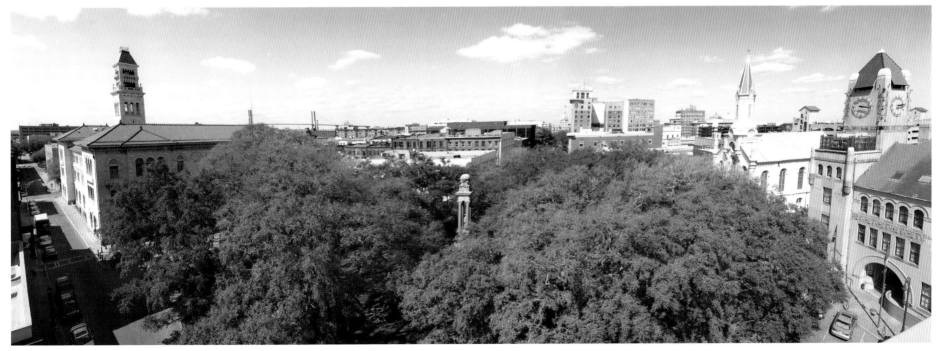

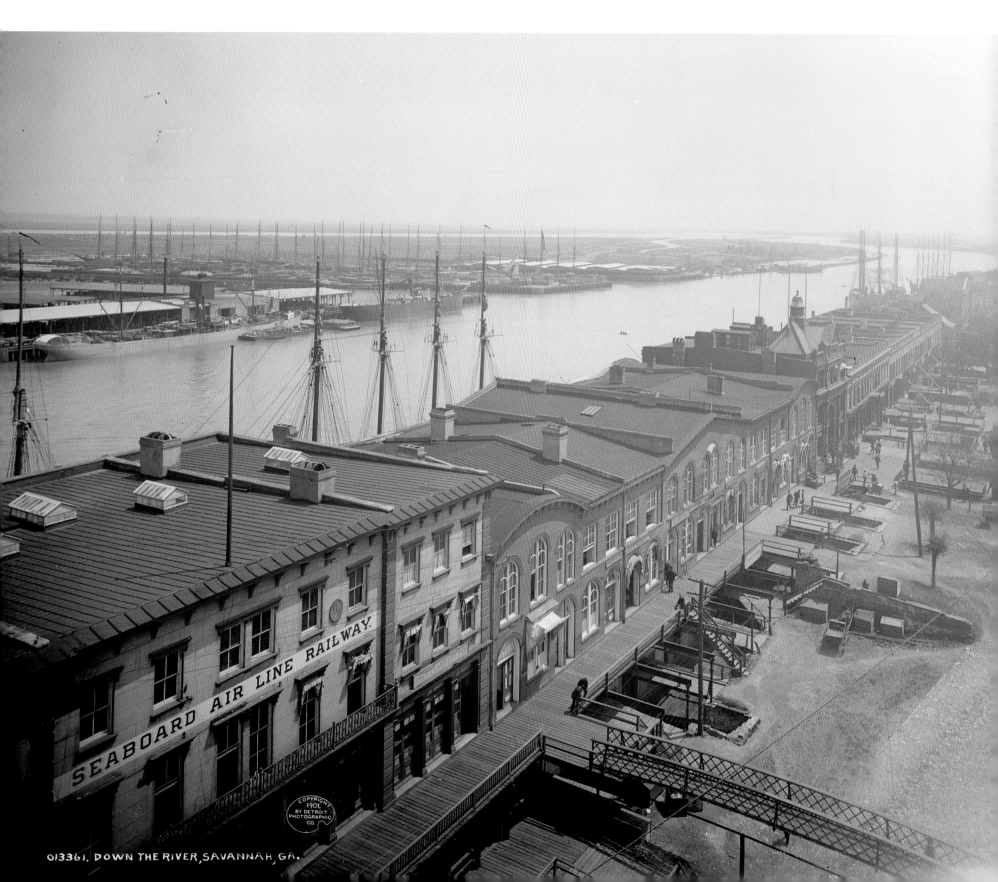

SEABOARD AIR LINE RAILWAY.

013361. DOWN THE RIVER, SAVANNAH, GA.

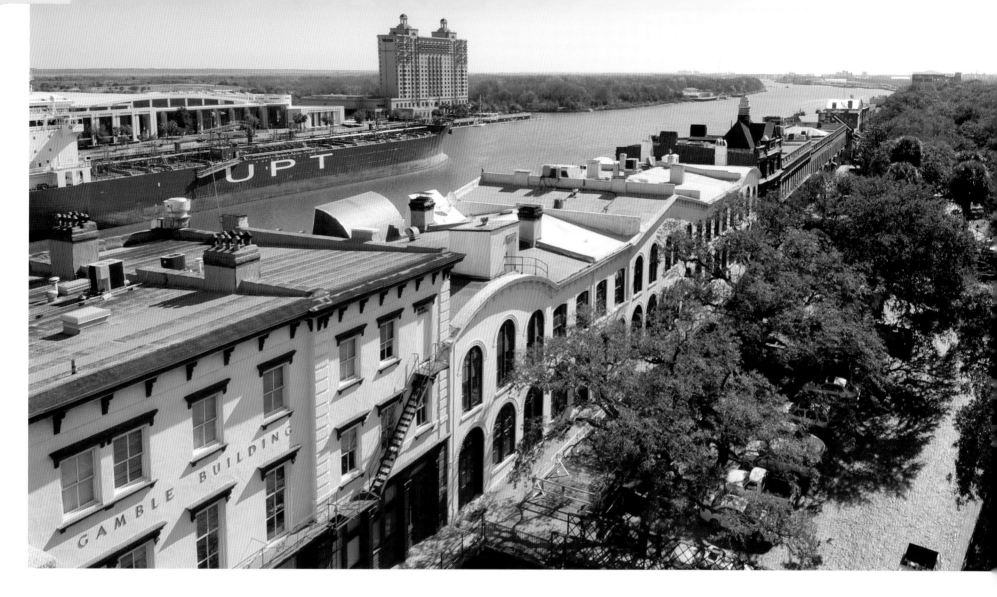

FACTORS WALK WAREHOUSES

Where the merchant princes of Savannah made their early fortunes

Left: From the 1700s through 1850, Savannah's riverfront reflected its prominence as a major port city. Cotton had become the most important export. Brick and stone warehouses built below the bluff were designed with lower floors opening to the wharves, convenient for loading goods onto ships on the riverside. The upper floors were at street level at the top of the bluff. Between the buildings and a wall built to retain the bluff, a narrow lane was maintained for carts carrying products to the warehouses from plantations and the railroad station. To connect the warehouses with the bluff and the rest of the city, bridges were constructed with iron supports and railings across this lane. This ingenious system was referred to as the "factors walk" because factors—the accountants or brokers for companies owning the businesses—used the bridges to get to and from their offices on the upper levels.

Above: In the 1950s, most of these old warehouses along River Street and Factors Walk were empty and boarded up, but today all that has changed. The iron bridges are a prized feature of this high-rent retail district of shops, pubs, restaurants, and cafés. Visitors stroll down River Street to sample a pecan praline or benne seed cookies. The street and ramps are surfaced with ballast stones that were once used to provide stability in the hulls of sailing ships. Before heavy cargo was loaded onboard, these stones were taken out of the ships and left behind. Many of the buildings have earthquake rods built into their construction. The ends of these rods can be seen in the form of iron stars or Xs. Charleston, just eighty miles drive away in South Carolina, had a frightening earthquake in the 1880s, so building designers in Savannah didn't want to take any chances.

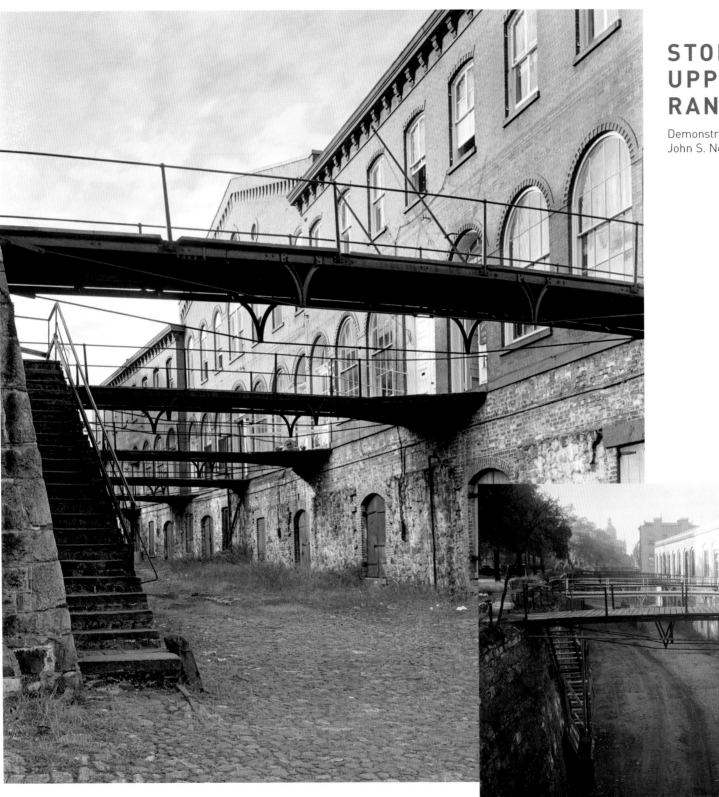

STODDARD'S UPPER AND LOWER RANGE

Demonstrating the versatile skills of architect John S. Norris

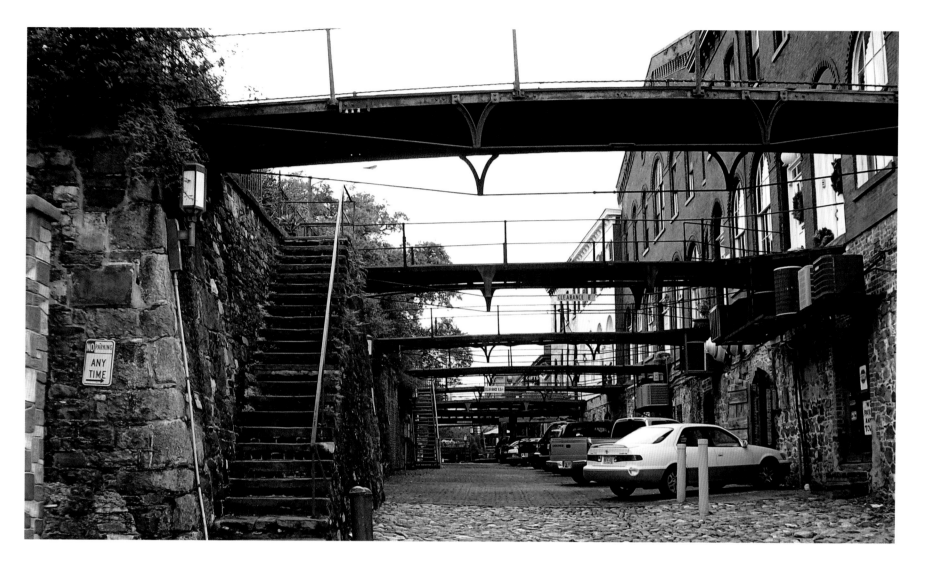

Left: In 1858 merchant John Stoddard commissioned architect John S. Norris to build a set of fine offices and warehouses. Norris was one of three prominent nineteenth-century architects in Savannah, along with William Jay and Charles B. Clusky. He employed a wide variety of building styles that encompassed the Greek Revival Custom House and the Gothic Revival Mercer-Wilder House and Green-Meldrim House. The brick-built Italianate style warehouse block was completed in 1859. A year later, with the prospect of Civil War looming, Norris moved his family back to New York. During the Civil War occupation of Savannah some of General Sherman's lower-ranked officers used this building's empty offices. After the war, the buildings were used by the Stevens Shipping Company. When the building was renovated in 1901, workers found a Civil War map drawn on the wall by Union soldiers, tracing their march from Tennessee through Georgia. These photos from the early 1940s show Stoddard's warehouses in decline along Factors Walk.

Above: Tenants of Stoddard's Upper Range—such as the Savannah Pilots Association, who were responsible for piloting sea-going vessels from the mouth of the Savannah River to the wharves upriver—and the Atlantic Towing Company are no longer in residence. Today the buildings are used for a variety of purposes including the restaurant Vic's on the River, which has an elegant dining space overlooking the waterborne traffic below. The restaurant holds a small portion of the historic map recovered from the 1901 renovation and has it on display in the restaurant.

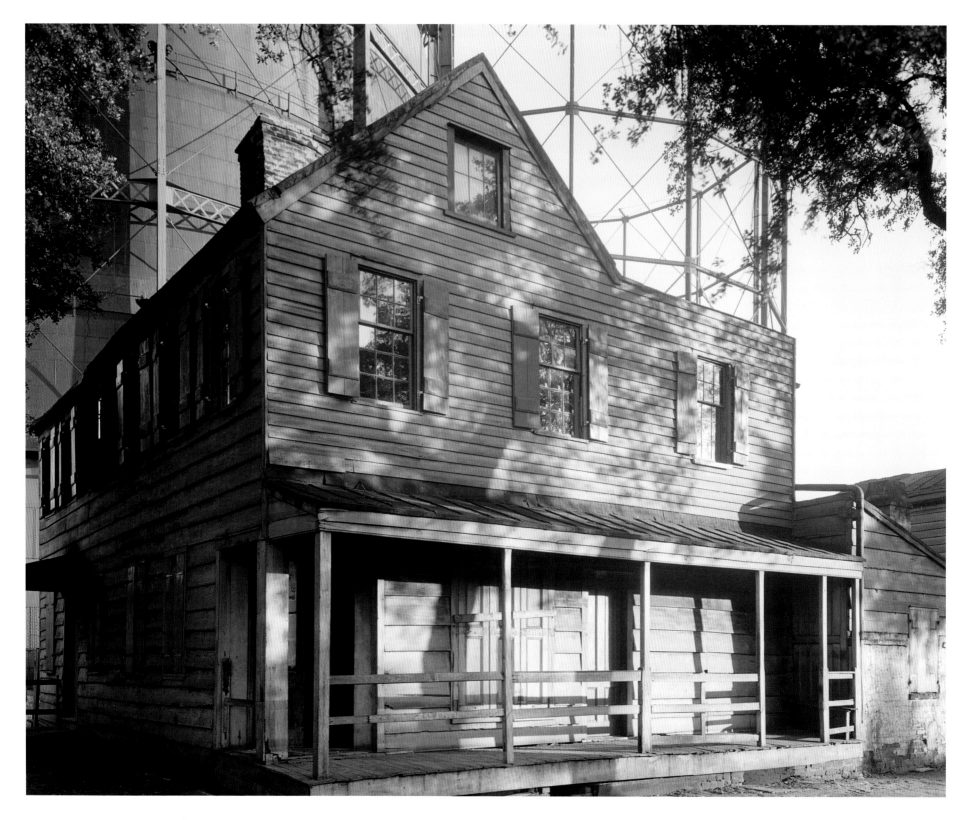

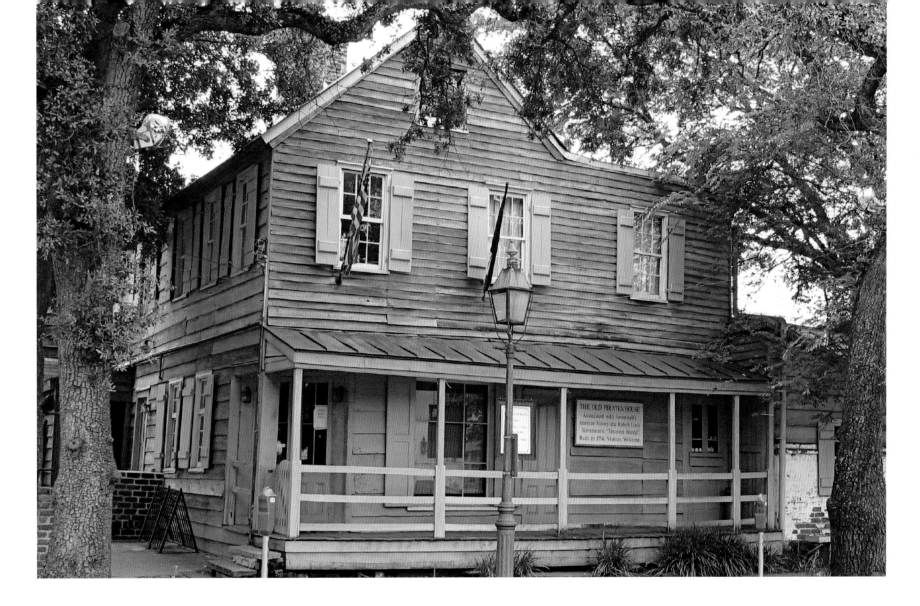

OLD PIRATES' HOUSE TAVERN

Reputed to be the place where Robert Louis Stevenson started writing *Treasure Island*

Left: The room said to be the oldest existing in Savannah is the Herb Room at the Olde Pirates' House Tavern. The structure is a maze of rooms and attached buildings, and was a favorite watering hole and roadhouse for pirates who found Savannah tempting in the eighteenth and early nineteenth centuries. It is claimed that such notorious bandits of the sea as Blackbeard and Jean Lafitte drank, dined, and slept at the Olde Pirates' House Tavern and that author Robert Louis Stevenson was staying at the inn when he wrote at least the first chapter of *Treasure Island*. The buildings were spared in each of three major fires that started in town, because flames were fanned by ocean breezes and spread quickly through the city to the west. The Olde Pirates' House was on the east side of the road now known as East Broad Street, which marked the edge of town.

Above: In the Pirates' House restaurant today, the atmosphere of swashbuckling pirates with wooden legs, talking parrots, and sailing ships is preserved. In the captain's room, plans were concocted by ships' captains needing crew to shanghai tipsy seamen at the bar, drag them through the tunnel leading to the river, and toss them aboard waiting ships. Hanging on the walls are pages mentioning Savannah from a rare edition of *Treasure Island* by Robert Louis Stevenson. It is said that Captain J. Flint died upstairs with Billy Bones by his side calling for more rum. In 1948 the property was acquired by the Savannah Gas Company.

COMMERCE ROW

James Oglethorpe's memorial marble bench is sited here

Top: As the town grew in the first half of the nineteenth century, a small park was maintained. It had a round-backed marble bench, placed in honor of the founder of Savannah, James Edward Oglethorpe. It is visible in the center of the park. Landscaping had already become important to the aesthetics of Savannah. The bench was said to have been placed on the spot where Oglethorpe pitched his tent upon climbing the bluff after disembarking from the good ship *Anne*, and stepping on ground that was to become the settlement of Savannah. When this photo was taken in the early 1900s, the handsome warehouses on the river extended to heights above Yamacraw Bluff. City Hall, (center) had been built on the spot previously occupied by the City Exchange Building, which was dismantled in 1904. City Hall was completed in 1906 with a distinctive dome of copper, which could be seen from most points within the city.

Bottom: Oglethorpe's bench is often used for relaxing before walking along Bay Street, which was once the main route used by planters bringing cotton and tobacco to waiting ships. Outside the entrance to City Hall are two tablets explaining Savannah's importance to the maritime industry. One denotes the 100th anniversary of the *Savannah*, the first steamship to cross the Atlantic Ocean. The other denotes the *John Randolph*, one of the first iron ships to be seen in the Americas. Across Bay Street is the U.S. Custom House.

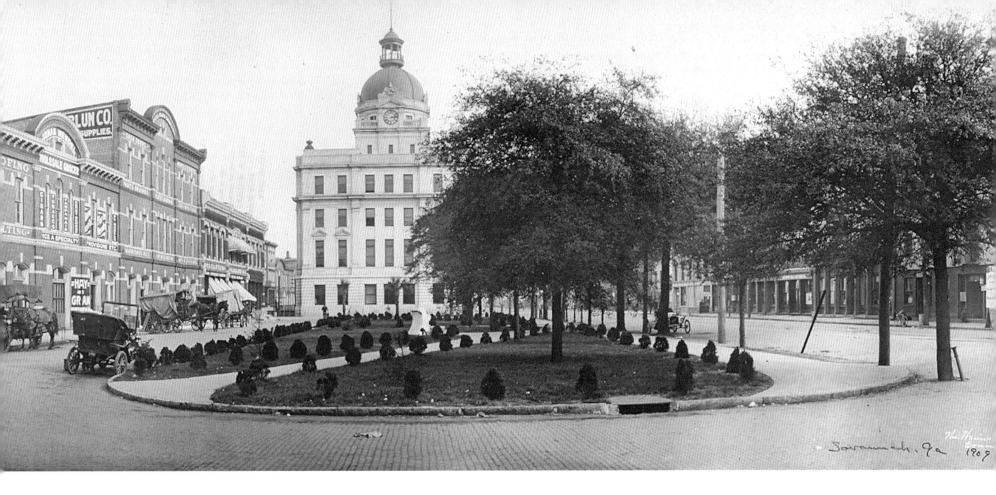

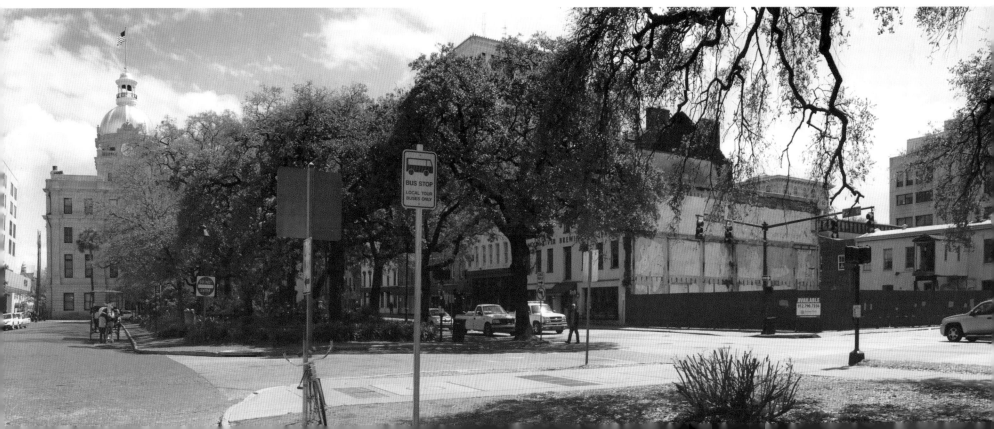

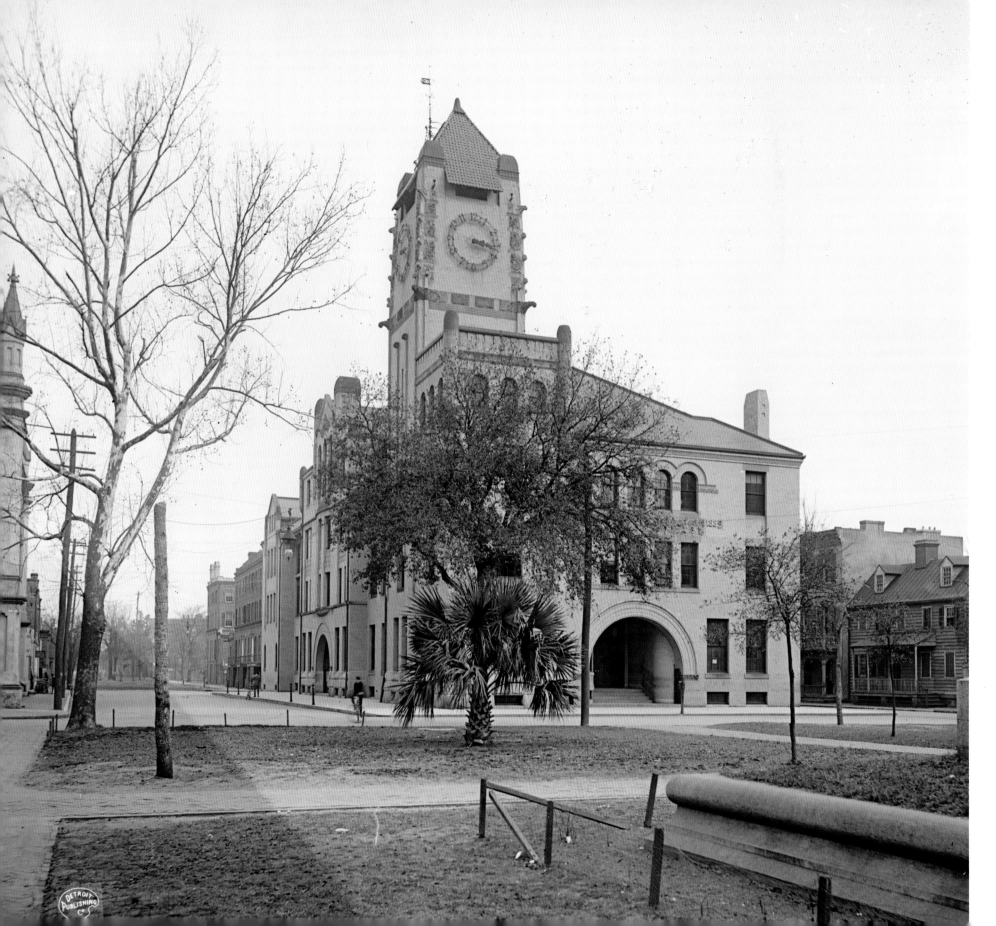

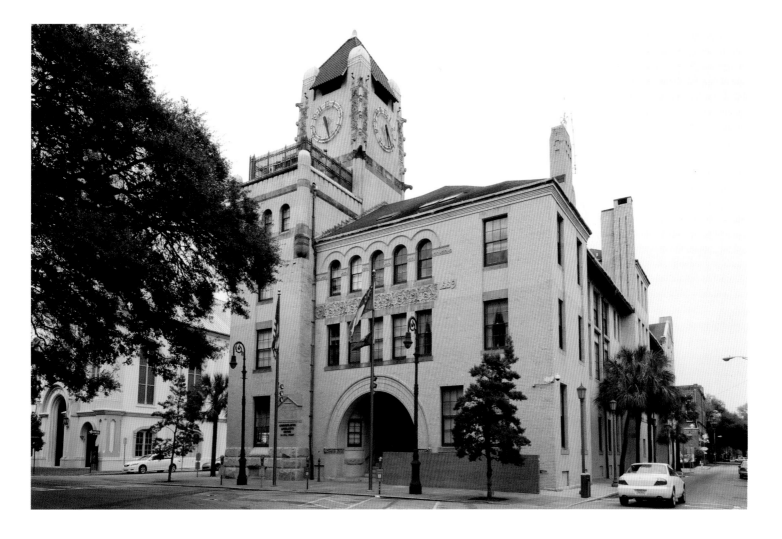

CHATHAM COUNTY COURTHOUSE

Chatham's fourth county courthouse has been standing for well over a century

Left: The first official Chatham County Courthouse, a redbrick structure, was completed in 1773 and faced Wright Square. In 1796 a great fire that destroyed much of Savannah gutted its interior. For several years court sessions were held in Savannah's theater. A second courthouse was constructed on the site in 1804 and was used until 1830, when the justices of Chatham County's court decided a new facility was needed. The new Greek Revival courthouse, completed in May 1832, was a two-story brick building covered with stucco and painted white. The courthouse occupied an entire block. This structure survived the Union occupation of Savannah in 1864 and 1865, but by this time a larger facility was needed. The building was demolished in 1889 to make room for a fourth courthouse (seen here in 1902) to accommodate the growth of Savannah and Chatham County.

Above: By the 1970s Chatham County had joined a growing number of counties that found their current courthouses inadequate to serve the judicial, administrative, and legislative branches of county government, but did not wish to tear down their historic buildings. In 1978 Chatham County built a new six-story courthouse and judicial center between Montgomery Street and Martin Luther King Boulevard. In the 1980s, the county spent $4.3 million renovating the 1889 courthouse on the southeast corner of Wright Square for the continued use of county offices. This building is made of pale yellow bricks, unusual for Savannah with so much red clay, and has an arched entrance on the west side and terra-cotta botanical patterns over the left door. The lights appearing on the Bull Street side are known as bishop's crook lights and are like those that were originally used throughout Savannah's streets.

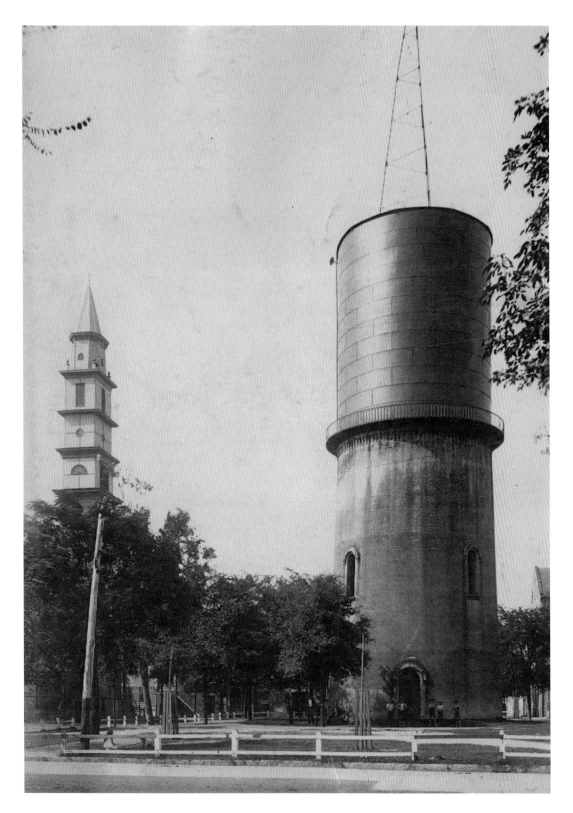

FRANKLIN SQUARE

Location of the first African American church in Savannah

Left: Franklin Square honors Benjamin Franklin, who served as a representative to London from both the colony of Georgia and the commonwealth of Pennsylvania; the square was laid out in 1791. It was the location of the city's stored water supply for many years and was often referred to as "Water Tower" or "Reservoir" Square. George Leile, born a slave in Virginia in 1750, came to Savannah when he was freed and is considered the first black Baptist missionary in America. Reverend Leile baptized many slaves on Savannah River plantations, including Andrew Bryan who, on January 20, 1788, organized the first African American congregation in America. It was on Franklin Square that Reverend Bryan was able to preach in the first church in America built by African Americans for themselves, in 1859. Slaves came to work on the First African Baptist Church after their daily obligations were met. The tiered steeple of the church was destroyed in a hurricane in the late nineteenth century. This photo is from 1890.

Right: The founders of Savannah's First African Baptist Church are portrayed in its stained-glass windows. Marks of slavery are still visible in the holes puncturing the floors downstairs. These are breathing holes used by slaves fleeing to freedom. Enslaved African artisans also left their signatures scratched onto pews in the balcony. A new monument graces Franklin Square today. This detailed sculpture is the work of James Mastin. The Haitian American Historical Society unveiled the sculpture in 2007, created to honor the Haitian Revolutionary War soldiers who fought alongside Count Casimir Pulaski in the siege of Savannah when the city was trying to break away from the controls of Great Britain. The six bronze soldiers on top of the granite monument represent the service and sacrifice of 500 volunteers of the Chasseurs Volontaires de Saint-Domingue. The hatless drummer boy is Henri Christophe, future president and king of Haiti, who was only twelve when he served in Savannah. The Chinese tallow trees scattered about the city originated from seeds sent to the colony by Benjamin Franklin. A note arrived with the seeds, in which Franklin said that he hoped they would flourish—which they did. They are recognizable by the leaves resembling Chinese paper lanterns.

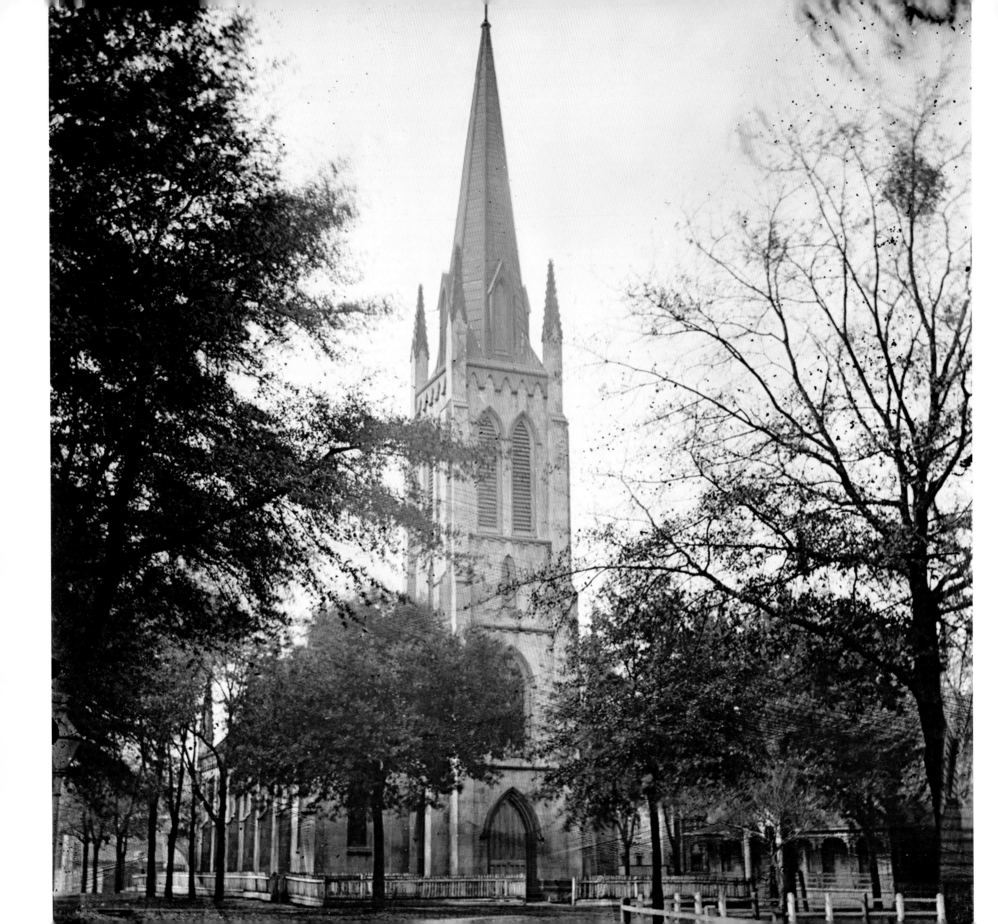

ST. JOHN'S EPISCOPAL CHURCH

Where Union officers worshipped in 1864 and 1865

Left: Saint John's Episcopal Church was completed in 1853 as a mission church to Christ Church Episcopal, Savannah's first church. For that reason, the first deacons and vestrymen of Saint John's were selected from Christ Church members. Saint John's is a striking example of English Gothic architecture. New Testament scenes are depicted in leaded stained-glass windows made in England and installed in the 1880s. For reasons lost to history, a ship's mast was built into the center of the church's spire. Stephen Elliott, the first Episcopal bishop of the Diocese of Georgia, served at Saint John's for his first assignment upon consecration. He openly shared his anguish over the issue of secession in his sermons as the winds of war gathered. When General William T. Sherman marched into Savannah in 1864, he and his army officers attended services at Saint John's, hearing both Union and Confederate preachers. Charles Green had offered his mansion, just across the courtyard from the church, to Sherman to be his private quarters. This photo is from 1865.

Right: A story is told that, having heard that Sherman intended to remove the bell from the church's belfry during the Union occupation in December of 1864, the women of Saint John's, in desperation, sent a telegram to President Abraham Lincoln requesting that the bell remain in the tower. Lincoln honored the request, and the bell still hangs securely in the belfry. A carillon calls people to worship today, and a 1928 edition of the Book of Common Prayer continues in use as the basis of order for worship. After services, friends gather for fellowship in the Green-Meldrim House, just a few steps across the courtyard. The Gothic house is open to visitors during the week, hosted by church members who serve as docents. The Holly Day Bazaar fund-raiser, begun in 1940, is held each November. In 2010 the services of a nationally recognized steeplejack were needed to secure a gargoyle and restore the cross on the steeple. He used no scaffolding for the job, just ropes and pulleys.

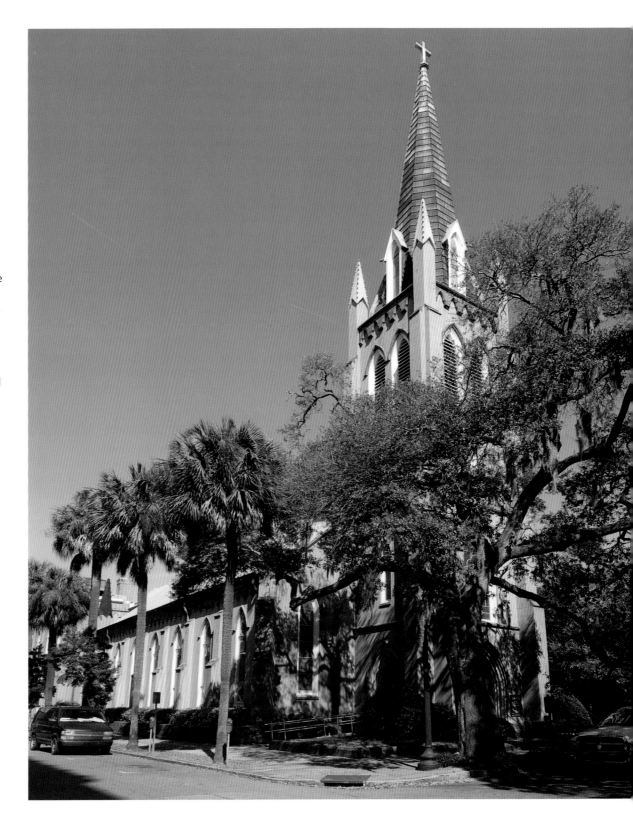

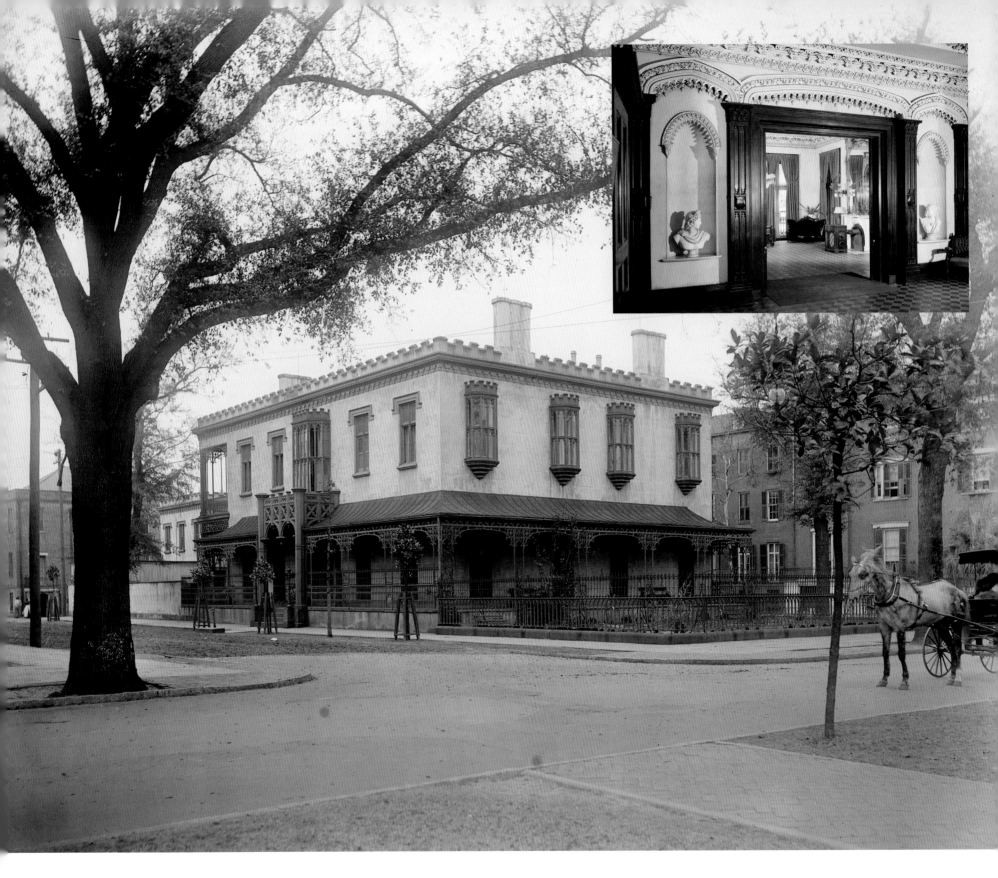

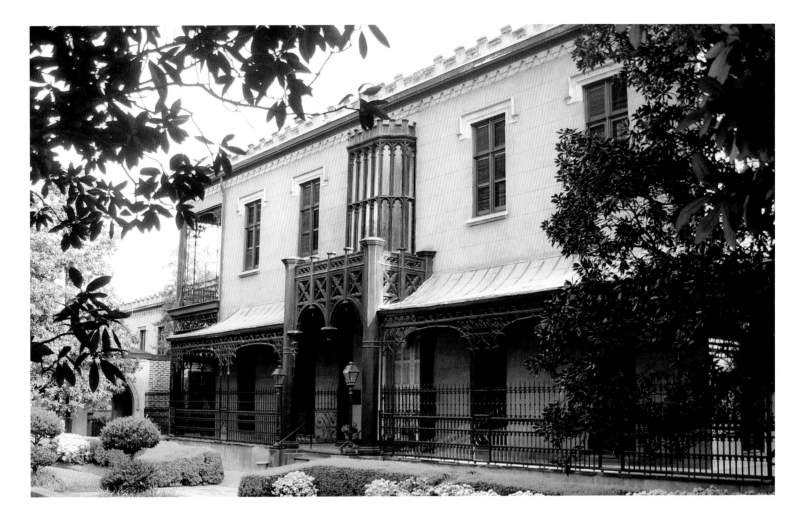

GREEN-MELDRIM HOUSE

Sherman's headquarters in Savannah until early 1865

Left: Charles Green, an Englishman who had made his fortune trading cotton in Savannah, offered his house to General William T. Sherman when he took the city in December 1864. In his memoirs, Sherman wrote: "At first I was strongly disinclined to make use of any private dwelling, lest complaints should arise of damage and loss of furniture, and so expressed myself to Mr. Green; but, after riding about the city, and finding his house so spacious, so convenient, with large yard and stabling, I accepted his offer." Sherman remained there until January 21, 1865. It was in this house that Sherman wrote out his celebrated telegram to Abraham Lincoln: "I beg to present you as a Christmas gift, the city of Savannah, with one hundred and fifty heavy guns and plenty of ammunition, also about twenty-five thousand bales of cotton." Ironically, many of those bales of cotton would have belonged to his host.

Above: Green got his house back after the war and on his death in 1881, the house passed to his son Edward Moon Green. He sold it to former Savannah mayor Peter W. Meldrim, a distinguished Georgia jurist who became president of the American Bar Association from 1912 to 1913. In 1943 the house was purchased by St. John's Episcopal Church across the street and the former kitchens, servants' quarters, and stable now serve as the rectory for the church. It was designated as a National Historic Landmark in 1976. The building is open for tours and visitors can admire the distinctive Gothic Revival architecture of John S. Norris, the man responsible for the Custom House on Bull Street and the Mercer-Wilder House. Many of the original features remain in the interior of the home, including American black walnut woodwork on the main floor, marble mantles, graceful chandeliers, and large, gold leaf-framed mirrors imported from Austria.

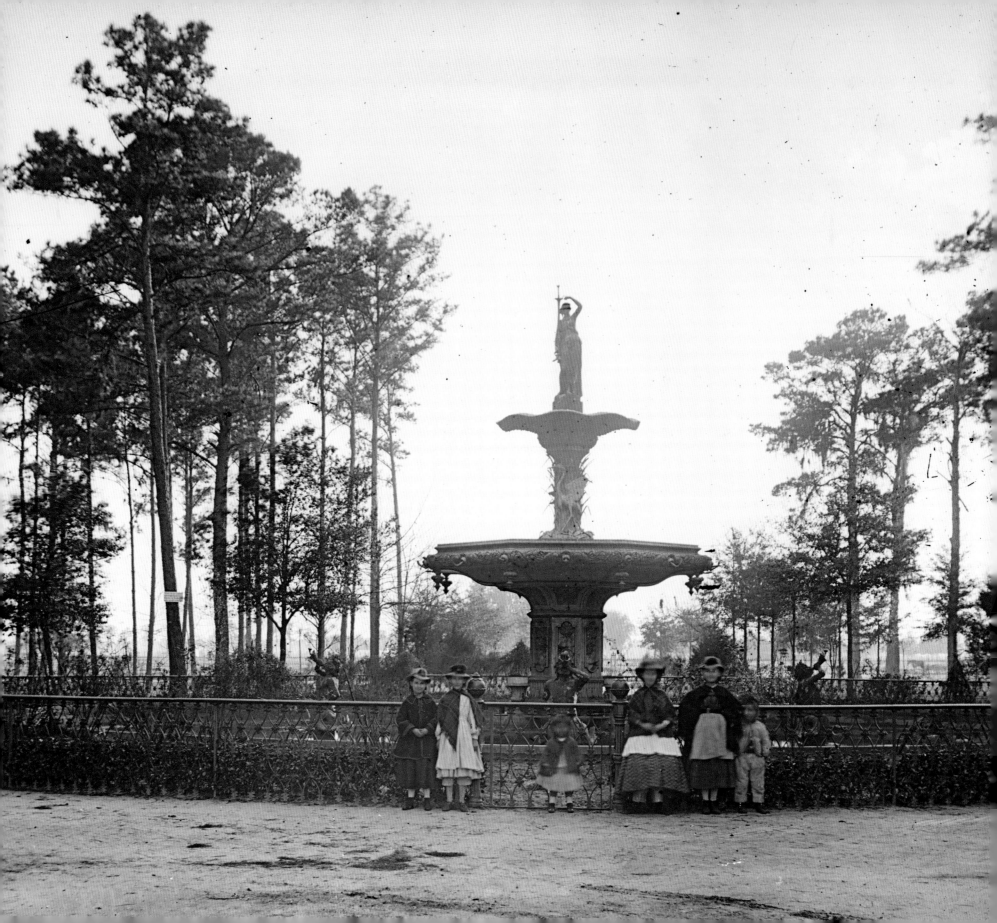

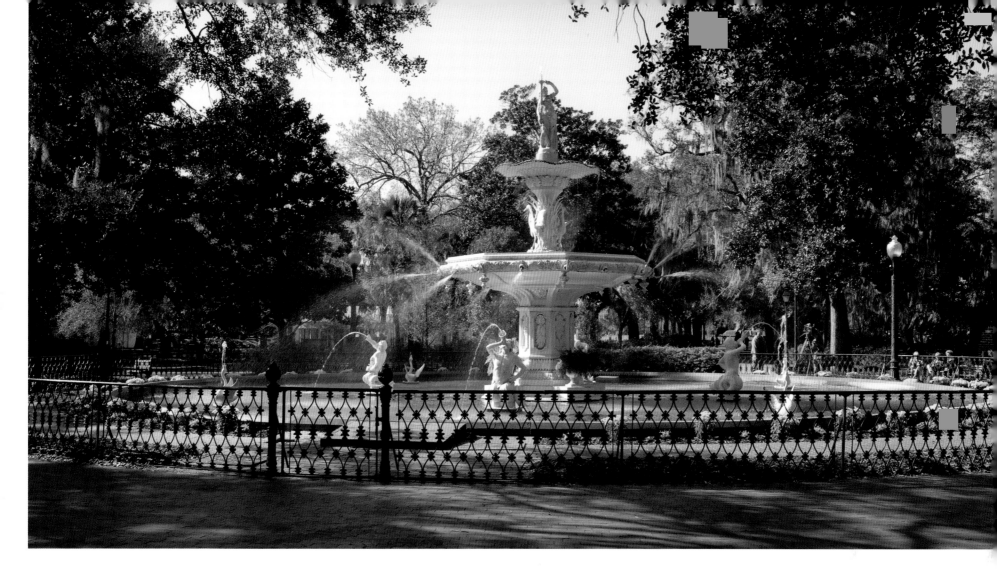

FORSYTH FOUNTAIN

Often used as the emblem for this beautifully preserved city

Left: For "the pleasure of the people," William Hodgson gave a ten-acre square of land to create a public park in 1851; Forsyth Park was completed in 1856. All common land owned by the city had been developed according to James Edward Oglethorpe's plan; from four wards and squares in 1734 to twenty-four by 1855. One entered Forsyth Park between two large stone sphinxes, and along the many walks were sculptures of Greek gods; large, raised stone flower gardens; and a small stone band pavilion among the trees of the arboretum. An additional twenty acres were cleared and served as parade grounds for Savannah's Confederate soldiers from 1860 onward. Two stucco-covered mock forts were built as drill targets. The Forsyth Park fountain is the elegant showpiece in the heart of the park. Families, sweethearts, schoolchildren, and military units have long used the fountain as their backdrop for photographs, as evidenced in this 1869 photo.

Above: Savannah is fortunate to have these verdant open spaces for all types of outdoor activities. Skateboarders, joggers, dog walkers, parents pushing strollers, and people enjoying picnics on blankets all make this park colorful and full of life. Many cities would have subdivided this area and built condos, but Forsyth Park is protected from that fate. On Saint Patrick's Day, the fountain water is dyed and the concrete swans spout green water. The park is the site of many Civil War reenactments and the Sidewalk Art Festival of chalk drawings by students of the Savannah College of Art and Design. Many movies have filmed scenes here, including *Midnight in the Garden of Good and Evil, Forrest Gump,* and *The Longest Yard.* The Children's Book Festival attracts thousands of book lovers each year. Often a wedding is in progress, or perhaps a jazz concert under the new band shell on the south side of the historic fort built for the Georgia National Guard in the early 1900s.

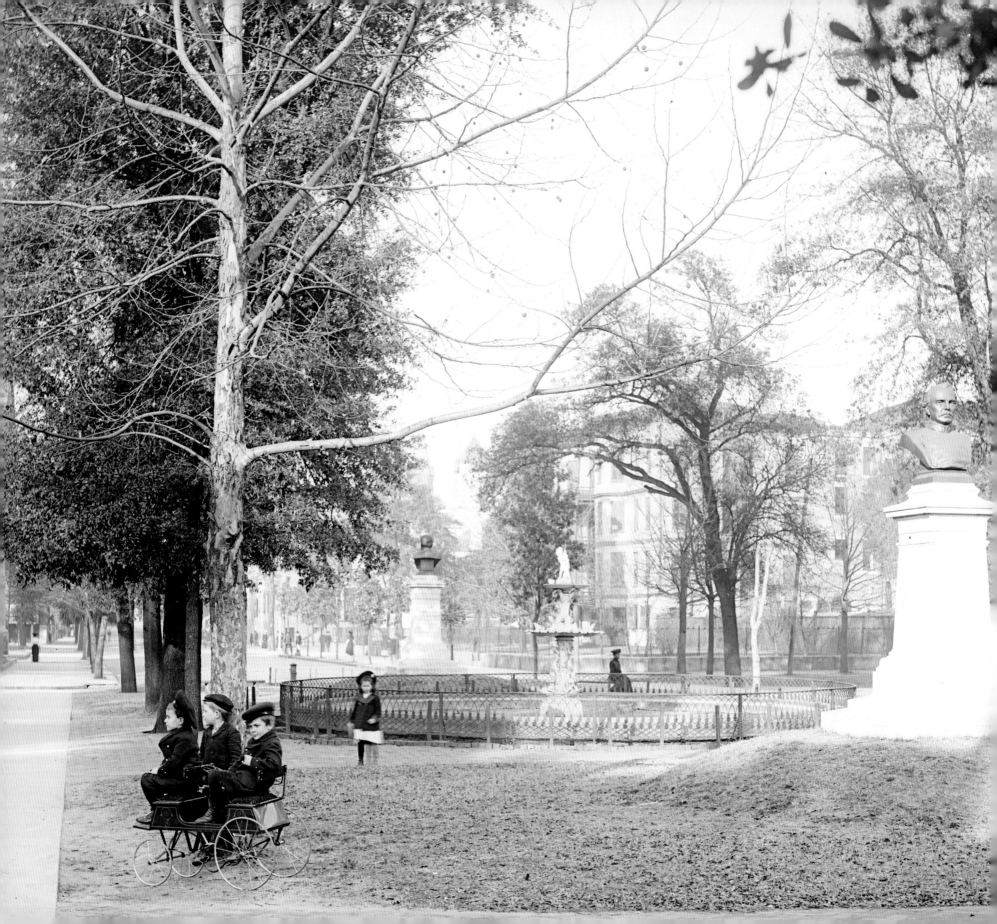

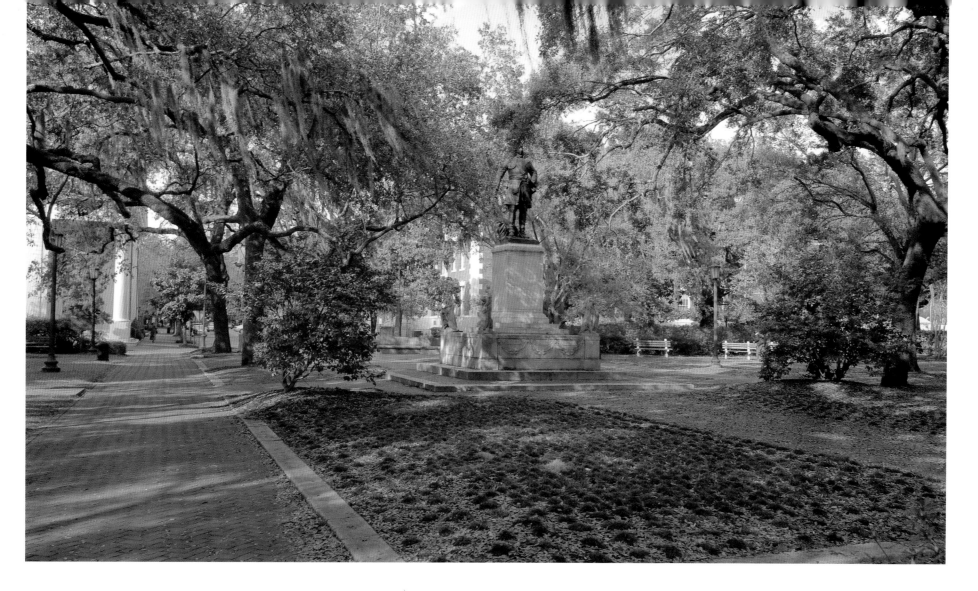

CHIPPEWA SQUARE

Where Forrest Gump delivered his most famous line

Left: This photograph of Chippewa Square was taken before 1899, when a devastating fire destroyed the wooden Chatham Academy (behind the trees in the center), Savannah's high school. This was taken sometime after 1865, the year the Civil War ended. Both busts raised on the stone pedestals are of Confederate generals from Savannah. General Francis Bartow led the Savannah militia in the First Battle of Bull Run (First Manassas) and was the first Savannahian to die in the Civil War. The other is General Lafayette McLaws, who fought at Harpers Ferry and Antietam, and later at Fredericksburg, Chancellorsville, and Gettysburg. Between the two memorials stands a tiered fountain that graced the center of Chippewa Square, a major attraction at the time for Savannahians strolling the streets, or gathering for picnics in the parks.

Above: In February 1910, the busts of both men were moved from Chippewa Square to their present site at the Confederate Monument in Forsyth Park. The fountain was also removed to make way for the new monument to General James Edward Oglethorpe. Sculptor Daniel Chester French and his assistant, Henry Bacon, produced this nine-foot-tall bronze sculpture of the general. It was unveiled on November 23, 1910. It faces south in the direction of Florida and the Spanish who were a threat to the new colony. In the movie Forrest Gump, the scene in which the title character eats his box of chocolates while waiting for the bus with the elderly woman played by Nora Dunfree was staged on the north side of the square. On the southeast side, across Bull Street, another point of interest are the two rain drains, called dolphin downspouts. These are attached to the former home of Dr. James Johnson Waring.

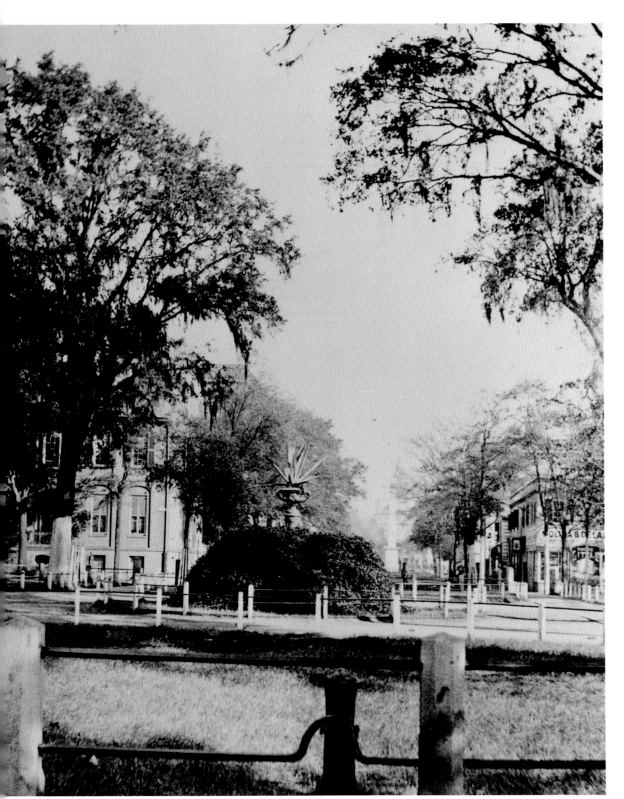

TOMOCHICHI MONUMENT / GORDON MONUMENT

The burial place of an outstanding Native American

Left: Chief Tomochichi of the Yamacraw, the indigenous people of the area, met the first colonists when they climbed the bluff in 1733, warmly greeted them, and offered them food and friendship. When Tomochichi died at age ninety-seven in 1739, his request to be buried in the city of his friends was honored. The center of Wright Square was selected as a fitting final resting place for the leader who had helped the settlers survive the challenging conditions of their new home. Oglethorpe served as a pallbearer during the elaborate parade that preceded the interment of Tomochichi. The colonists and members of the tribe paid tribute in a ceremony fitting for a Native American and important figure in the settling of Savannah. A pile of rocks, representing an Indian burial mound, was placed above the grave site as a memorial. This photo dates to 1870.

Right: No records exist to explain the fate of Tomochichi's remains after his monument was demolished in the 1880s to make way for the burial of William Gordon and the construction of his ornate monument on the same site. Gordon, the founder of the Central of Georgia Railway, had brought great wealth to the city and people of Savannah. In 1899 the Colonial Dames of Georgia—led by Nelly Kinzie Gordon, daughter-in-law of William Gordon and mother of Juliette Gordon (who, after marriage, became Juliette Gordon Low, founder of the Girl Scouts of America)—were responsible for the placement of a large granite boulder chinked from Stone Mountain in northern Georgia to honor Tomochichi. Girl Scout troops visiting Low's birthplace heard of her mother's response when the granite boulder was delivered on the Central of Georgia Railway with a bill for $1 payable on Judgment Day. She wrote saying that she'd be much too busy on Judgment Day to pay bills—and enclosed the dollar.

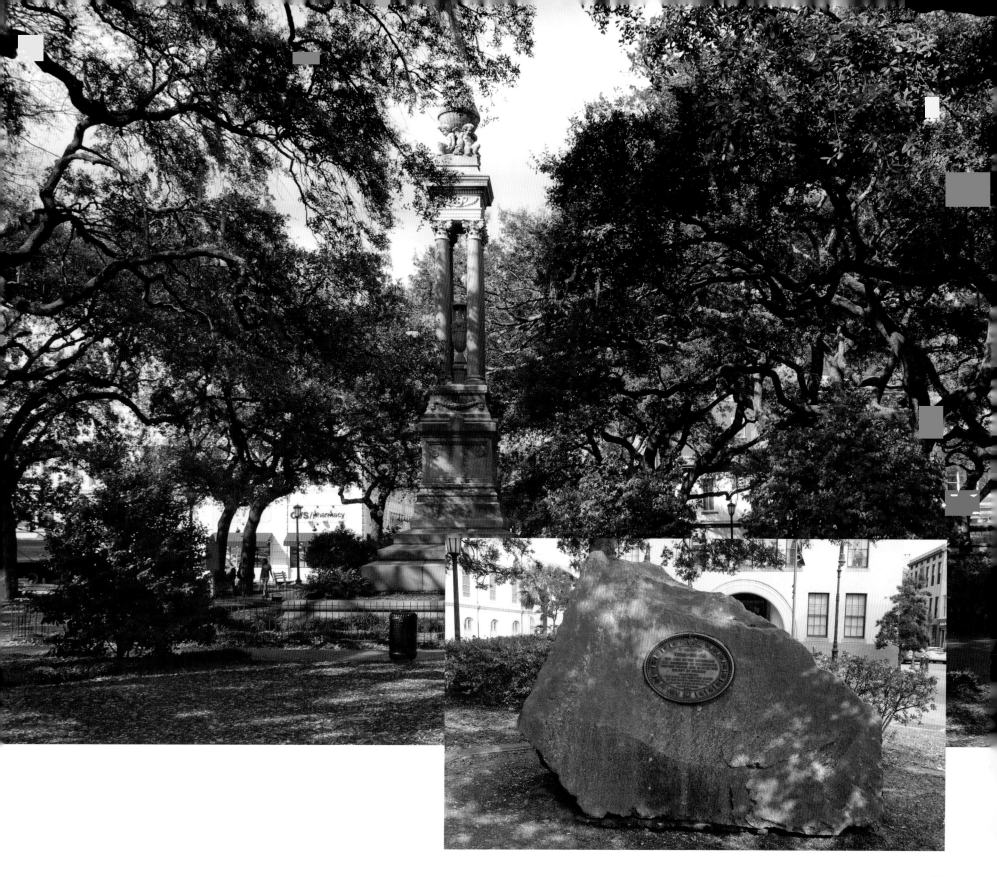

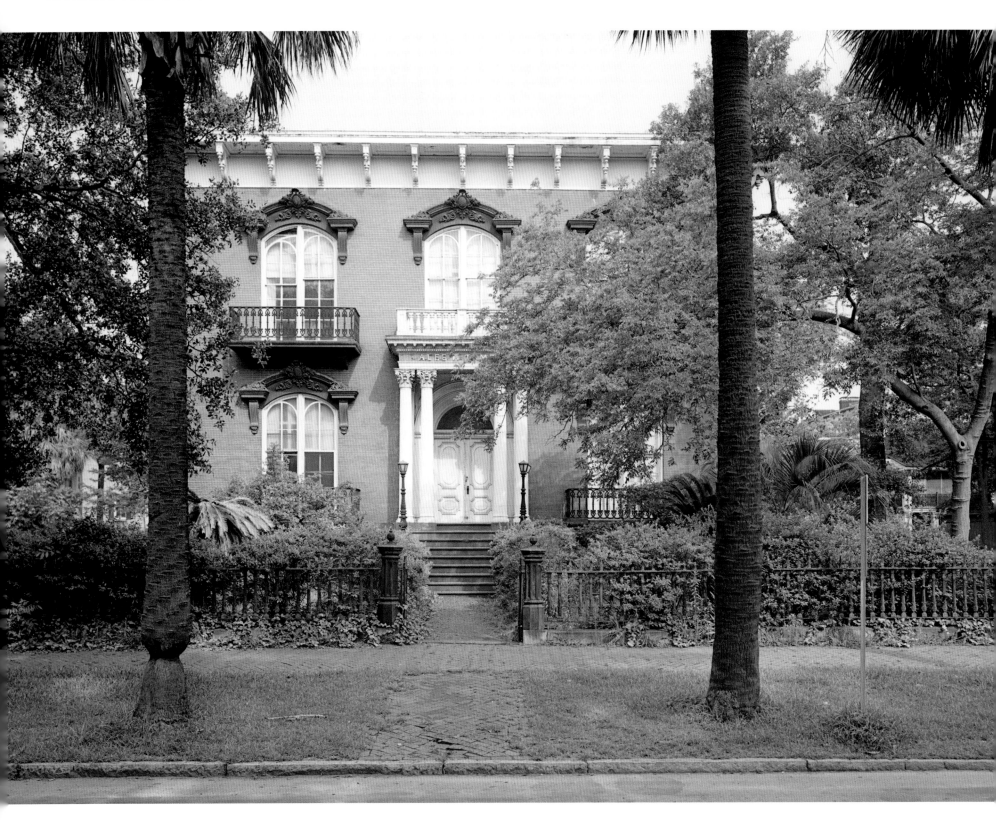

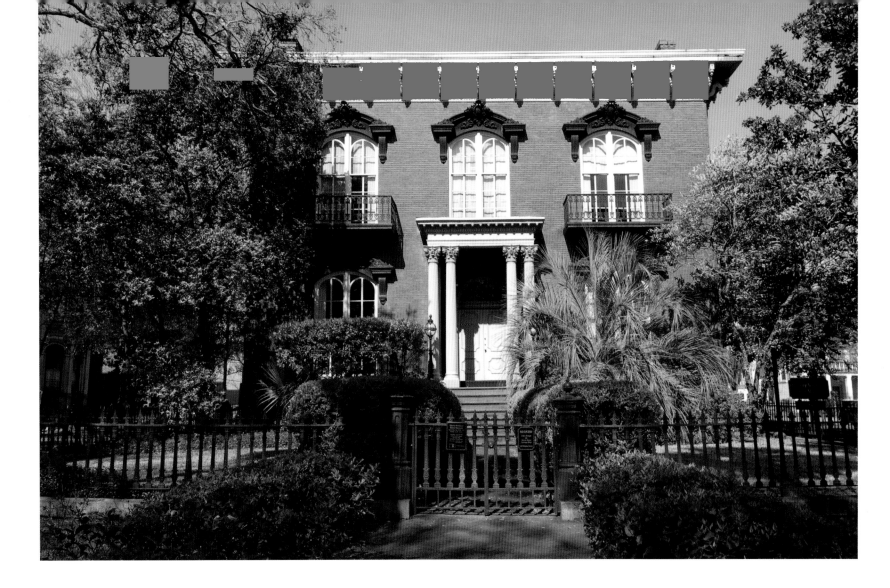

MERCER-WILDER HOUSE

The center of intrigue in the book *Midnight in the Garden of Good and Evil*

Left: Construction of the Mercer-Wilder House began in 1860, a year before the owner of the lot, Confederate officer Hugh Mercer, was called to war. Neither he nor any other Mercer family member would live in the home. During the occupation of Savannah by Federal troops in 1864 and 1865, materials on the site of the unfinished home were used to build makeshift shelters in Monterey Square across the street, to guard against an unusually cold winter. Having lost the family fortune built on the antebellum cotton industry, the Mercer family sold the lot and materials to the Wilder family. Cited in a historic foundation survey as "nationally significant" for its elegant Italianate architectural style, the home on Monterey Square was designed by the New York architect John Norris. Tall, arched windows and ornate ironwork balconies reflect the grandeur of a bygone era in the Deep South.

Above: Savannah songwriter and lyricist Johnny Mercer (great-grandson of Hugh Mercer), knew the home bearing his family name as belonging to the Lyons family, who had the longest tenure in the home, or as the Shrine Alee Temple, as it became. Well into the twentieth century, the home fell into disrepair. In 1969 Jim Williams, a dedicated preservationist, bought the house, which had been vacant for nearly a decade. He spent two years restoring it and filled it with eighteenth-century portraits and beautiful antique furnishings from his private collection. His sister, Dr. Dorothy Kingery, permits guided tours of the first floor of her home to share these treasures. The Mercer House became known internationally when Williams was charged with murder after the shooting of Danny Hansford in the home. The events became the focus of the 1994 best-selling book *Midnight in the Garden of Good and Evil*.

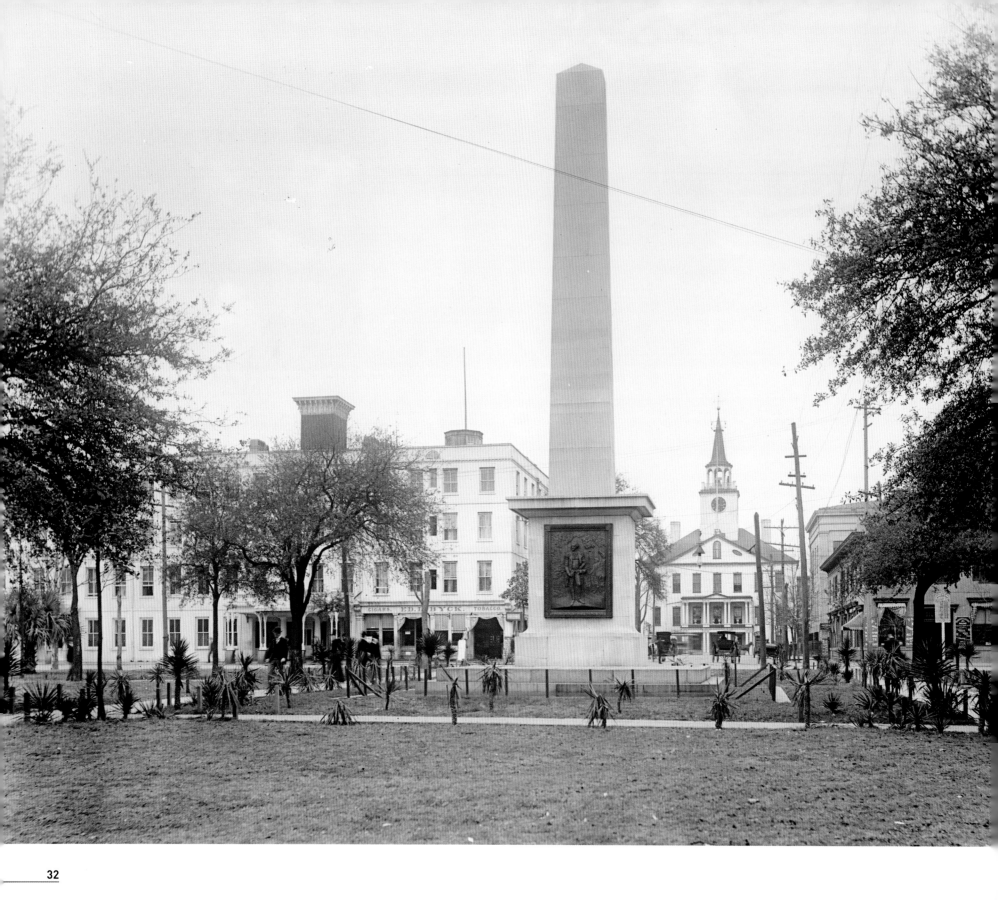

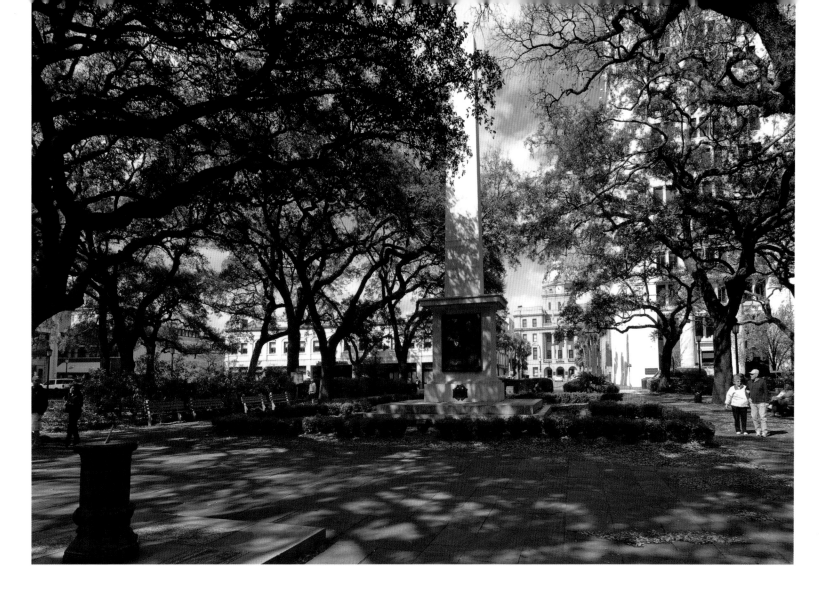

JOHNSON SQUARE

Where God and mammon sit side by side

Left: With the energetic idealism of youth, James Edward Oglethorpe led 114 settlers on their three-month journey to the New World. Once they landed, they immediately set to clearing the land and laying out the grid that would become Savannah's claim to city-planning fame. The first square was named in honor of the royal governor of South Carolina, Robert Johnson, who had sent workers to help these new settlers. By the time this photo was taken in the late nineteenth century, colonists' homes had been replaced by the posh Pulaski House Hotel (left), and the Custom House (right), where the tariffs of trade—King Cotton ruled—were collected. The City Exchange building (center) had become the defining architectural landmark, and Nathanael Greene, George Washington's commander of troops in the southern colonies, was honored with a central monument.

Above: From the early days of the colony, Johnson Square has been the focal point of business activities. As the financial center of the historic district, today it remains true to its original concept. Banks command each corner with law offices renting space above, as well as accounting, tax and investment firms. The House for Strangers, where visitors lodged in the 1700s, was replaced with hotels such as Whitney Hotel, Hotel Savannah, and Hicks Hotel, which are all defunct now. The primitive colonial church was replaced with the stately building of Christ Church Episcopal. The founder of Girl Scouts of America, Juliette Gordon Low, was married to her "Billow" here in 1886. The general store where colonists bought salt, lard, dried venison and other staples, and the gristmill and ovens, which provided daily bread, have all faded into history. From August 10, 1776, when the Declaration of Independence was read to a cheering crowd, to the present, Johnson Square has remained a focal point of business and civic activities. A sundial was put in Johnson Square in 1933 by the Society of Colonial Wars in memory of Colonel William Bull of South Carolina, who helped Oglethorpe lay out the city two hundred years earlier.

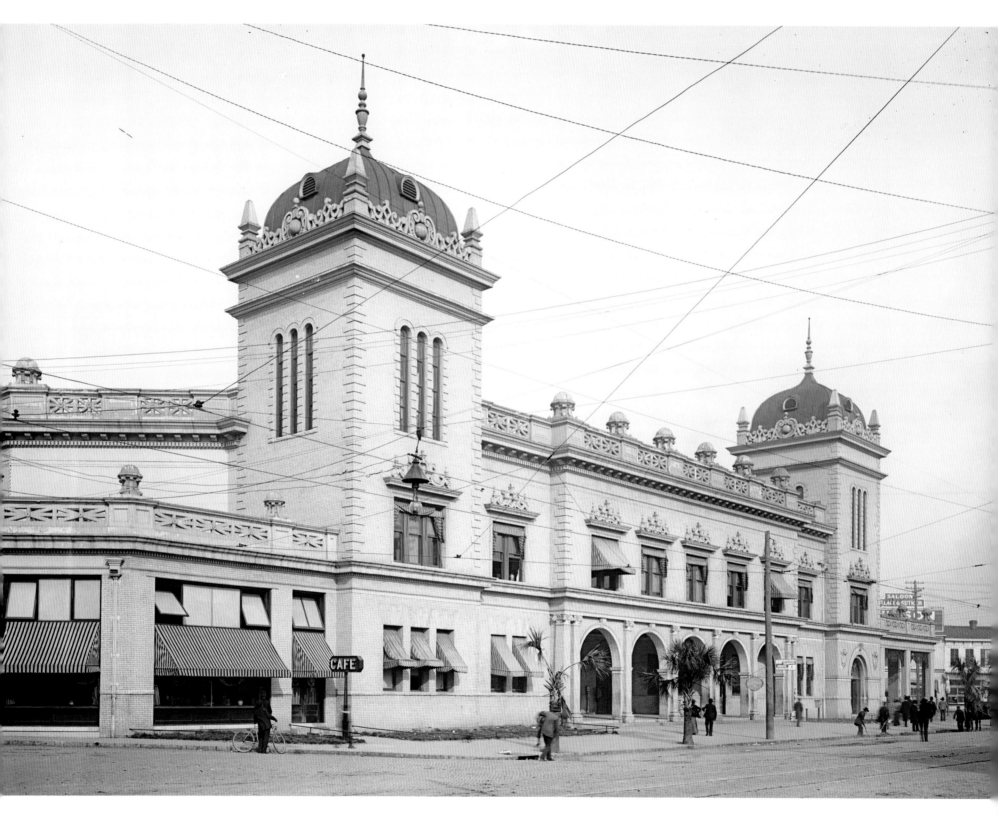

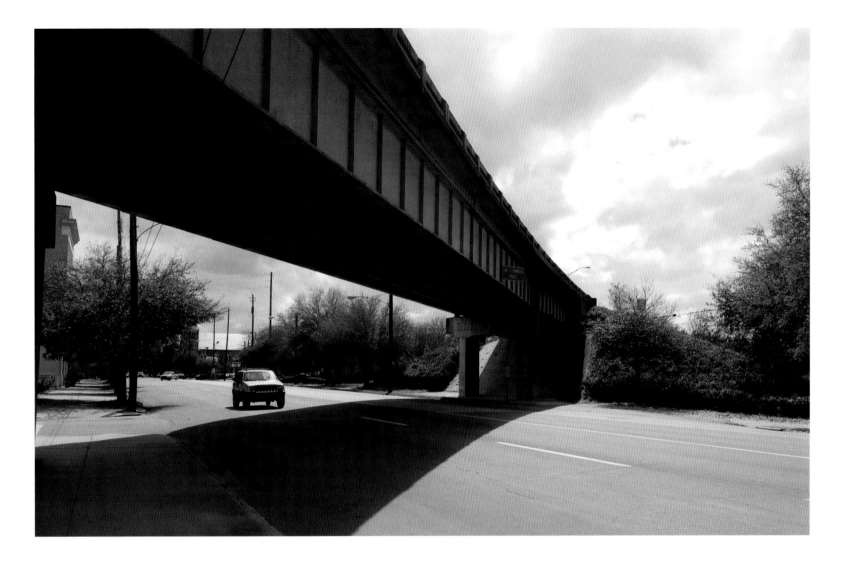

SAVANNAH UNION STATION

City planners decided to remove the "relic of a bygone era" in 1963

Left: A combination of Spanish Renaissance and Elizabethan styles graced Savannah's Union Station. The Savannah Union Station was designed with opulence in mind by Frank Pierce Milburn and cost $150,000 to build in 1902. The unforgettable feature of the interior was the general waiting room, an octagonal room measuring eighty feet in diameter with two tiers of windows high above the marble floor. Exterior walls were made of pressed brick with granite and terra-cotta trimmings. However, travel by train waned as automobiles provided independence and airplanes made long journeys more convenient. The train station was viewed as a dinosaur: an unappreciated relic of a slower, simpler, more genteel era. Union Station was demolished in 1963 to make way for an interstate highway interchange.

Above: The installation of the flyover removed 600 feet of storefront display in 1960. When the word got out, angry protests ensued. Herbert Blumenthal was a firm leader in the opposition cry, naming all the mom-and-pop businesses that would be lost. The saddest of all losses was Union Station, an irreplaceable piece of history. Savannah would not be the first city to reverse a long-standing road project. The Savannah Development and Renewal Authority has looked into the best ways to develop Martin Luther King Boulevard and return that section to its historic street plan. One solution would be to bring I-16 into West Gwinett Street.

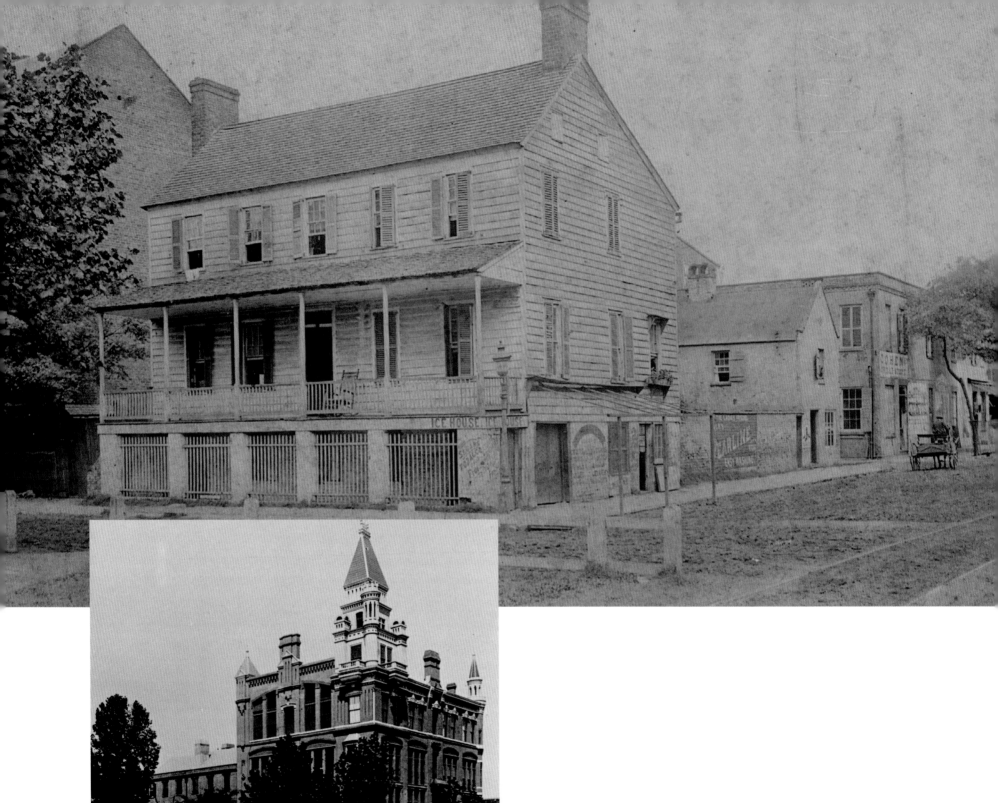

TELFAIR SQUARE

This corner site has hosted many buildings over the years

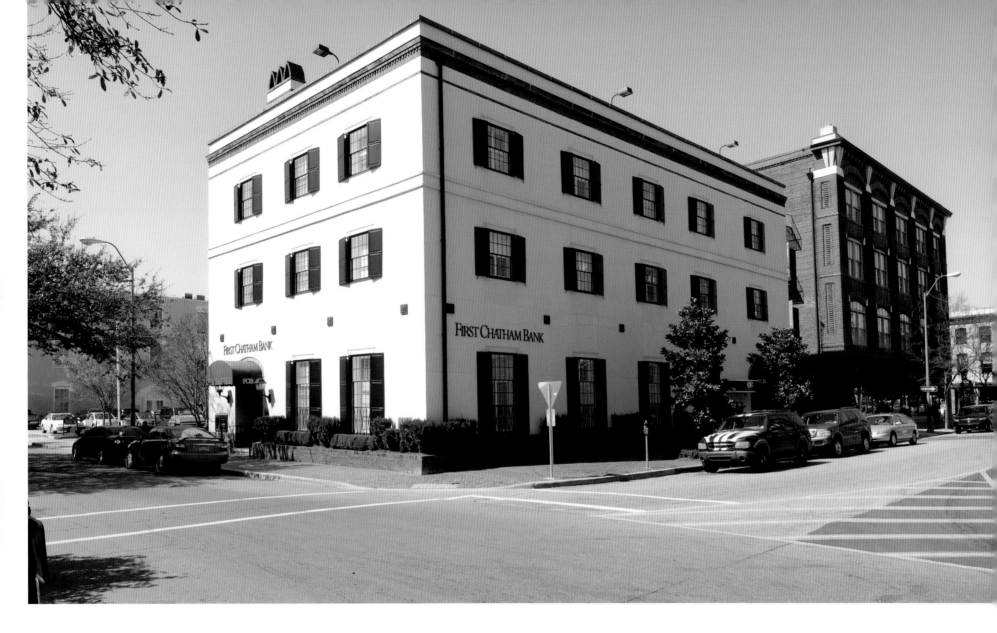

Left: James Oglethorpe's ingenious city plan defined land usage around squares. To the north and south of each square were housing lots for the families who would settle the colony. On the east and west sides were larger lots for businesses, public buildings, and religious structures. Telfair Square illustrates the evolution of a ward through Savannah's history. One wooden home on the north side became a boardinghouse and inn where George Washington stayed during his visit to Savannah in 1791. This was replaced by the imposing, magnificent International Order of Odd Fellows Hall (inset), which was lost within a year to Savannah's devastating fire of 1889. The royal governor's residence was replaced by the Telfair family mansion in 1820.

Above: Soon after the fire, William Gibbons Preston designed a new building on the same site. It featured terra-cotta designs related to the philosophy of the Odd Fellows organization—clasped hands, eye of the sunburst, and chain links. Miller and Miller, a furniture store, operated out of the ground floor in 1935. In 1936 the Helmly Furniture Store purchased the building and tore it down. The most recent building on this continually evolving plot is home to the First Chatham Bank which inherited a spectacular three-dimensional mural by local artist Augusta Oelschig that hung behind the tellers' stations. In danger of being cut up and sold, Oelschig's depiction of Savannah landmarks was bought by Mary and Howard Morrison Jr. in 1998 and relocated to the Chamber of Commerce on Bay Street to be more visible. Telfair Square is also home to the Telfair Museum of Art, the Jepson Center for the Arts, Trinity United Methodist Church, and government buildings.

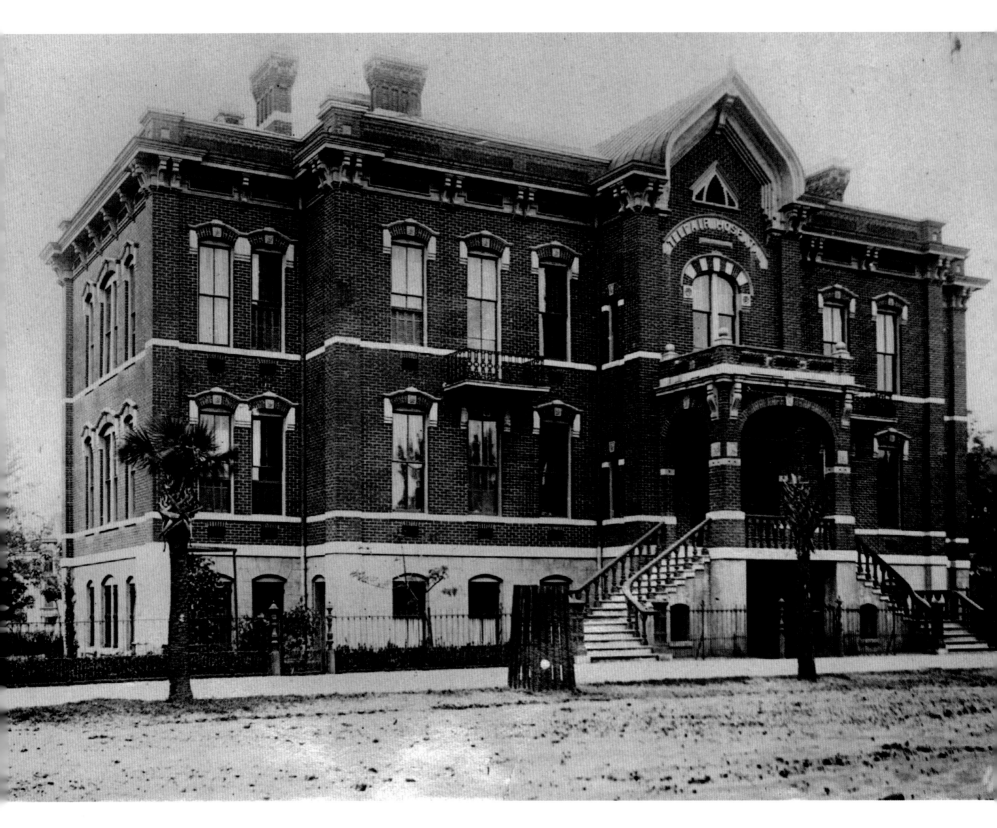

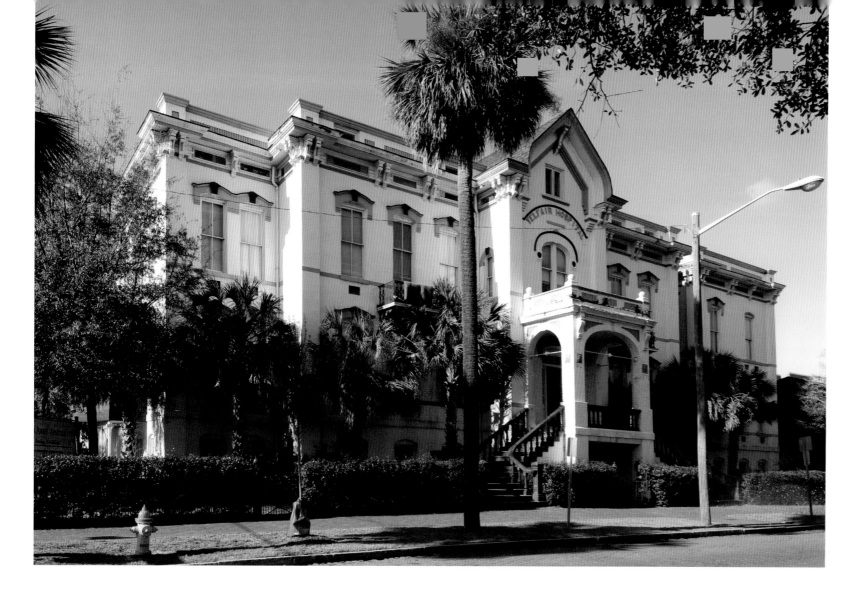

TELFAIR HOSPITAL / TELFAIR APARTMENTS

Influential architect Alfred Eichberg's first Savannah commission was a hospital

Left: Native Atlantan Alfred Eichberg partnered with fellow architect Calvin Fay in 1881 and began working in Savannah. Their first project in the city was the Mary Telfair Women's Hospital on Park Avenue at Drayton Street, on the corner across from Forsyth Park. Completed in 1884, the hospital project was funded at the bequest of Mary Telfair through her will, which specifically detailed the purpose and requirements of this medical facility meant to serve the needs of women. Pictured in 1930, it stands as the longest-operating women's hospital in the United States. Although Fay eventually returned to Atlanta, Eichberg continued to influence architectural style in Savannah with his Central of Georgia Railway office buildings in 1888, and the redbrick and terra-cotta Fox and Weeks Funeral Home.

Above: In 1960 the Mary Telfair Women's Hospital joined with Candler General Hospital to become a first-rate obstetric unit. The Telfair maintained a board of Savannah women who visited the newborns on a regular basis and conferred with the administration regarding special needs. The tall magnolia trees growing outside the open windows comforted new mothers with their sweet fragrance before the days of air-conditioning. In 1978 groundbreaking ceremonies were held on the new site near Reynolds Street and DeRenne Avenue in the southern part of the city. A joint agreement was signed with St. Joseph's Hospital, forming the St. Joseph's/Candler health-care system. The old hospital building on Park Avenue was sold. After standing vacant for a number of years, the building was spruced up and became the Telfair Arms Apartments for seniors who needed affordable housing.

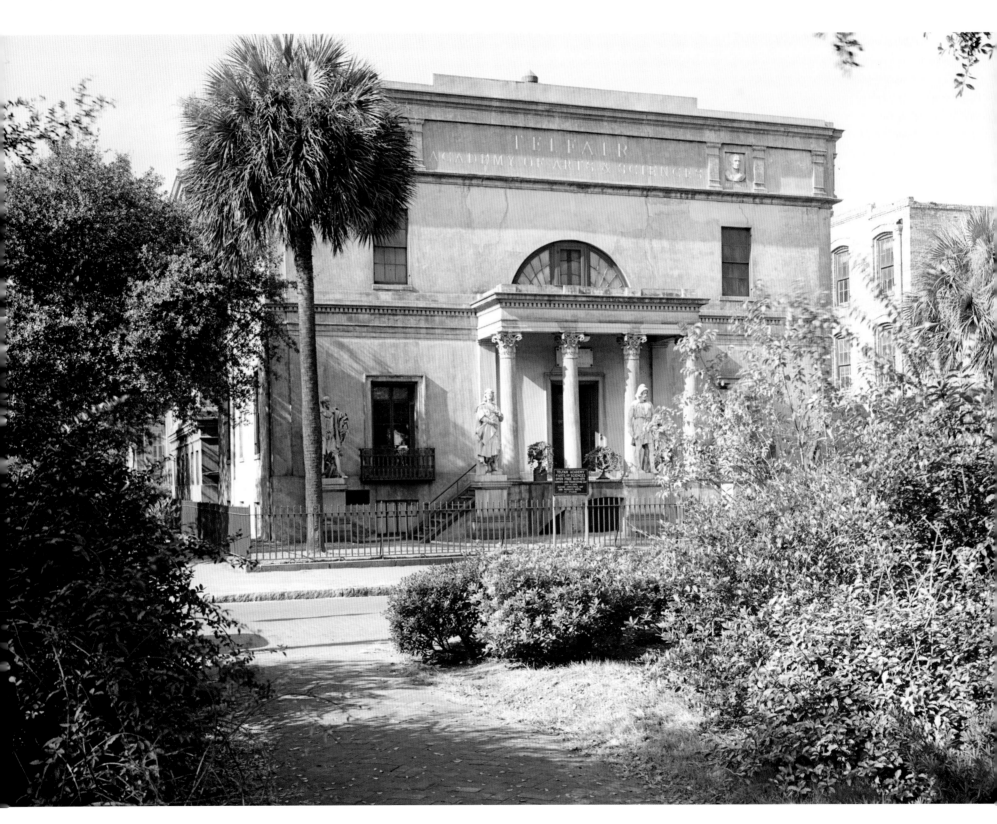

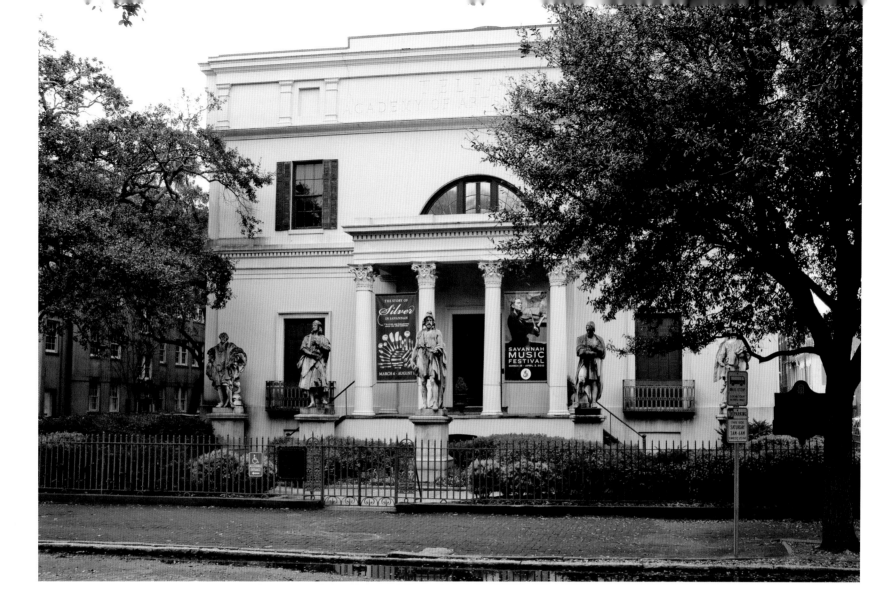

TELFAIR ACADEMY OF ARTS AND SCIENCES

The Telfair was one of the first art museums in the South

Left: By the time this photo was taken in 1936, the Telfair Academy of Arts and Sciences had already celebrated fifty years as a museum. The house was originally commissioned by Alexander Telfair in 1819 and was a William Jay design. The Telfair mansion was bequested by the owner's daughter, Mary Telfair, and became the Telfair Academy of Arts and Sciences in 1886. It was one of the first art museums in the South. Five large sculptures grace the entrance to the museum; the statues are of Phidias, Raphael, Rubens, Michelangelo, and Rembrandt. The building became a National Historic Landmark in 1976.

Above: The Telfair collection includes major works by Childe Hassam, Frederick Frieseke, Gari Melchers, and Julian Story's massive painting *The Black Prince of Crécy*. Sylvia Judson Shaw's famous *Bird Girl* sculpture is on display, having been moved from the Trosdal family lot in Bonaventure Cemetery. The sculpture was photographed by the late Jack Leigh for the cover of the book *Midnight in the Garden of Good and Evil*, and had become a tourist attraction. The exciting interactive ArtZeum, a 3,500-square-foot gallery for children and families, is a part of the recently opened Jepson Center for the Arts addition to the Telfair complex on Telfair Square.

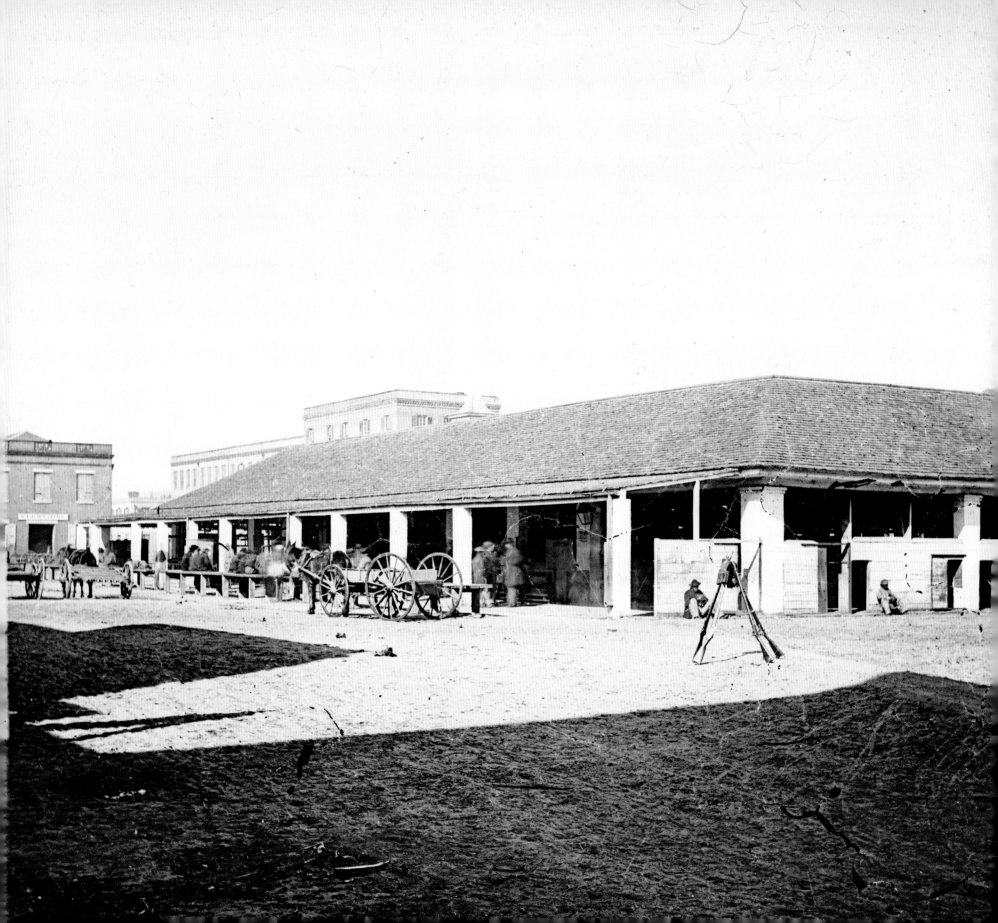

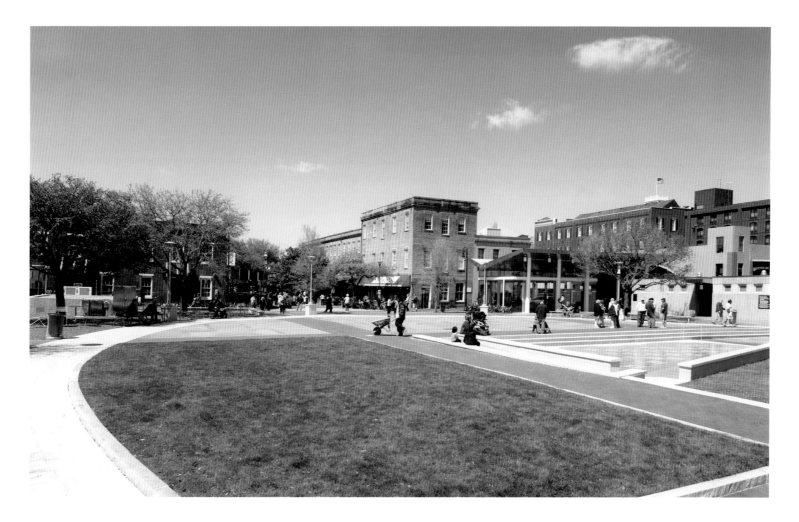

ELLIS SQUARE BARRACKS

From a market to a barracks and ultimately a beautiful open space

Left: The earliest covered market structure to have been photographed on Ellis Square was this simple rectangular building with an open atrium in the center. Merchants could find protection from the heat of Savannah's summer sun and the downpours of the rainy season while still enjoying the free flow of air through the City Market. When General Sherman's troops occupied Savannah toward the end of the Civil War, they were ordered to set up their tents and sleep in the public places of the city. One of their makeshift barracks areas was the City Market. The unguarded, stacked rifles and caisson in the photograph of the old City Market taken during the occupation of Savannah indicate a stark time in the history of the city. The severe shortage of the very goods for which the City Market was built left the facility vacant, and it was used for caring for the sick and injured—Union and Confederate—following the Battle of Fort McAllister a few miles outside Savannah.

Above: The simple one-story City Market was torn down after it came to be remembered only as a hospital. Within just four years, a new, larger, more fashionable structure was to rise as hopes turned to the future. The city council requested bids to erect a market in Ellis Square with a price tag not to exceed $60,000. Today, that subsequent market building has been removed, leaving an inviting green space, though the surrounding buildings from the archive photo are still in place to anchor the scene.

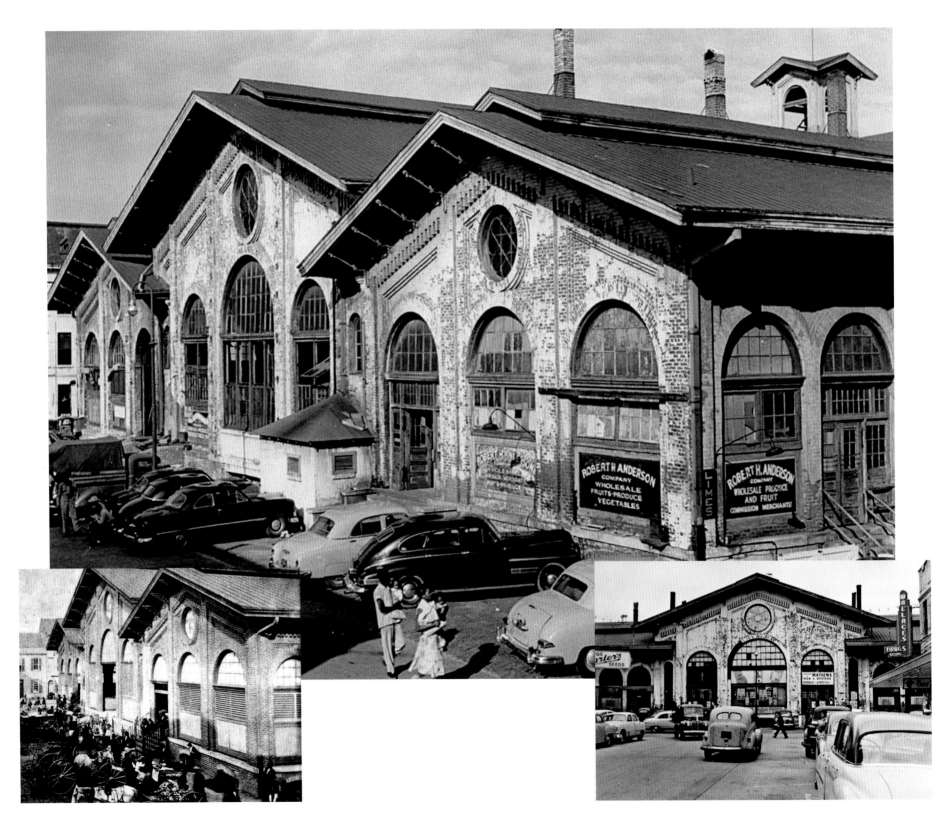

ELLIS SQUARE MARKETPLACE

The removal of the Victorian market building was a spur to preservationists

Left: The distinctive Victorian-style City Market building stood for over eighty years in Ellis Square. When it opened in 1872, it became one of the landmarks of Savannah. Its unique design and bustling livestock and produce stalls were a major attraction of the city. Urban development in the 1950s brought its demise. In 1954 the city signed a fifty-year lease, allowing the existing structure to be razed and a parking garage to be constructed. Anger over the demolition of the market helped spur the historic preservation movement and establishment of the Historic Savannah Foundation. This nationally recognized organization has worked tirelessly since 1955 to save the city's historic homes and buildings in the National Historic Landmark District, the largest in the United States at 2.5 square miles.

Above: One of the graceful round windows located under the vaulted roofline of the old City Market building was saved and can be seen at the Massey School History Museum on Calhoun Square in downtown Savannah. When the fifty-year lease expired, the wrecking ball and hopes for the future were already in place. The parking garage was demolished in 2005. The new Ellis Square is green and open, with a glass-walled visitors' center. There is a giant walk-on chessboard with life-size pieces. An interactive fountain delights children. Five mature live oaks were transplanted to the square. Savannah's newest public art is a lifesize bronze statue of Johnny Mercer, sculpted by resident Susie Chisholm, which greets visitors at the west end of the square.

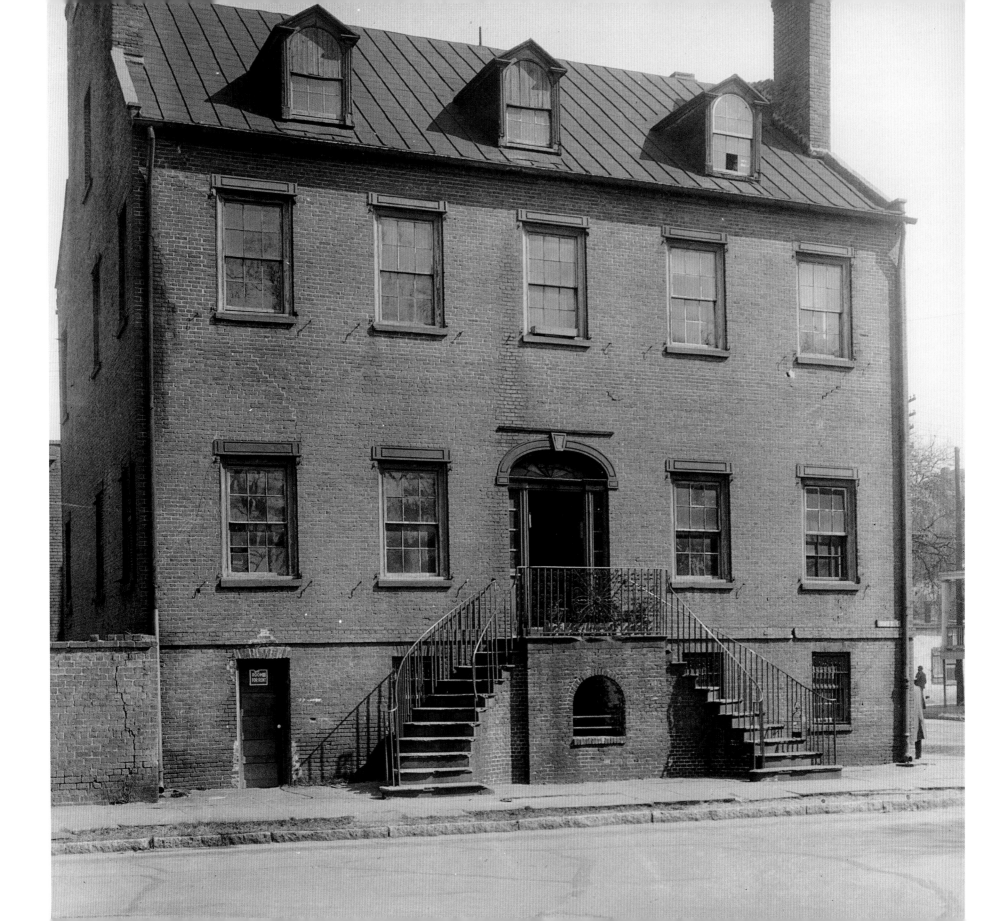

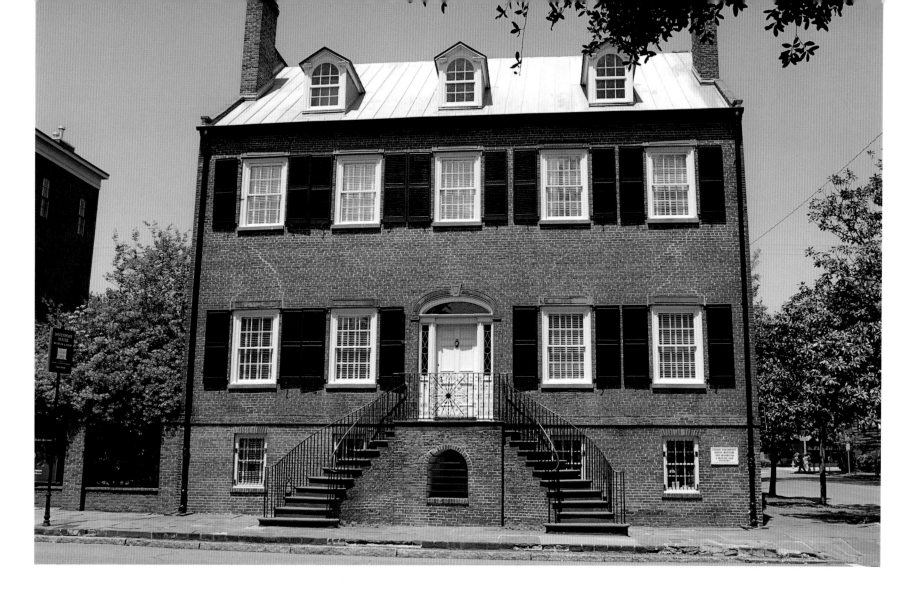

ISAIAH DAVENPORT HOUSE

The birth of the preservation movement was generated by the threat to this house

Left: Isaiah Davenport moved from Rhode Island to Savannah in 1799, only three years after Savannah's devastating fire of 1796. He was a master builder and constructed his own home on Columbia Square to showcase his skills. He designed and built it between 1815 and 1820 in the Federal style, with which he was familiar. Symmetry and balance were maintained inside and out, with a center hallway on both floors. Exacerbated by the Great Depression, the local economy slumped with the loss of the cotton industry when the boll weevil decimated the South's cotton crop. Davenport House became a tenement, as did so many other beautiful old homes. By 1954 it was destined for demolition. The menacing machine with the wrecking ball was idling on Habersham Street, waiting for the signal. This photo dates to 1934.

Above: Alarming destruction was taking place throughout the Savannah Historic District. Priceless old homes were being knocked down for their handmade Savannah gray bricks to build new houses in the southern part of the city. Wooden structures deemed not up to code were flattened overnight. Having lost the colorful City Market on Ellis Square for a parking garage just one year earlier, seven courageous Savannah women turned the tide of demolition in favor of preservation. After purchasing the Davenport House, they formed Historic Savannah Foundation, which today is a model to the world for creative restoration and renovation. The 2.5 square miles of tenderly restored buildings and preserved landmarks can be credited to Katherine Judkins Clark, Elinor Adler Dillard, Anna Colquitt Hunter, Lucy Barrow McIntire, Dorothy Ripley Roebling, Nola McEvoy Roos, and Jane Adair Wright.

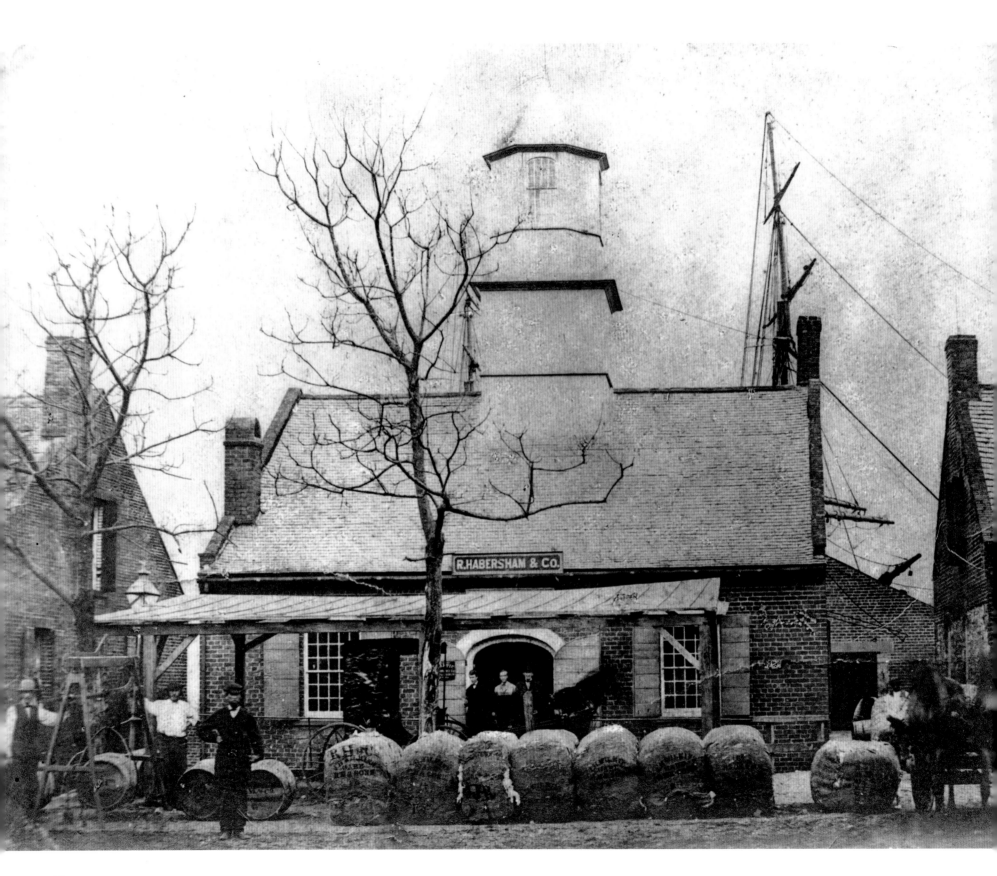

HABERSHAM AND COMPANY / RIVER WALK

One of the pioneering trading companies of Savannah

Left: Commerce on the Savannah River thrived as merchants such as Robert Habersham led Savannah back to prosperity after the Civil War. In this 1868 photograph of his offices on Bay Street, Habersham is standing on the right wearing a tall hat. Robert's grandfather, James Habersham, who had built Savannah's first wharf, was managing partner of Savannah's first mercantile concern in 1744, and was the first Georgian to export cotton—from these same offices. Robert joined the family business and served as a merchant for over sixty years. He was a broker of plantations and slaves, served as an attorney for absentee Savannahians, sold machinery for use by rice and cotton planters, rented cotton-packing machines, and ran the Habersham Rice and Flouring Mills that served Savannah in the 1850s and 1860s. He died in 1870 at the age of eighty-seven.

Above: The close of the nineteenth century brought the end of Habersham and Company and the end of the trading dynasty. Robert's son, William Neyle Habersham took over the business from his father in 1870, but the boll weevil, a beetle that feeds on cotton buds, made the cotton business unprofitable. Two of William's four sons were killed on the same day in the Battle of Atlanta in 1863. Looking past the spot where the offices stood is the riverfront and Rousakis Plaza, named for John Rousakis, the mayor of Savannah who was responsible for the River Street restoration. No longer are cotton ships sailing off to England, but instead tourists from all over the world are shopping and dining at Savannah's many restaurants while watching cargo ships and tour boats on the busy harbor.

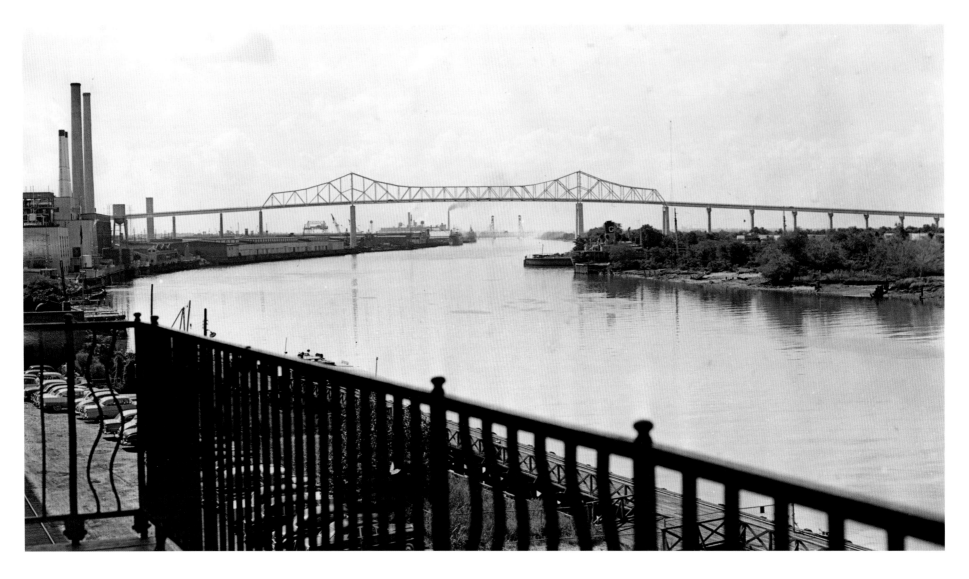

EUGENE TALMADGE BRIDGE

As ships got larger, the Eugene Talmadge Bridge got higher and safer

Above: One of the few entrances to Savannah was the cantilever truss bridge, constructed in 1953, crossing from Jasper County, South Carolina. In the late 1980s it had become a danger for a new generation of larger ships to enter Savannah's port, the largest single-terminal container port in the United States. Only at low tide could the ships get under the Talmadge Bridge, named for former governor Eugene Talmadge. And that concern made it a danger for anyone who might try to drive on the bridge.

Right: Due to two shipping accidents in 1983 and 1990, when ships rammed into the pier supports of the old bridge, it was decided that the time had come to replace the bridge. Completed in 1990, the new Eugene Talmadge Bridge facilitates traffic between Georgia and South Carolina. It is 185 feet high above the water at high tide. At first it was named for Tomochichi, the chief of the Yamacraws and friend of the settlers, but it regained its original name after public meetings on the issue. The new bridge is 1.9 miles in length, cable-stayed, but has no pedestrian access. It has been compared in looks with the Arthur Ravenel Jr. Bridge in nearby Charleston.

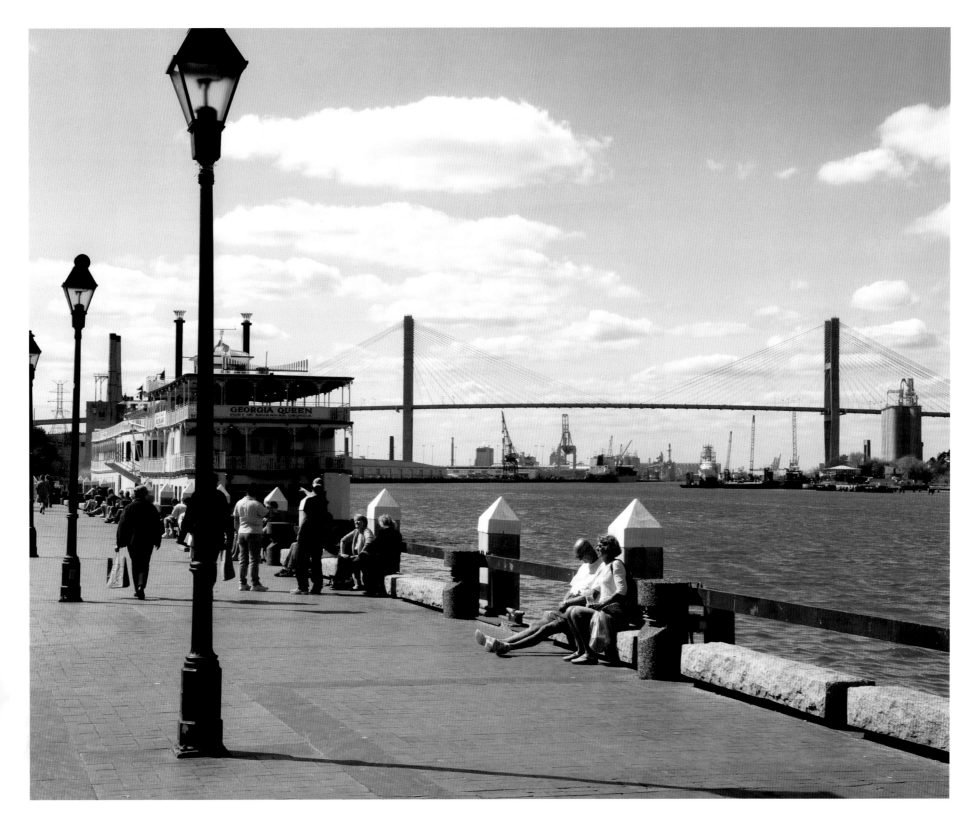

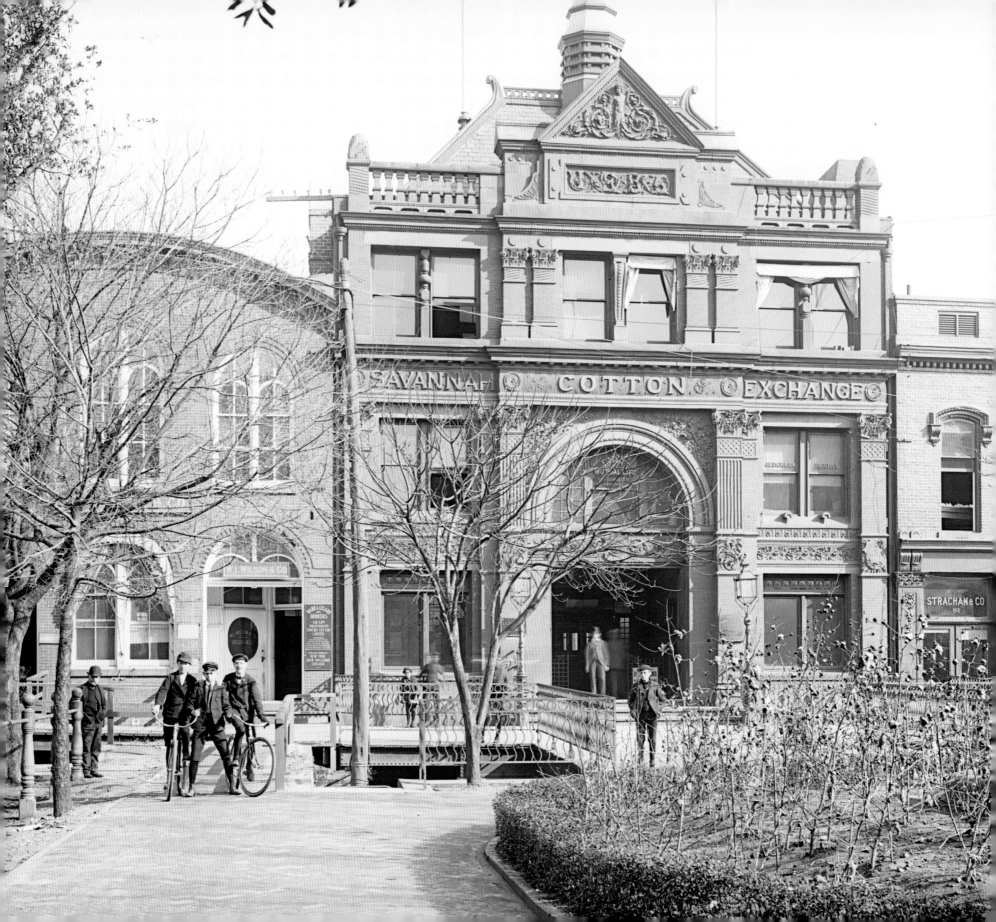

COTTON EXCHANGE

When cotton was king, it ruled the city exchange

Left: In the eighteenth and early nineteenth centuries, Savannah's economy was diversified. Eli Whitney's simple invention, the cotton gin, brought dramatic changes as did William Gordon's Central of Georgia Railway. Savannah turned primarily to cotton production and distribution. When the old City Exchange, erected in 1799 for merchants, was demolished in 1905, cotton had become king in the South. William Gibbons Preston won the competition to design the new exchange building on a different site; it would be called the Cotton Exchange. Drayton Street, below the selected site, could not be blocked from river access, so the massive Romanesque brick building was built on iron pilings and supports above the road. The building reflected the dominance of the cotton industry in elaborate, intricate carvings of parts of the cotton plant—stems, leaves, blossoms, and bowls. Savannah was whimsically placed at the center of the world on a terra-cotta relief on the building, putting "in stone" the city's position as the world's leader in cotton export.

Right: The Solomon's Lodge, organized in 1733, now owns the Cotton Exchange. From 1776 to 1785, because of the turmoil of the Revolutionary War, no meetings were conducted and many records were lost. James Oglethorpe was the lodge's first Worshipful Master. This lodge is the oldest English-constituted lodge of Freemasons in the Western Hemisphere in continual operation. On Labor Day 2008, a car racing up Drayton Street shot across Bay Street and obliterated the winged lion and fence adorned with medallions of poets and presidents, and heavily damaged the front of this treasured building. Irreplaceable history was destroyed. More recently, after extensive repairs, the building is now open for tours.

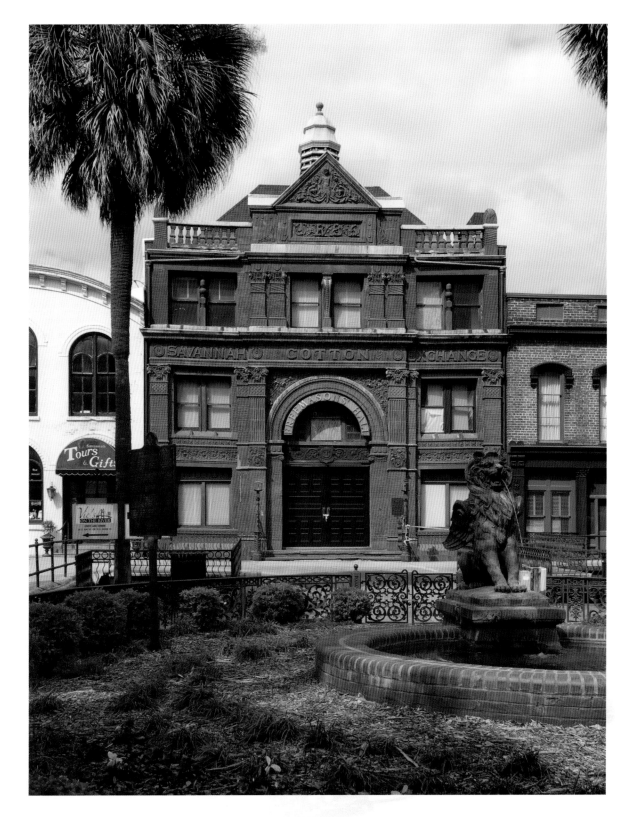

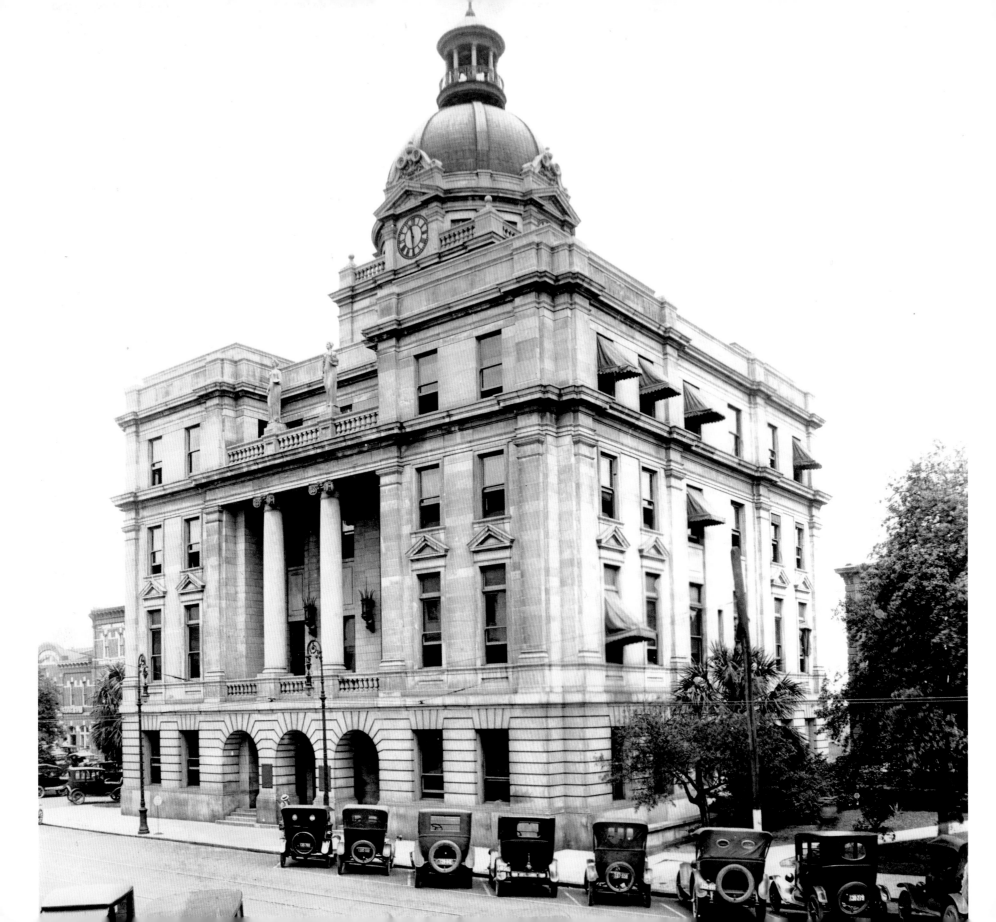

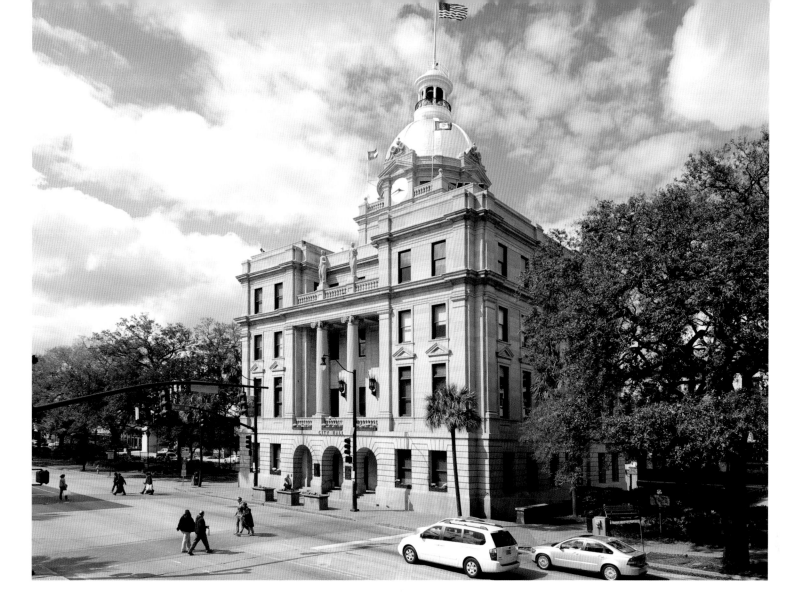

CITY HALL

Glistening under a gold leaf cupola since 1986

Left: At the head of Bull Street, the first street laid out running north and south according to the city plan of founder James Oglethorpe, the first City Exchange building was built in 1799, overlooking the wharves of the Savannah River. Its four-square design, with three generous floors adorned with graceful piazzas and a tower topped with a distinctive cupola, was the focal point of Savannah's skyline for almost a century. Although Mayor Gamble headed a valiant effort to have the City Exchange restored, it was torn down and replaced by the stone city hall building in 1906 (pictured in 1926). The mayor's determination was not totally in vain, however. The cupola and bell of the old City Exchange were saved and mounted in a replica bell tower on Bay Street.

Above: Mills B. Lane, former president and chairman of the Citizens and Southern Bank, and his Beehive Foundation generously funded the replacement of the copper surface of the dome with gold leaf. The gold leaf replaced the controversial greenish paint, used since the 1960s, which was worn and unsightly. All work was done from scaffolding and ropes secured to the cupola 150 feet above the Savannah River. The workers complained of the wind, but one huge compensation was that Savannah's man-eating gnats could not fly that high. Savannahians had a thrill when they drove to work one morning in 1986 and encountered the shiny new dome. Some hinted that a desire to remind Atlanta that Savannah was the first capital of Georgia was motive enough for the only known gold-capped city hall in Georgia.

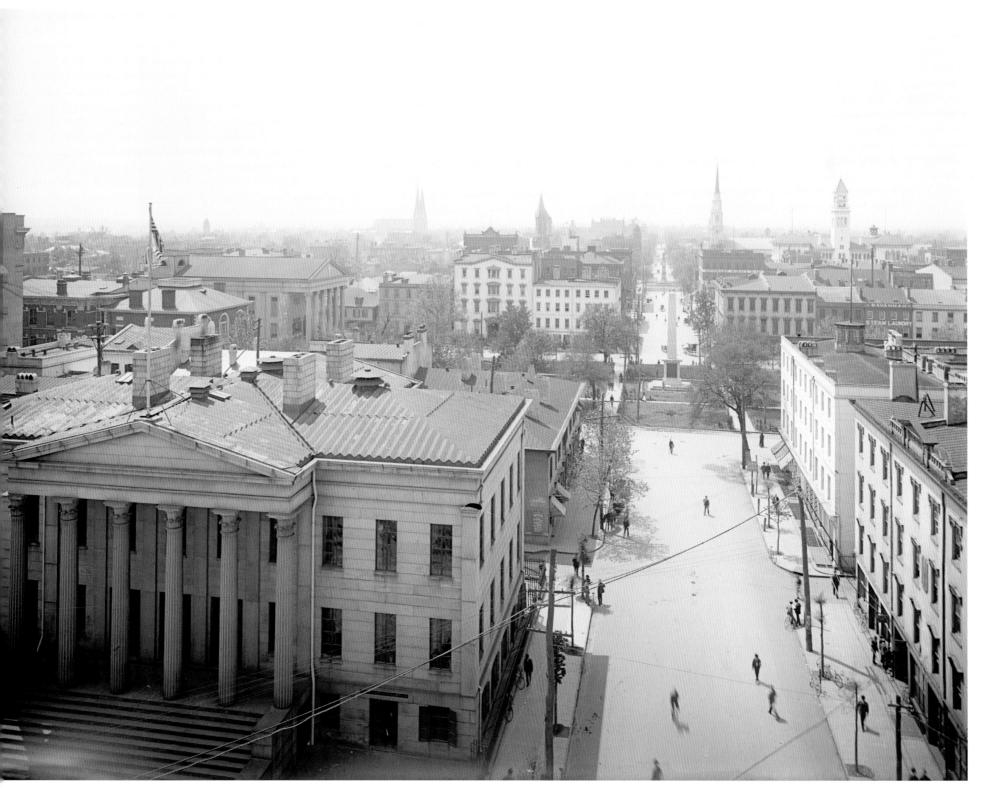

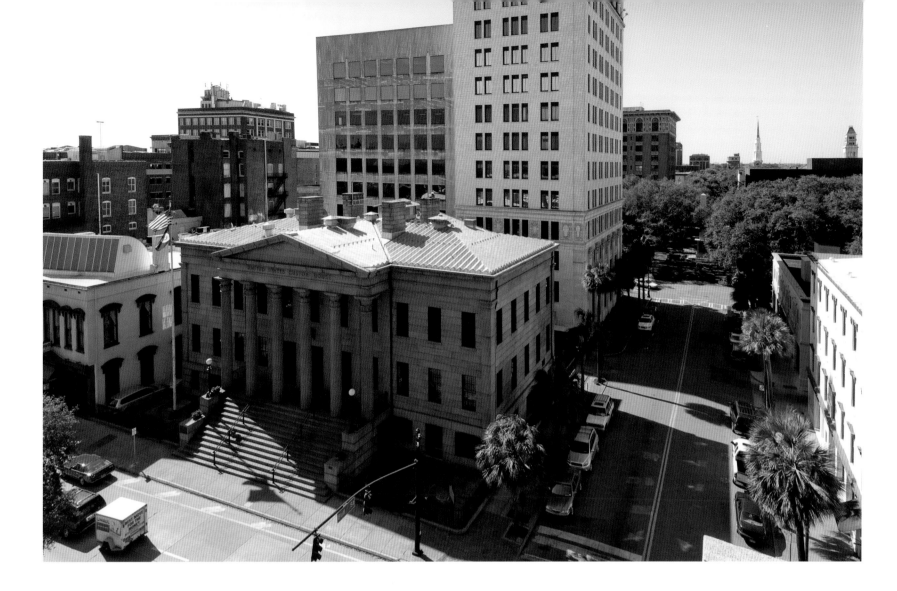

CUSTOM HOUSE ON BAY STREET

Witness to Sherman's review of his troops after the capture of the city

Left: This elevated view of Savannah showcases the early buildings that graced Johnson Square and highlights the unique grid pattern of the city's streets and squares as one would look from north (bottom of photo) to south on Bull Street: the granite Custom House where the taxes of trade were collected, the stately hotels of Johnson Square—the Screven House, the Whitney House, and the Pulaski House (left to right around the Nathanael Greene obelisk in the center of the square)—and, moving north to south, the spires of the Lutheran Church of the Ascension (Wright Square), the Independent Presbyterian Church, the Italianate-Romanesque tower of the old post office (Wright Square), and, in the distance, the twin spires of the Roman Catholic Cathedral of St. John the Baptist on Lafayette Square. It is directly above the spot where General William T. Sherman reviewed his troops after the fall of Savannah in 1864.

Above: Little has changed in this view of the stone-built Custom House since the archive photo was taken from high up in City Hall at the end of the nineteenth century. Unlike so many customs houses—the one in New Orleans has been turned into an aquarium—the Savannah U.S. Custom House continues to serve its original purpose of administering trade through the busy port of Savannah. In 1974 it was listed on the National Register of Historic Places, but it remains a working building, dominating the corner of East Bay and Bull streets since 1852.

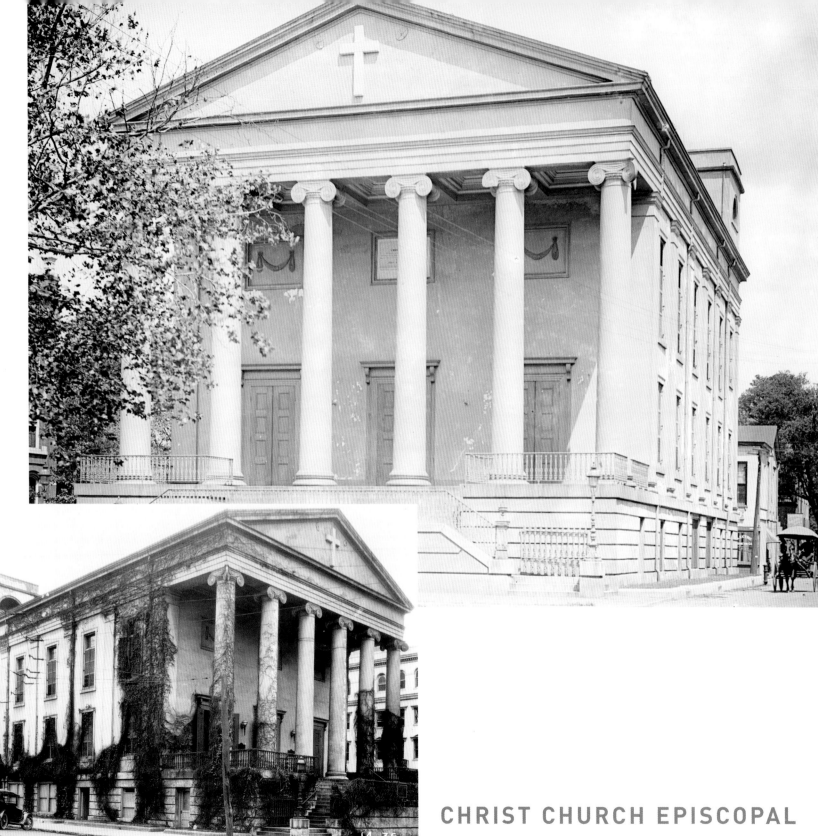

CHRIST CHURCH EPISCOPAL

The first church of the colony and the "mother church of Georgia"

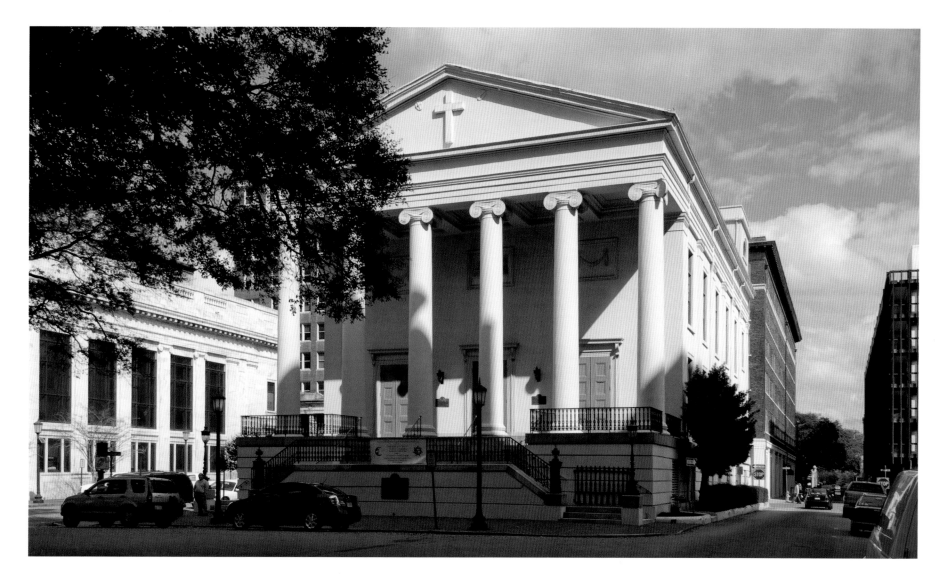

Left: Prayers of thanksgiving were offered for the safe voyage from England of Dr. Henry Herbert, who had volunteered his services to try to meet the spiritual needs of the first colonists of Georgia. Thus began the history of Christ Church Episcopal in Savannah, the "Mother Church of Georgia," on February 12, 1733. The third rector, John Wesley, is credited with beginning the first Sunday school in America at Christ Church and, along with his brother Charles, publishing the first hymnal on the continent in English. The current building, the third structure on the site, designed in 1838, was considered the finest example of the classical Greek temple style in the South. The bell in Christ Church's belfry was forged by Revere and Sons in Boston in 1819 and is still rung for services. The inset photo shows the building as it looked, complete with creeper, in 1934.

Above: Christ Church Episcopal is the only church in the Savannah Historic District still standing on its original trust lot, as designated by James Oglethorpe. Its all-inclusive welcome remains a symbol of the values of those who led in the settlement of the colony of Georgia. Though its original Greek-style stairway was modified early on, the architectural grace, simple lines, broad open piazza, three wide entrances, and strength of structure and character remain, as when the building was completed. Following an interior fire in 1895, renovation included installation above the altar of the magnificent ascension window, a commission of the Louis B. Tiffany Company of New York, as a memorial to Stephen Elliott, the First Episcopal bishop of the Diocese of Georgia and rector of Christ Church Episcopal. Christ Church's musical heritage is supported by her Harrison and Harrison organ, crafted in England, which fills the back gallery of the church nave.

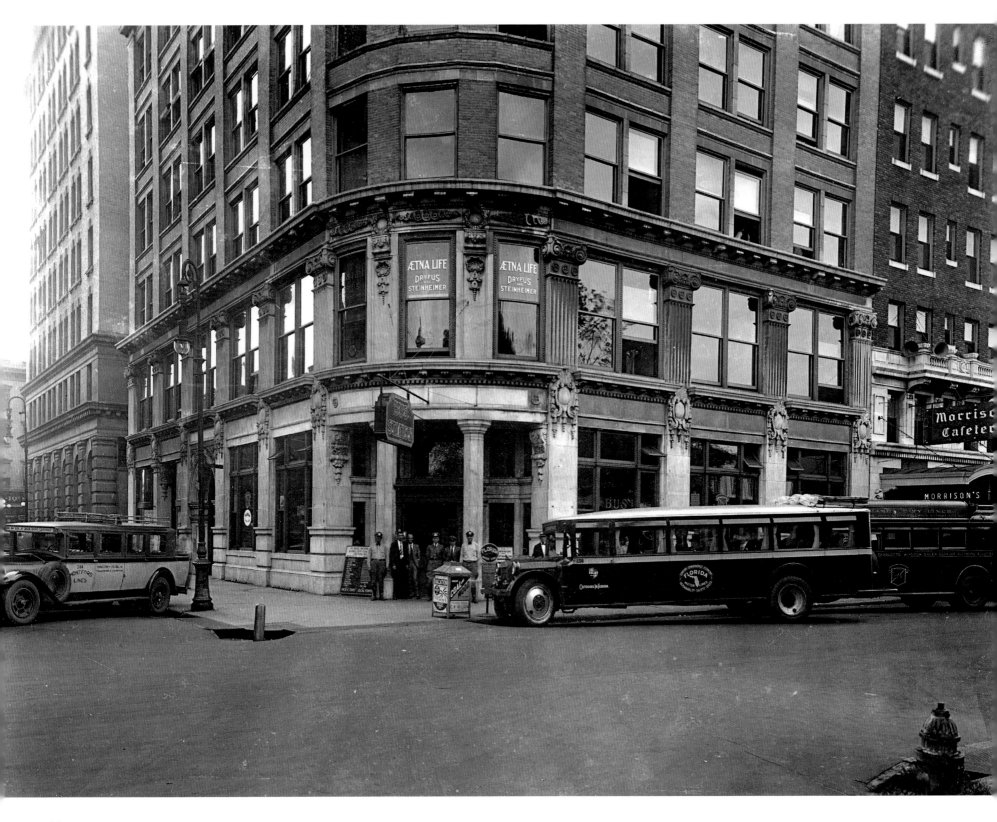

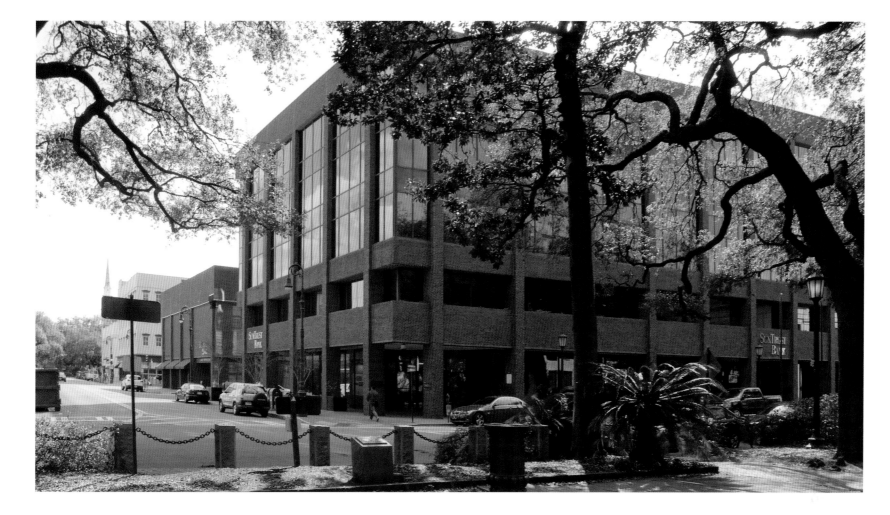

GERMANIA BANK / SUNTRUST BUILDING

From blockade-runner to banker, Henry Blun built one of the city's first skyscrapers

Left: The Germania Savings Bank was constructed on Bull and Congress streets, facing the southwest corner of Johnson Square. It was the tallest building in Savannah when constructed in 1903, and was later called the Blun Building. The bank was founded by Captain Henry Blun, a German immigrant who enlisted in the Confederate army and served at Fort Pulaski. In 1864 he fitted a sloop for blockade-running and successfully delivered cotton and important dispatches from the Confederate government to contacts in Nassau. After the war, Captain Blun began his banking career and, in 1890, organized the Germania Bank on Broughton Street, of which he was the president. In 1903 Blun laid the first brick for the new Germania Bank Building facing Johnson Square, a handsome eight-story structure, the first of Savannah's tall office buildings. For a brief time, the ground floor of the building held the Greyhound Bus Station, as seen in this 1930 photograph.

Above: After serving as the city's bus station, the building reverted back to its original purpose as a bank. The building continued as the Industrial Bank Building, housing the Home Federal Savings and Loan on the ground floor. Law and banking offices occupied the upper floors. The beautiful old building was torn down in 1975 to build the SunTrust Bank. That was the year in which three adjacent historic skyscrapers— the Blun Building, the Liberty Bank Building on Broughton Street, and the Whitney Hotel—were demolished to make room for the SunTrust Bank and its accompanying parking deck. Members of nearby Christ Church Episcopal, which is located between a bank and a speakeasy, called Bo Peep's Pool Hall, described the pew in which they sat on Sunday mornings as being on either the C&S Bank side or the Bo Peep side of the church.

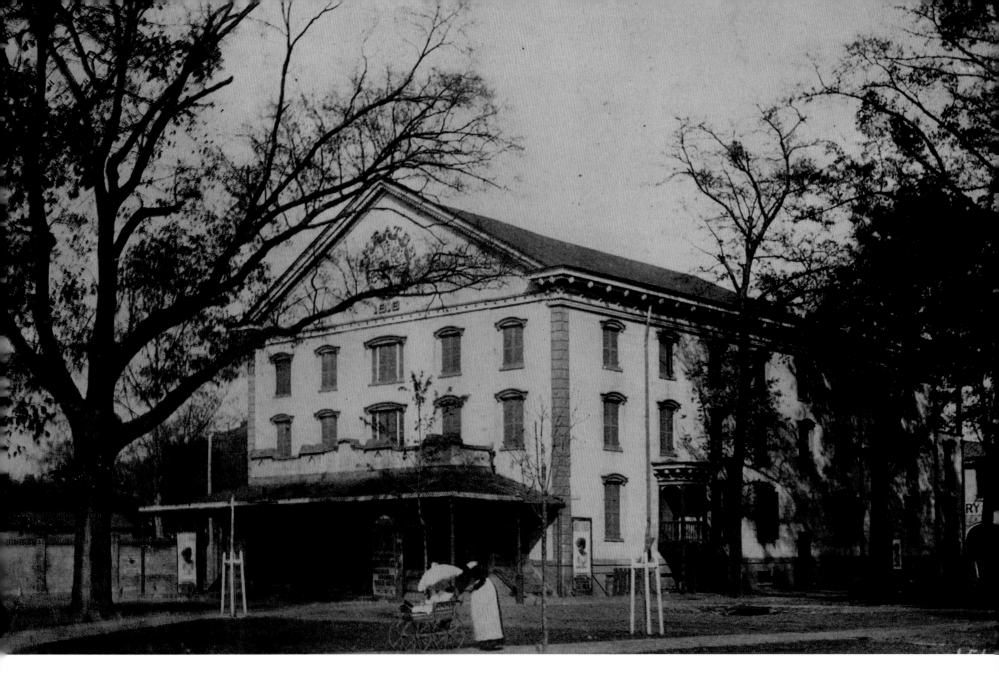

SAVANNAH THEATRE

Drastically modified over the years, but the shows still go on

British architect William Jay designed the original Savannah Theatre, shown here circa 1890. In contrast to a rather simple exterior, with a slightly projecting covered entrance, the interior was magnificent. The proscenium was flanked by four large columns with a painting of Athena, the Greek goddess of the arts. Two tiers of box seats and a balcony were supported by cast-iron columns with capitals and bases gilded in gold. Since its completion in 1819, the structure has suffered two fires, and renovations have left it drastically altered from the original building. Ironically, when John Wilkes Booth performed at the Savannah Theatre just months before he assassinated President Abraham Lincoln, the play in which he performed was *Julius Caesar*.

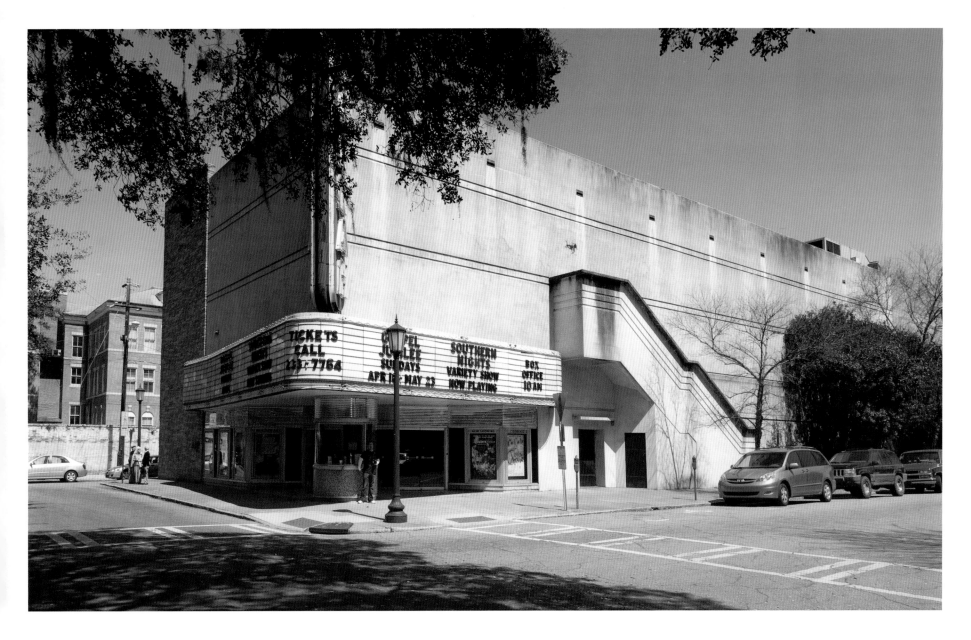

Due to the devastation of a blaze in 1948, the theater was remodeled in its current Art Deco style. During the mid-twentieth century, it became a movie house before it was sold to the Little Theatre of Savannah in the late 1970s. Restored in 2002, it is now a popular active theater with live entertainment plus seasonal performances that showcase national and local talent. A gallery of photographs, prints, and drawings of those who have performed at the Savannah Theatre line the walls of the lobby and the wide, carpeted stairway to the balcony. Included are John Barrymore, Sarah Bernhardt, and the brothers Edwin and John Wilkes Booth.

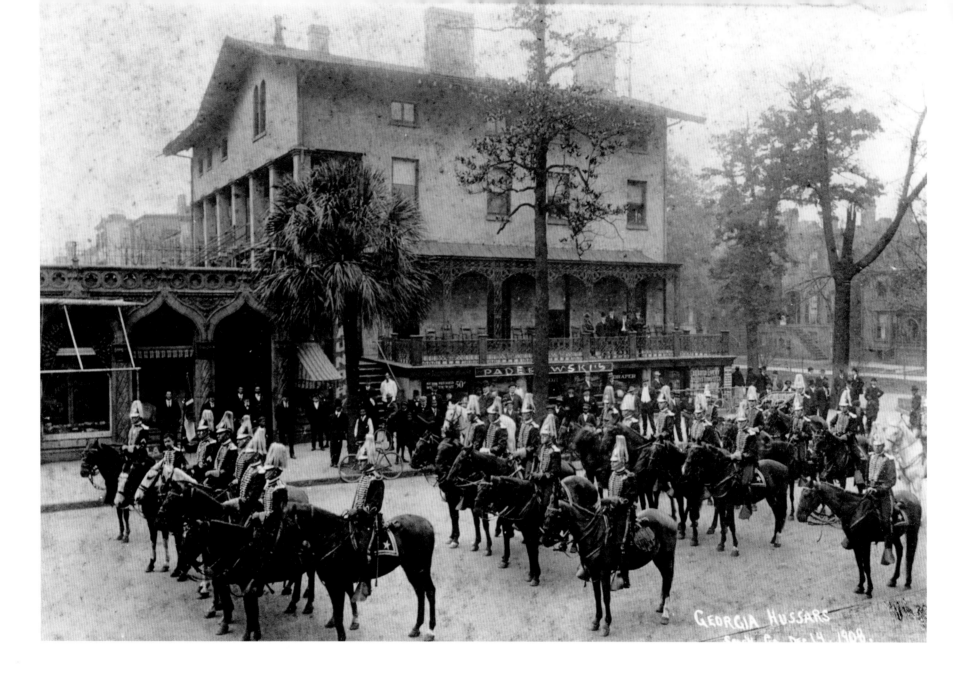

GEORGIA HUSSARS

SOUTH CO DEC 14 1908

GEORGIA HUSSARS

A cavalry regiment that can trace its history to 1736

A troop of mounted soldiers was formed on February 13, 1736, to patrol and protect the colony of Georgia in case of attack by the Spaniards in control of Florida. The troops marched south and fought at Bloody Marsh near Brunswick in 1742 and at the Siege of Savannah in 1779. Shortly after the War of 1812, they became the Georgia Hussars. Their headquarters included the plain, stucco-over-brick building that was originally built as a home for the DeRenne family, photographed here in 1908. The other building, next to the DeRenne home, is a single-story Moorish rococo structure of stucco-over-masonry with elaborately molded terra-cotta Corinthian columns adorned with ornate twisted vertical bands suiting its elaborate Middle Eastern facade. It was the only structure of this style in Savannah.

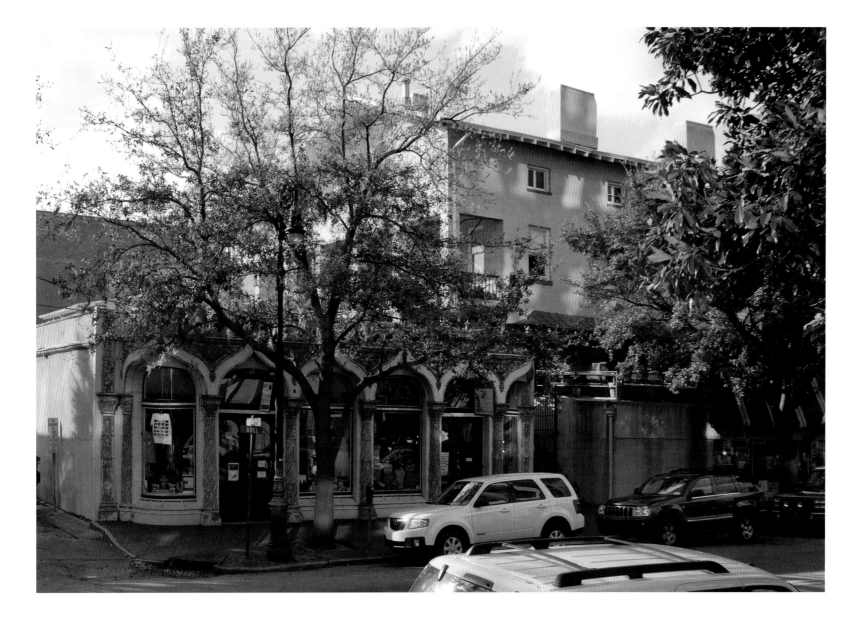

The larger old Georgia Hussars building is today headquarters of the Knights of Columbus Savannah Council #631, which was chartered on March 23, 1902. The headquarters of the Saint Patrick's Day parade committee, which organizes the second-largest Saint Patrick's Day parade in the United States, operates out of the basement. Ground floor space on the corner has long been occupied by a souvenir, clothing, and gift shop called Charlotte's Corner. The smaller neo-Gothic building to the left, once a showroom for Henry Ford's Model T's and A's, is a gift shop. Although Mr. Ford's offices and plants were in Dearborn, Michigan, he fell in love with Savannah and wintered in the area for years. Bull Street is one of the most interesting streets for walking in the Historic District. Walkers pass through five squares beginning with Johnson Square at the north end, and continuing through Wright, Chippewa, Madison, and Monterey squares. The Georgia Hussars, who remained mounted horse cavalry until October 1940, are still an active unit in the Georgia National Guard.

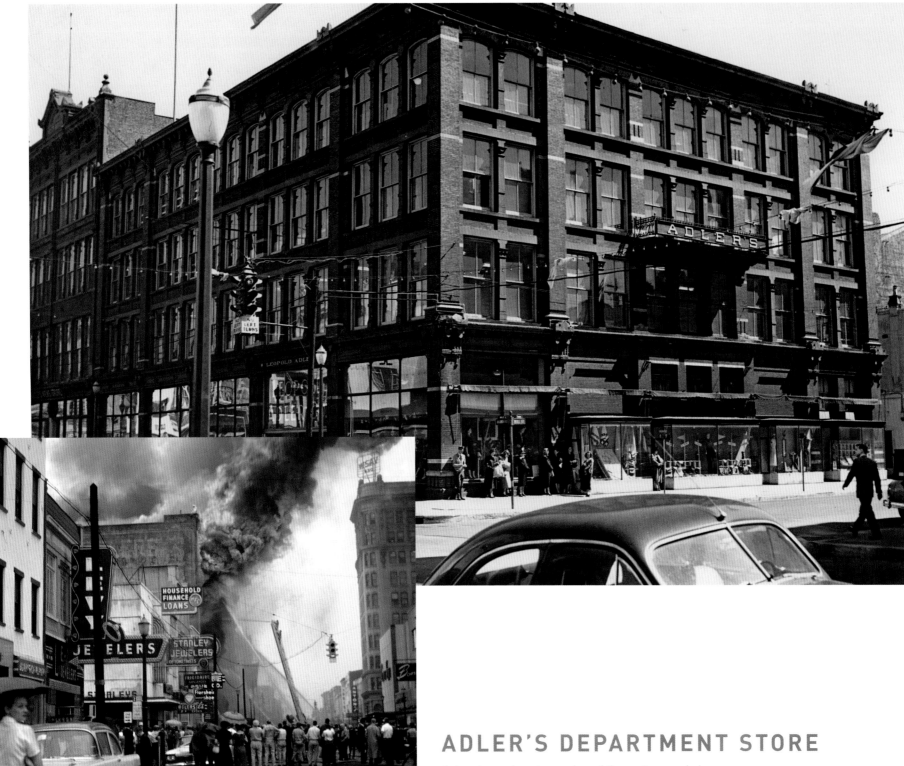

ADLER'S DEPARTMENT STORE

A downtown shopping anchor of the postwar period

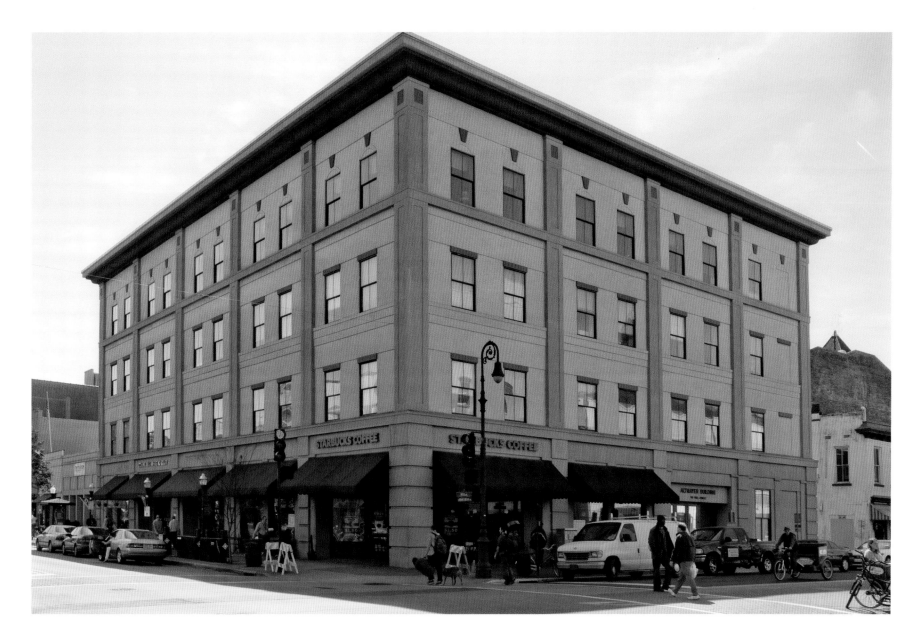

Left: At the intersection of Bull and Broughton streets stood the landmark downtown shopping anchor, Adler's Department Store. At the time of this 1948 photograph, it was a thriving family-owned business. In 1958 the Adler family suffered more than personal loss as a massive fire (inset) consumed not only the family business but a treasured historic downtown building. Leopold "Lee" Adler II, grandson of the founder, and his wife, Emma Morel Adler, were among the dedicated, effective leaders of Savannah's preservation movement. Lee Adler was a champion for preserving historically significant, depressed neighborhoods without displacing low-income residents.

Above: After fire completely destroyed Adler's Department Store, it reopened on a smaller scale in a new location. On this site a new building was constructed, but it was no longer used as a department store. The new construction had no particular style or character. Built on the footprint of the old store and with the same dimensions, its facade was solid walls of stucco with only a few tiny windows on the top floor overlooking Broughton Street, and no windows on the Bull Street side. In recent years, the building has undergone a renovation that has much improved its appearance. The stucco facade has been scored into four sections with windows on every level. The facelift has created a building reminiscent of the old Adler's.

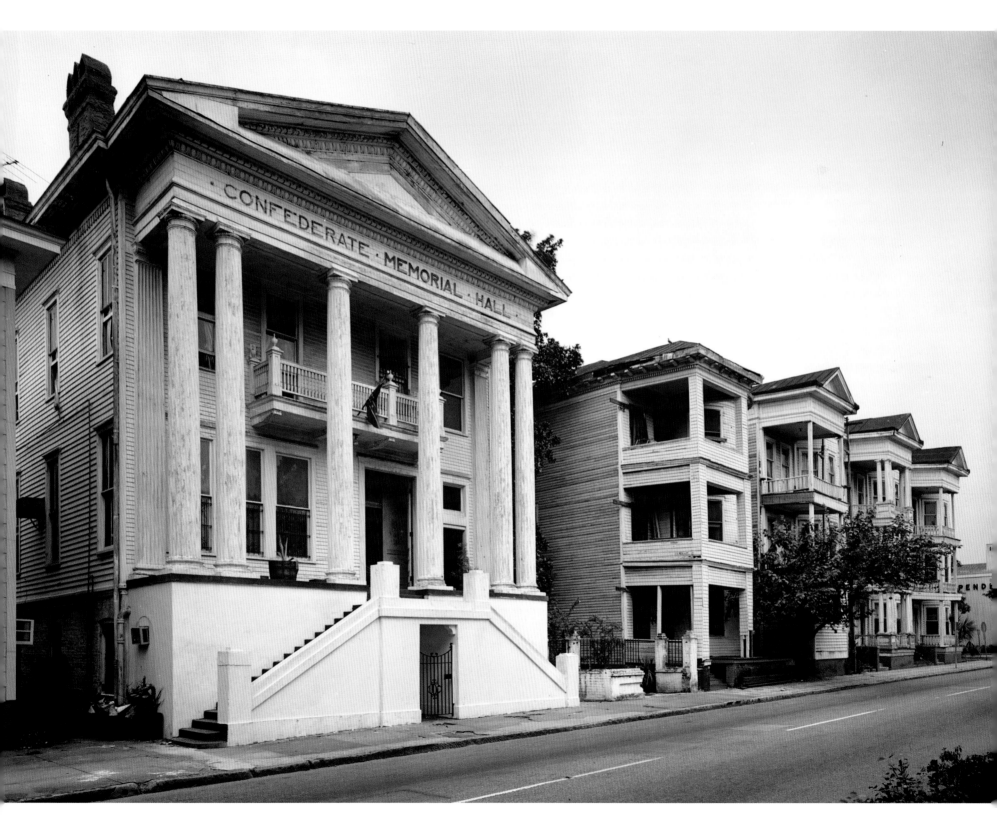

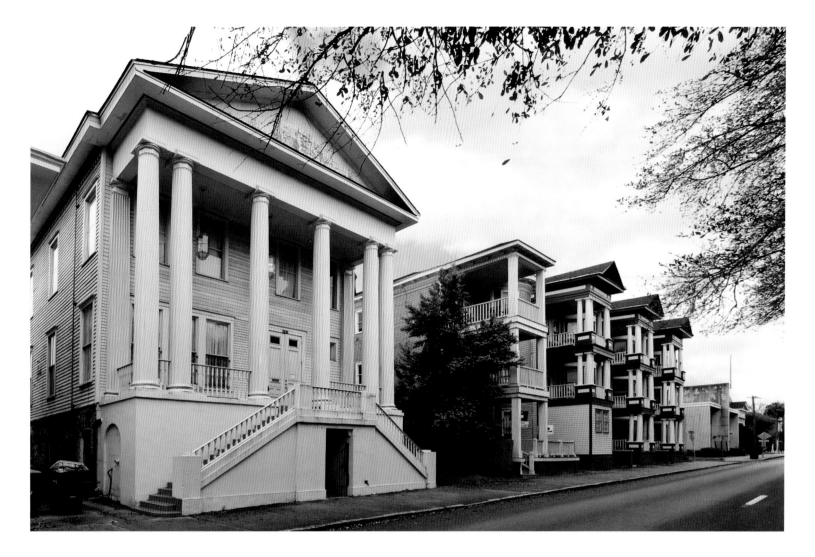

CONFEDERATE MEMORIAL HALL

A grand building constructed almost twenty years after the Civil War

Left: The Confederate Memorial Hall on Drayton Street, with the open green acreage of Forsyth Park in its lap, was constructed in 1884 for city alderman Solomon Krouskoff of the Krouskoff Millinery Company. Krouskoff served as the secretary and president of the board during his tenure in office. From 1913 to 1972, the United Daughters of the Confederacy occupied the building. This national society was founded in 1894 for female lineal descendants of soldiers who served in the Confederate forces. The mansion was constructed with six stately columns across the entrance, which were six feet in circumference and forty feet tall. The words "Confederate Memorial Hall" were emblazoned above the entrance. The front doors were twelve feet tall, and led into spacious rooms with thirteen-foot ceilings.

Above: The Confederate Memorial Hall suffered a major fire, which left the building a burned-out shell. The words over the entrance burned but fortunately the columns remained intact and salvageable. The mansion was converted to the Confederate House bed-and-breakfast in 1987. Restoration took eleven years of painstaking remodeling. Attention to every detail prevailed as crystal chandeliers imported from Europe were suspended from the high ceilings, heavy mahogany doors from Honduras were hung, and pink marble floors were laid down in the entrance hall, transporting this elegant mansion back in time to the original grandeur for which it was known in 1884. A Chickering grand piano graces the living room.

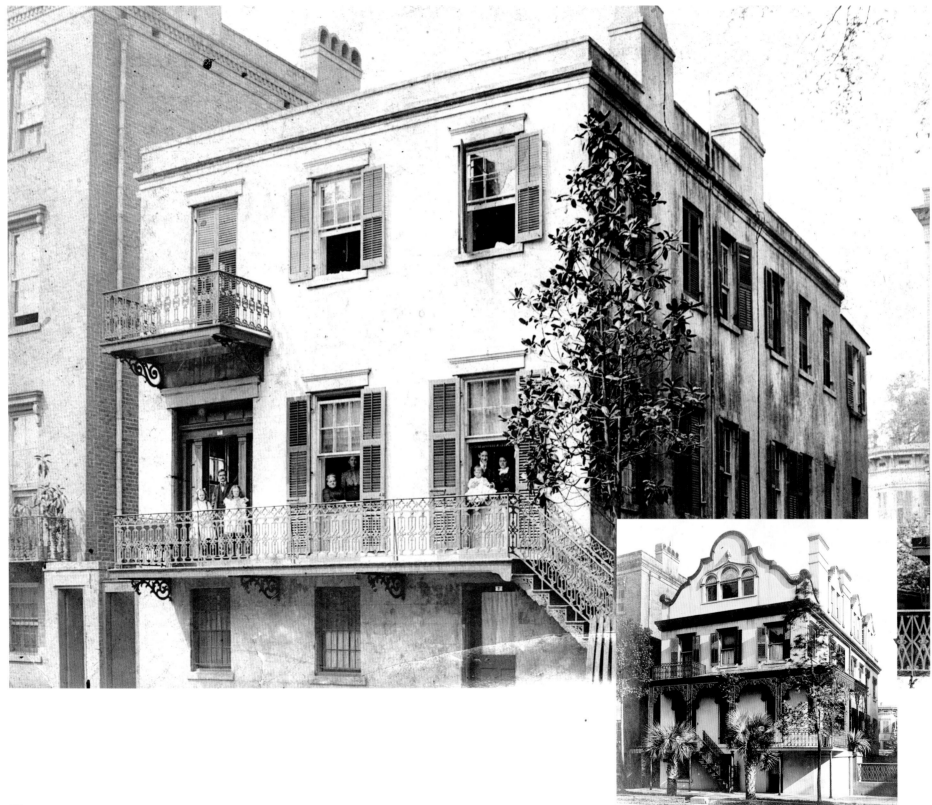

KING HOUSE

Fancy ironwork and palm trees give this house a New Orleans flavor

Left: The home at 10 West Taylor Street is known locally as the Ruskin King home, although the Fred Waring family lived there before them. In the true Southern fashion, Dr. King had a ritual of coming home from his office each day at noon for a large dinner and a long nap under the ceiling fan before returning to work. In the garage was a charger for an electric automobile. Until it was remodeled, this original 1852 two-story house would not stand out as original among the many homes built for the rising middle class of the mid-nineteenth century. In 1905 Miss Nina Pape held some of the first classes of her fledgling Pape School on the second floor of the house before the school had permanent buildings on Bolton Street. The treads of the stairs showed wear from the many feet running up and down for lessons. The home was augmented in the early 1900s with cast-iron balconies, Ludowici tile roof, and a Dutch Colonial third floor. The result was a mid-nineteenth century house with a New Orleans accent. Charles Cluskey, an antebellum architect and prominent designer of Greek Revival–style houses and public buildings, is thought to have influenced, if not designed, these transforming elements, which changed the appearance of the house dramatically. A feature that is unusual today but was common back then was a "dumb waiter," a hand-hauled lift to bring heavy dishes up from the basement to the dining room.

Right: The house is now the headquarters of the Hurn Museum of Contemporary Folk Art, and with an appointment, this traveling artwork may be viewed. The King House was featured on the cover of *Home and Garden* magazine in March 1940. Today the tall palm trees visible in the inset photo of 1911 at the front of the house have risen to roof level and complement the New Orleans flavor of this beautifully preserved house.

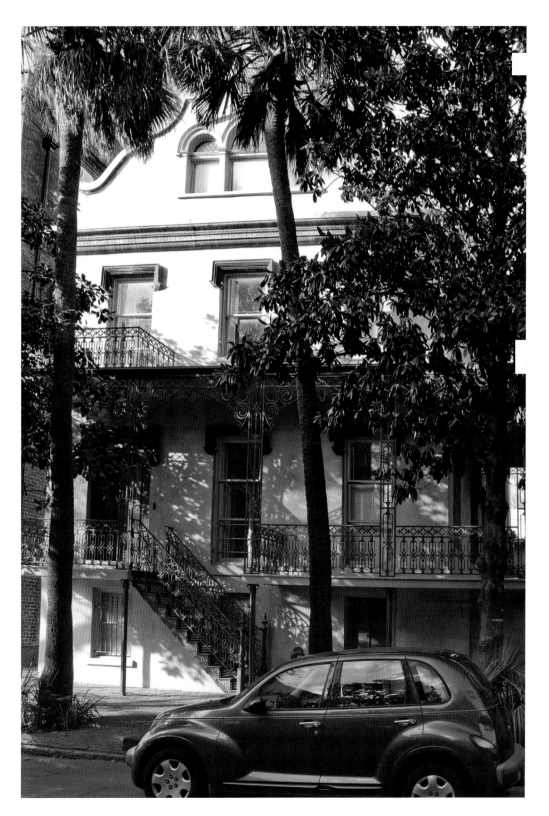

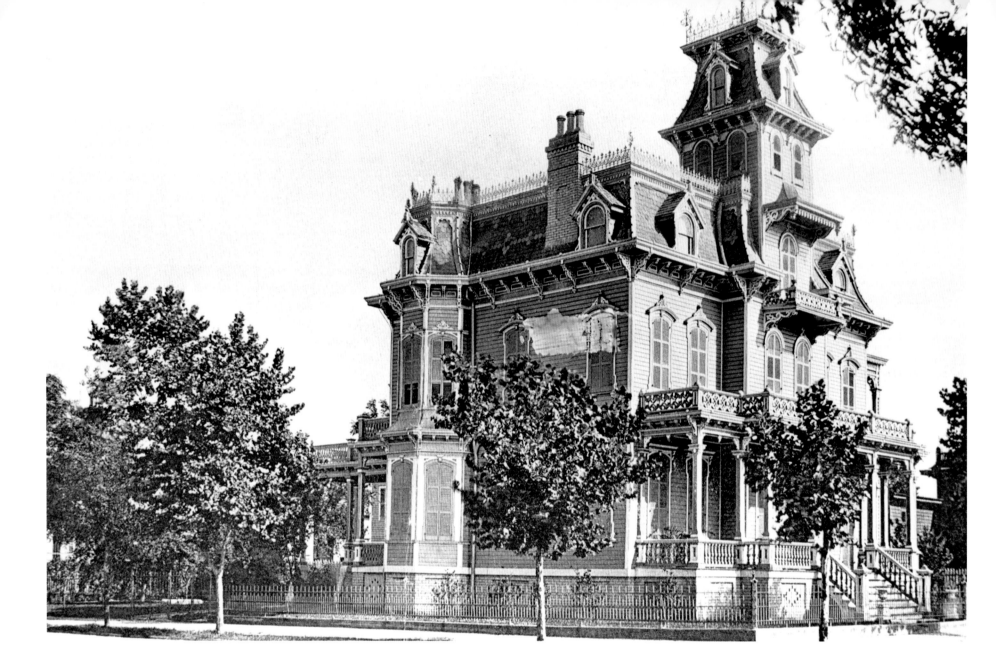

PAPE UPPER SCHOOL

One of the many schools started by the inspirational educator Nina Anderson Pape

Nina Anderson Pape completed her studies at Columbia University and immediately began what would turn out to be a remarkable career as a pioneer in women's education. In 1897 she founded the Froebel Circle to "increase health and happiness of the underprivileged"—the poor children of Savannah's Yamacraw Village. She opened Tybee Island's Fresh Air Home for disadvantaged youth in 1897. The upper floor of a house at Tybee Island was rented and fifty children were enrolled. In 1905 she established the progressive Pape School in the imposing high Victorian mansion that became the first private upper school in Savannah. Nina Pape was instrumental in bringing the concept of early childhood education to Georgia, including a kindergarten in her school in 1911.

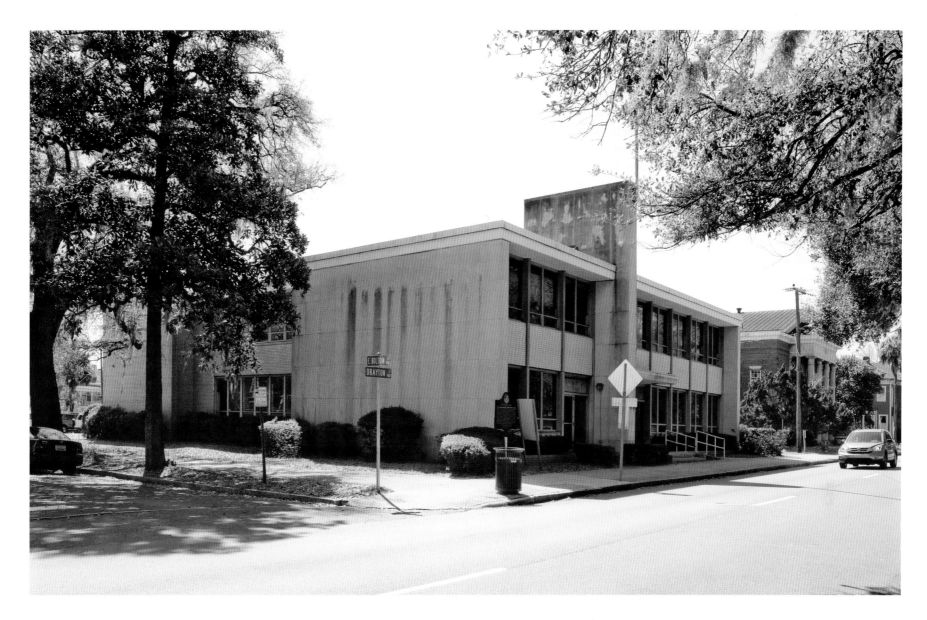

Today the site has no connection with education and the modern structure that replaced the school is unoccupied. Nina Pape became a leading advocate of progressive higher education for women in the twentieth century. She reorganized her school along the idealistic lines advocated by Woodrow Wilson, allowing the students to create their own governance and even make their own rules. She died in 1944 and is honored as one of Georgia's "Women of Achievement." In 1955 the Pape School became the Savannah Country Day School, which is thriving today on a site south of Savannah near Vernonburg. There was a celebration of the 100th anniversary of the founding of Pape School in 2005, and many alumni returned for the dedication of a Georgia Historical Society marker outside.

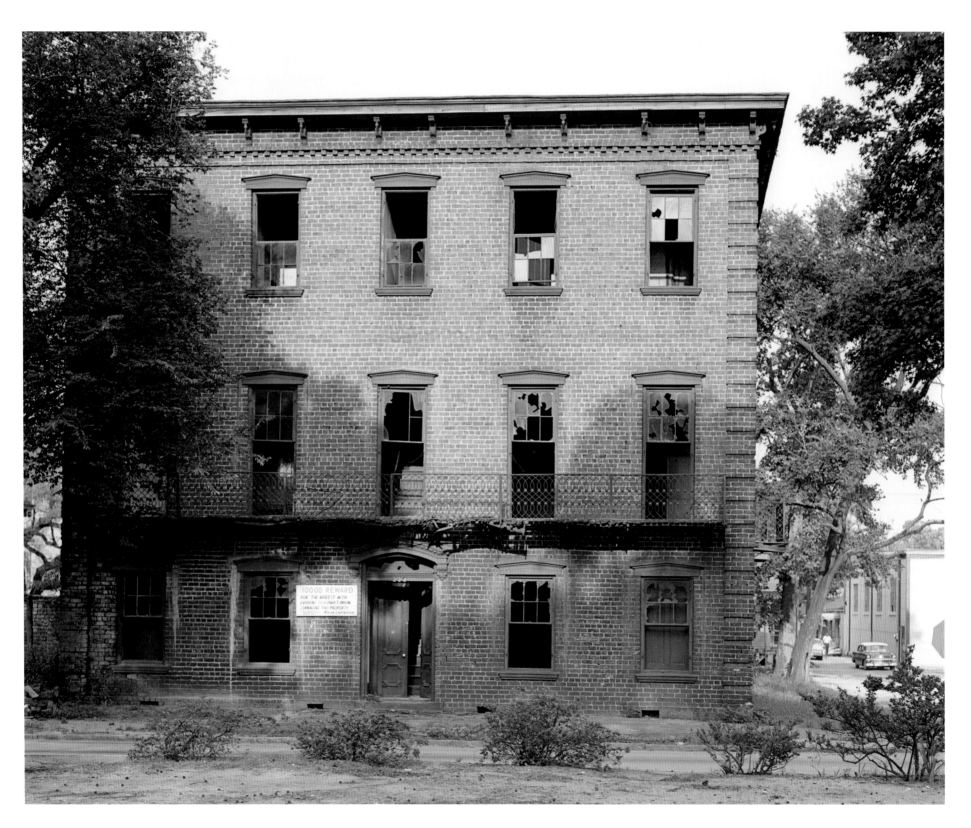

10000 REWARD
FOR THE ARREST WITH
EVIDENC TO CONVICT ANYONE
DAMAGING THIS PROPERTY

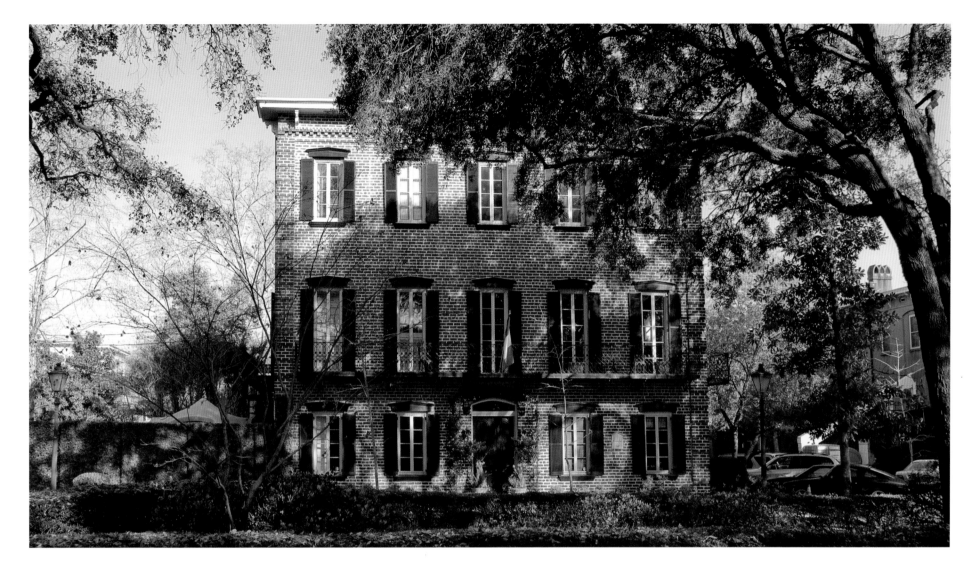

324 HABERSHAM STREET

This 1885 building has been lovingly restored to its former pomp

Left: This building faces Troup Square, named for George Michael Troup, governor of Georgia from 1823 to 1827. Savannah's once-proud, dignified, and understated style began to sag as its cotton-based economy foundered. The boll weevil mercilessly swept the South in the early twentieth century on its path through Texas, Louisiana, Mississippi, Alabama, and, finally, Georgia. The national exodus to suburban living signaled the death knell for downtown. Urban blight was evident in the entire Historic District. Block after block of family homes and irreplaceable architectural examples became tenements or were torn down. Savannah was hit hard. Just one example was the decimation of Troup Square, seen here in vandalized decay in 1969.

Above: Built in 1872, the house at 324 Habersham Street is a fine example of careful restoration and preservation from slum house to showpiece. When the house was purchased in 1970 the owners began a two-year restoration with 3 percent Housing and Urban Development money. Today, it is the Murphy Gallery, which displays and sells works by Savannah artist Michelle Murphy. This building is part of a row of houses known as John McDonough Row, all built around the 1880s. This area of town was originally composed mainly of working-class Irish families who knew and supported each other, and this friendly neighborhood spirit prevails today as folks routinely gather in Troup Square at sunset for drinks and conviviality.

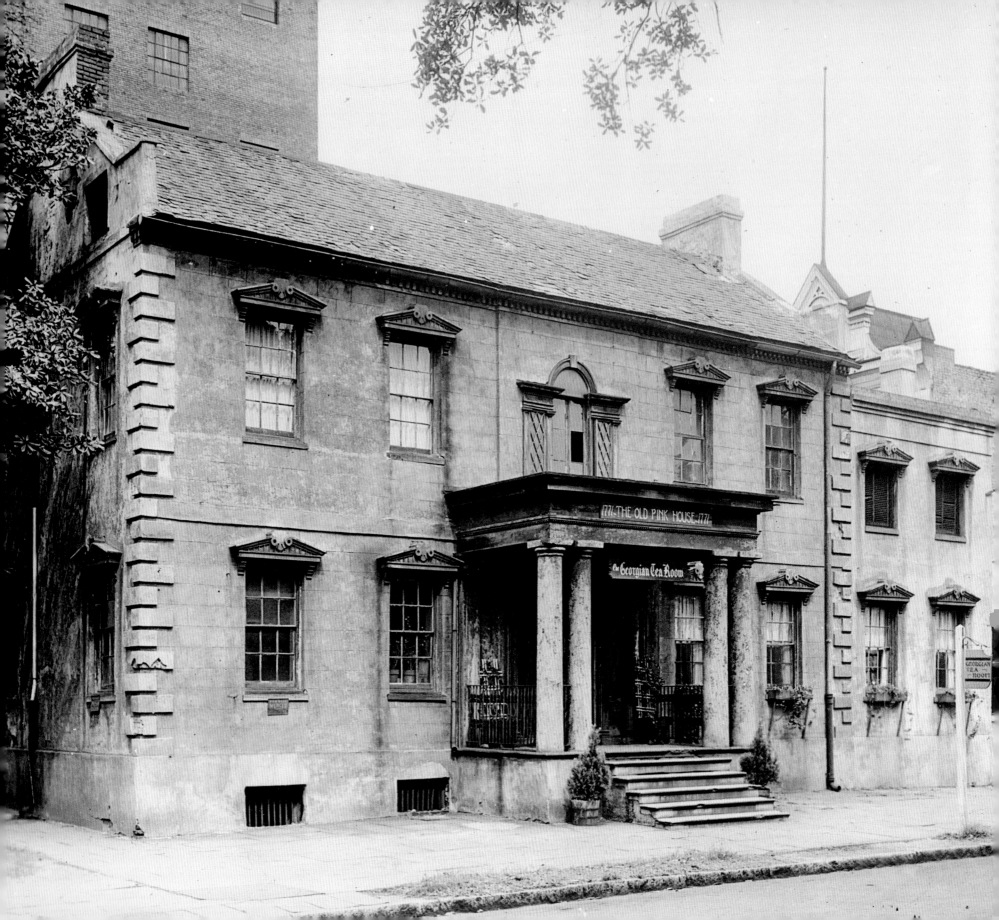

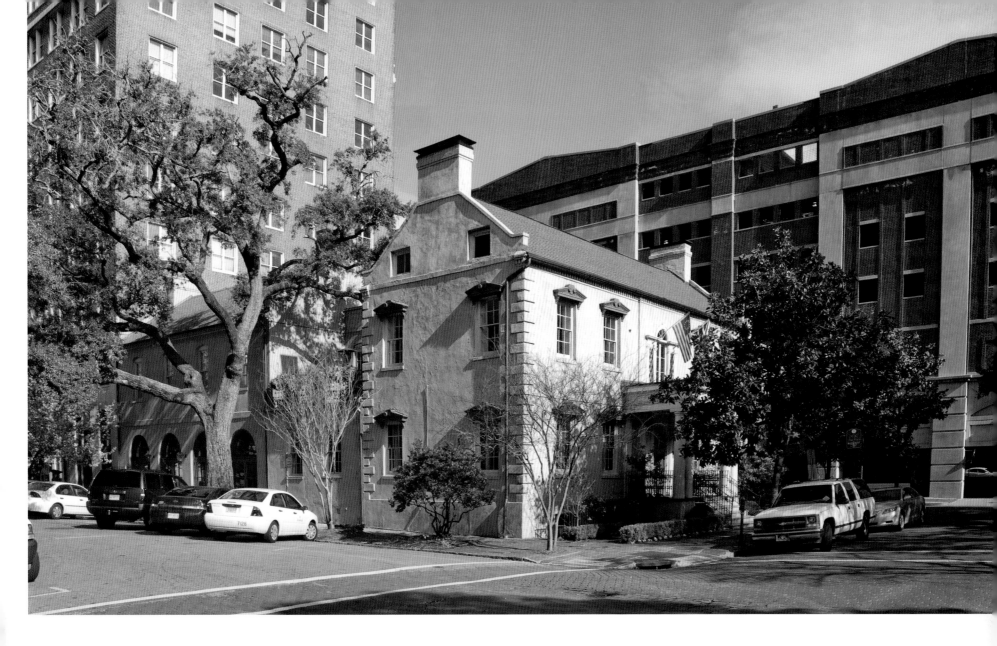

OLDE PINK HOUSE

James Habersham's mansion has been used as a bank, an army headquarters, and a tearoom

Left: The Olde Pink House, or Habersham Mansion, has a fine lineage. It was built in 1771 and was occupied by merchant James Habersham, Jr. until 1802. Library of Congress notes show that it was occupied by "the Boltons," architect William Jay's sister and brother-in-law, from 1804 until 1812, when it was used as the Planters Bank, the first state bank of Georgia. During the Civil War, when Savannah was captured and occupied by Union troops, Brigadier General Lewis York used this house as his headquarters. After the war was over, the house served as an attorney's office and a bookstore. Alida Harper opened it in the 1930s as a Georgian tearoom. This photo is from 1934.

Above: The building was used by many businesses until 1970, when it was purchased by Heschel McCallan and Jeff Keith and transformed into the Olde Pink House gourmet restaurant, with a restored dining room with authentic furniture from 1779. It still maintains its original pink color, created by the strong iron oxide pigment in the clay bricks, which leached through the porous bricks and down the surface of the house, making it pink.

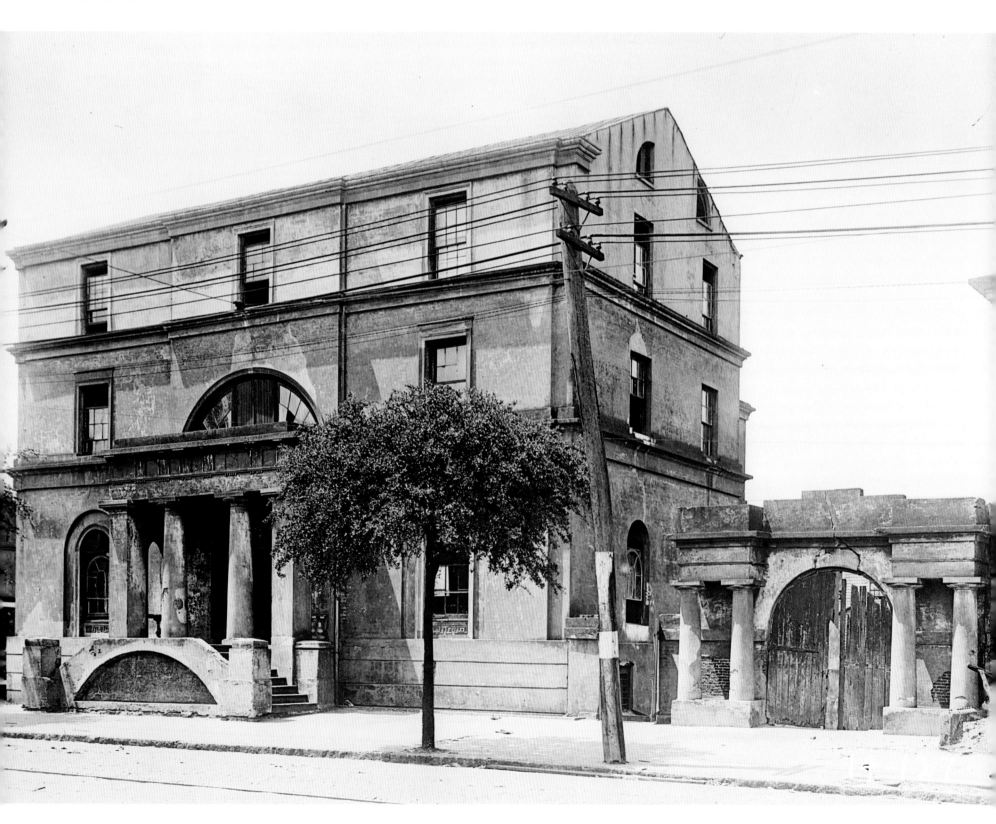

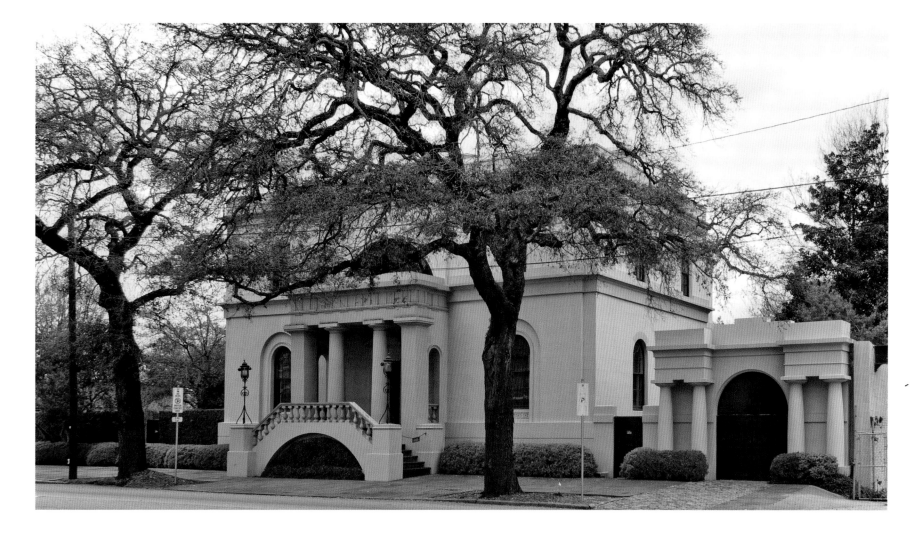

SCARBOROUGH HOUSE

Once the home of William Scarborough, now the home of Ships of the Sea Museum

Left: William Scarborough was one of the merchant princes of Savannah who sought to reflect his success in the mansions he had built to architect William Jay's designs. The resulting homes were Savannah's most elegant masterpieces. The day his home was finished in May 1819, Scarborough and his wife Julia welcomed President James Monroe to one of their elegant parties. The Scarboroughs often had furniture removed when they threw a "blowout," as Julia Scarborough called her popular galas. William Scarborough was a leading figure in the Savannah Steamship Company which financed the maiden voyage of the steamship *Savannah*. In 1870 the house became a boys' orphanage run by the Bishop of Savannah. In 1878 George Wymberley Jones DeRenne purchased the house and gave it to the board of education as a school for black children called West Broad Street School. This photo is from 1934.

Above: The Scarborough House reverted back to the DeRenne heirs when the school closed. In 1966 Elfrida DeRenne Barrow gave her share to Historic Savannah Foundation for their headquarters. In 1996, it was acquired by the Ships of the Sea Museum. Scarborough House is an elegant setting for a collection of ship models, paintings, and maritime antiques. Among the detailed models is one of *The City of Savannah*, which was 248 feet long, 38 feet wide, and iron hulled.

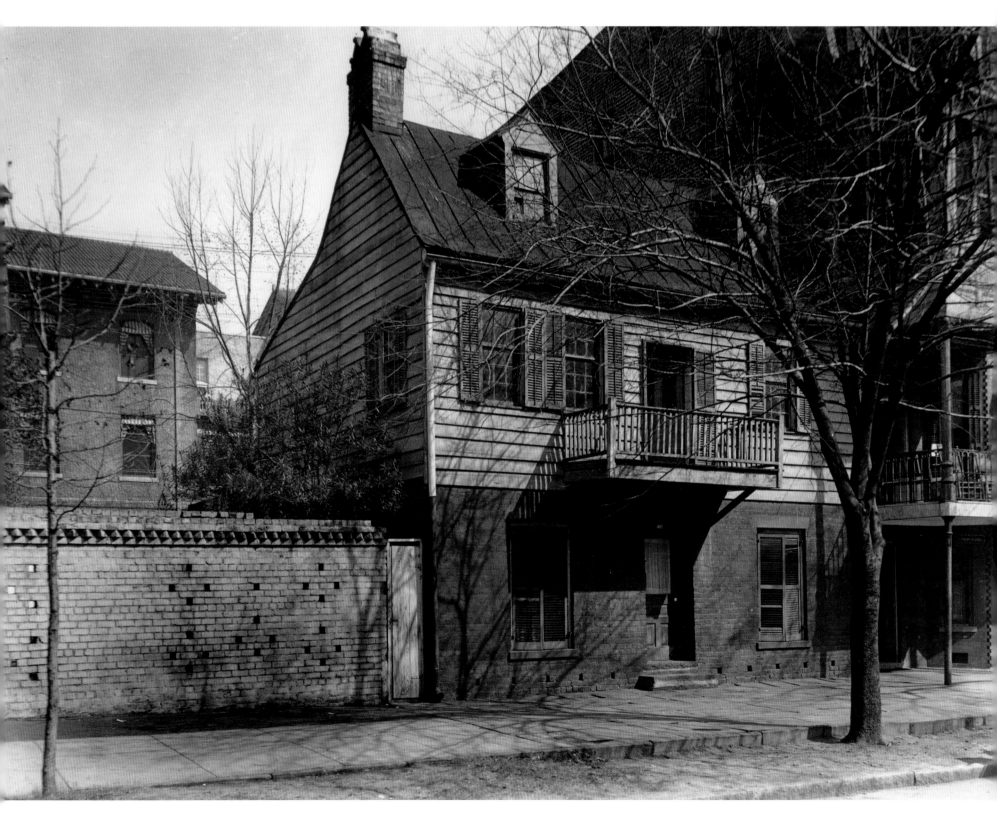

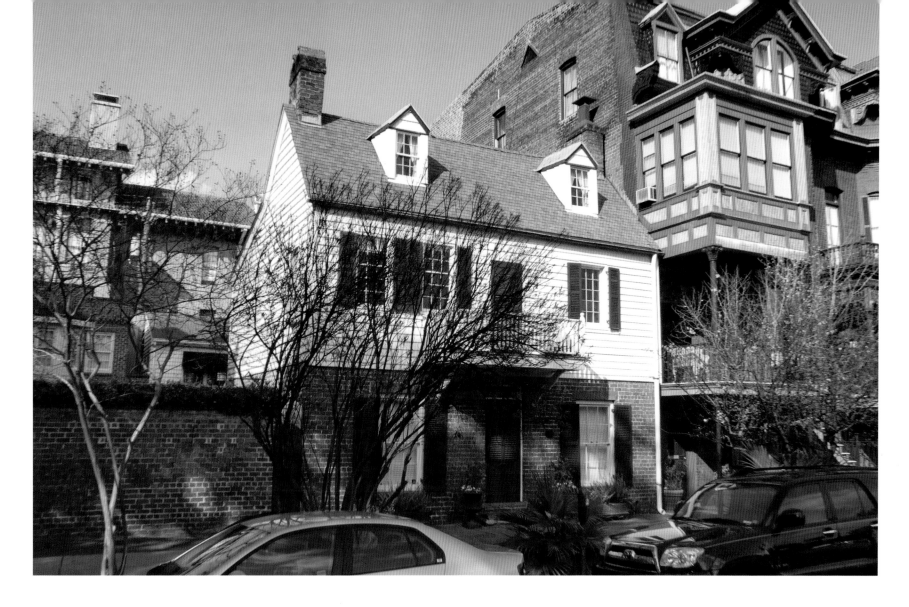

CHRISTIAN CAMPHOR HOUSE

This original saltbox cottage has gone up in the world since 1767

Left: Completed between 1760 and 1767, the Christian Camphor House is one of the very few houses remaining that closely resemble those built by the first colonists. All others of the era were destroyed by fires or were demolished as the economy grew and architectural styles changed. Built on a lot measuring sixty feet by ninety feet, the standard deeded to each colonist, the home was a simple, one-story clapboard structure with a chimney at one end. It is of saltbox design, with the roof extending with less pitch above an attached rear shed. It was raised one floor onto a brick foundation in 1871 to diminish the nuisances of street dust and noise. The added height also made the upper living level more comfortable during Savannah's sweltering summers by catching cooling breezes. This photo was taken in 1945.

Above: The current owner of the Christian Camphor House has the original deeds, passed on by previous owners. Adding to the charm of the home is a unique hidden staircase that allows access to the attic sleeping space. Just outside the back door of the main house is a large brick-enclosed courtyard with the original cistern. Through the courtyard is the carriage house, which now serves as a guesthouse. Featured on many of Savannah's popular home tours, the house reaches back in time to present a true view of old Savannah. It is also a favorite stop on local ghost tours. It is said that the Christian Camphor House is haunted by numerous ghosts, including the spirits of men who died nearby in the old marine hospital, York Hall.

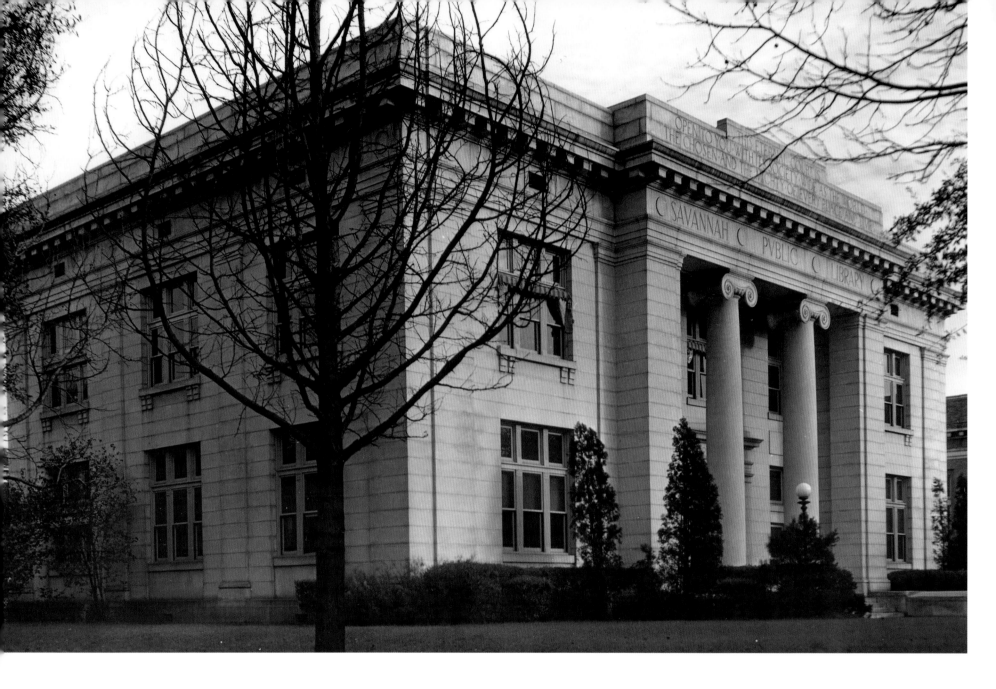

LIVE OAK PUBLIC LIBRARY

Constructed in 1918, Savannah's main library keeps expanding

The main public library stands at 2002 Bull Street. In 1903 the Georgia Historical Society and the City of Savannah established a temporary library service in Hodgson Hall on Gaston and Whitaker streets. This three-year experiment proved that Savannahians wanted a permanent library. This "main" library (as it has been considered since its construction) was opened in 1918, at a cost of $104,041.78. A major donation from the Carnegie Foundation allowed the building to be completed on schedule. The photo shows the building in 1930. Designed by H. W. Witcover, the library is a fine example of neoclassical architecture. A renovation was completed in 1936 when the Works Progress Administration added a small wing.

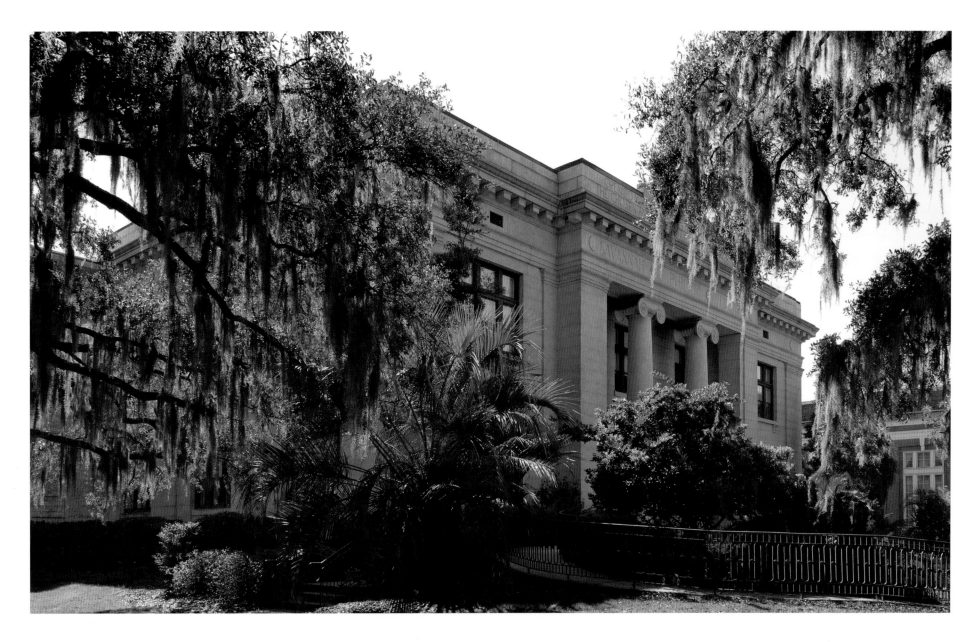

In 1966 an addition doubled the size of the library, making it better able to handle the dramatic increase in the number of patrons after the implementation of desegregation. In 1999 another major renovation again doubled the size to 66,000 square feet. It was painted in the neoclassical style of Scottish architect Robert Adams. The library's split-block addition of 1966 was replaced with white Grecian marble and vivid colors in the rest of the decor, making its environment even more inviting and friendly. Large expanses of glass windows provide spectacular views of the imposing live oak trees along Bull Street. In honor of these trees, the entire library system was renamed Live Oak Libraries in 2002.

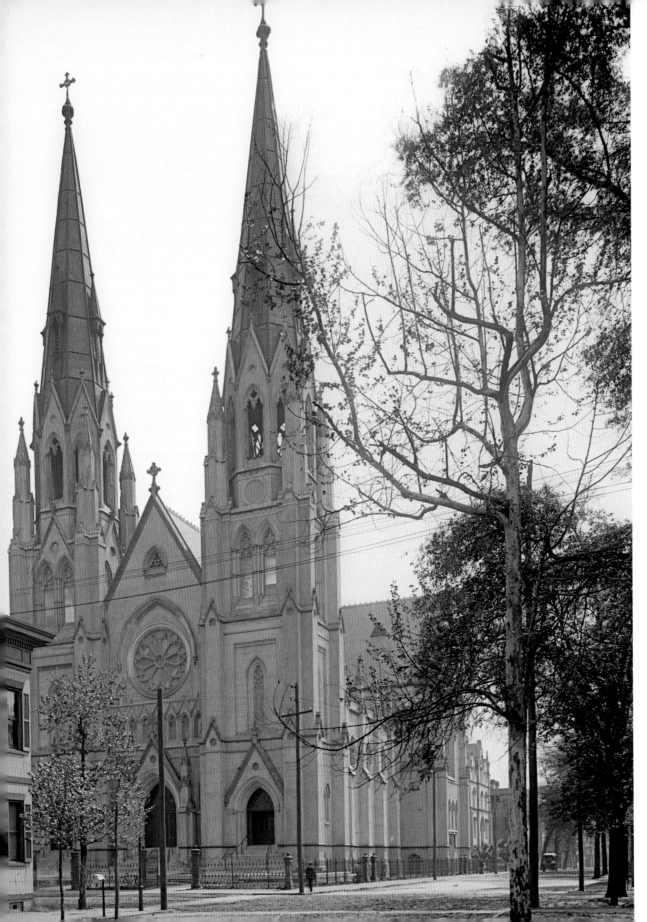

ST. JOHN'S CATHEDRAL

Survivor of a calamitous fire

The charter issued in 1732 for the settlement of Georgia prohibited Catholics from practicing in the colony for political reasons—as Spain was in control of Florida and Roman Catholicism was the state religion of Spain, it was feared that a more liberal policy would foster spying and possible insurrection. Once England and Spain were no longer at war, Catholics were not only welcomed to the colony, they eventually built the largest church in town. The first Catholics to immigrate to Savannah were French, who influenced the name (Cathedral de St. Jean de Baptiste). However, by 1876, when the structure was dedicated, the patron saint of the Cathedral of St. John the Baptist was St. Patrick, a reflection of the large Irish population of Savannah at the time. This photo shows the cathedral at the turn of the century after the spires had been added in 1896.

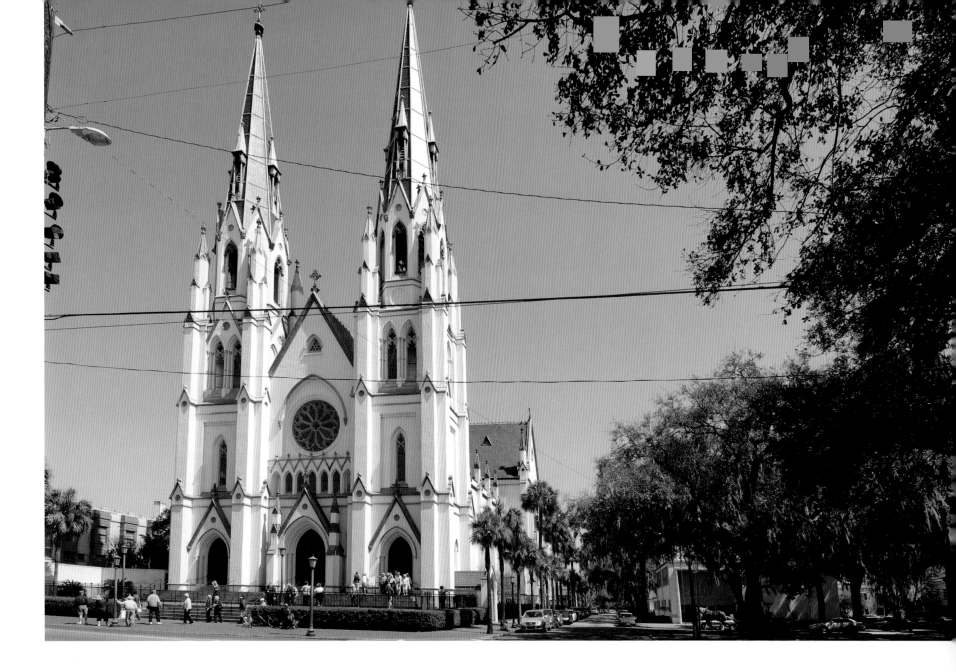

In 1898, just two years after the addition of the spires, this spectacular building was nearly destroyed by fire. Through diligent efforts, it was rebuilt by 1899. In the 1950s, the Stations of the Cross were treated to resemble marble. Visitors enter quietly and sit in silence, absorbing the magnificence of the interior. The aisle windows represent scenes from the gospels and lives of the saints. On the south wall of the transept is the coat of arms of the Reverend Thomas McDonough, tenth bishop of the Diocese of Savannah.

The coat of arms on the north transept belongs to Pope John XXIII. The north transept window is of Christ's ascension into heaven and the south transept depicts the assumption into heaven of the Virgin Mary. Savannah artist Christopher Murphy directed the installation of the murals. Three windows above the high altar show scenes from the life of St. John the Baptist. The rose window shows Saint Cecilia with her organ. St. Patrick's Day Mass in the cathedral is a yearly tradition for the Hibernian Society.

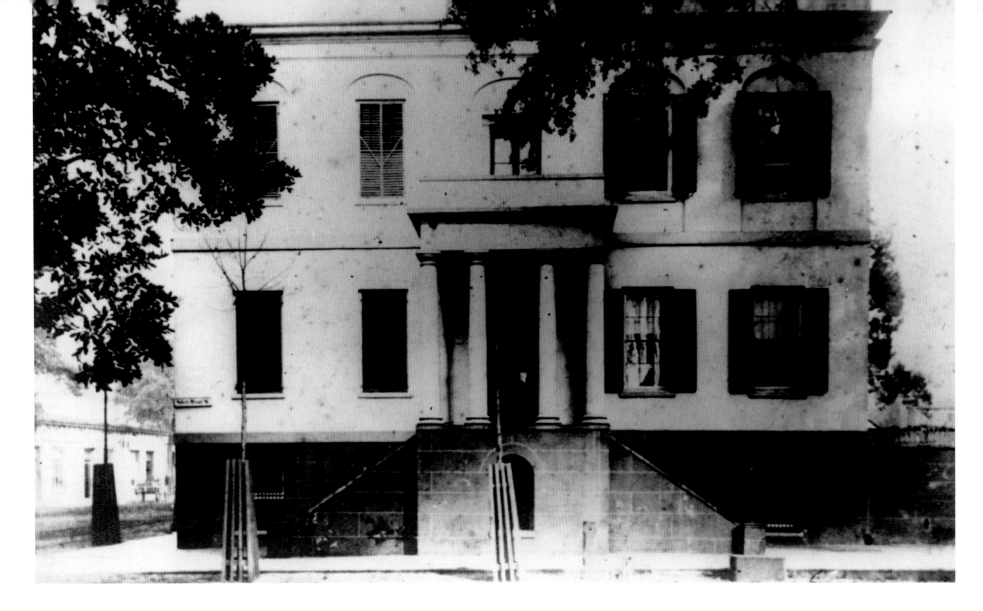

WAYNE-GORDON HOUSE

Birthplace of the woman who brought scouting to the girls of America

Above: The Wayne-Gordon House is best known as the birthplace of Juliette Gordon Low, founder of the Girl Scouts of America. This home was built in 1821 for the first U.S. Supreme Court justice from the state of Georgia, James Moore Wayne, who sold it to Juliette's grandfather, William Washington Gordon. This imposing Regency mansion in shades of brown is on Oglethorpe Avenue. The original solid Regency style of the Wayne-Gordon House was augmented in 1886 when architect Detlef Lienau added the third floor to the house and the stately side piazza overlooking the large English garden on the property. Juliette Gordon, nicknamed "Daisy," was born in this home on Halloween night in 1860. The photo was taken in the early 1900s.

Right: Four generations of the Gordon family have lived in the house since William Washington Gordon bought it in 1831. The Girl Scouts purchased the home in 1953 and opened it as a program center and museum in 1956. Today, troops from all over the world come to take part in hands-on activities and learn about the founder of the Girl Scouts. Juliette Gordon Law had worked as a Girl Guide leader with Boy Scouts founder Robert Baden-Powell in Britain before returning to America in 1912 to form her own troop of American Girl Guides along with her cousin Nina Pape. The name of the organization was changed to Girl Scouts of the U.S.A. the following year. Experiencing the gaslight era in the 1880s with low shimmering lights, scouts hear this family story as it entwines through Savannah and U.S. history.

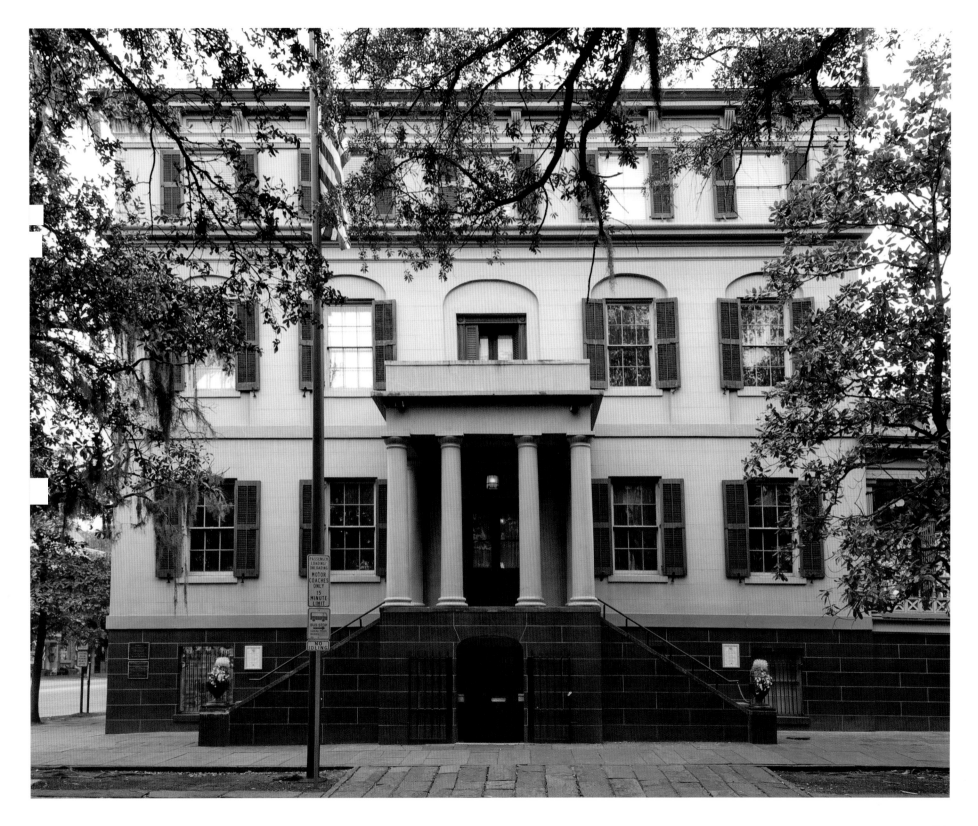

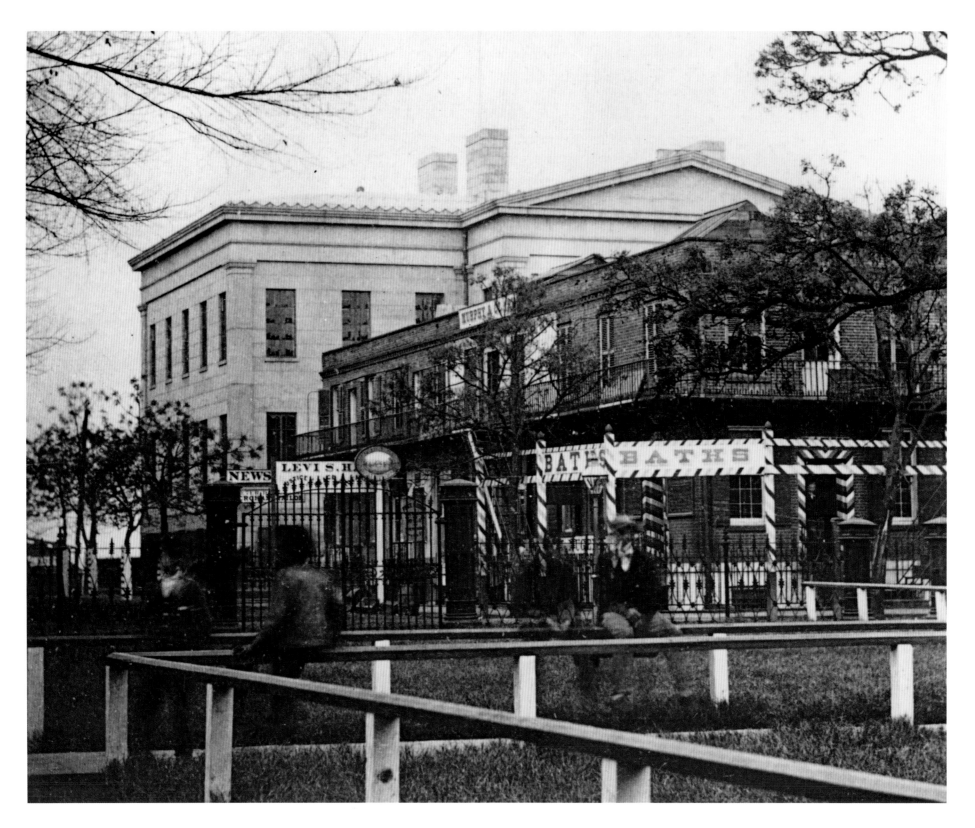

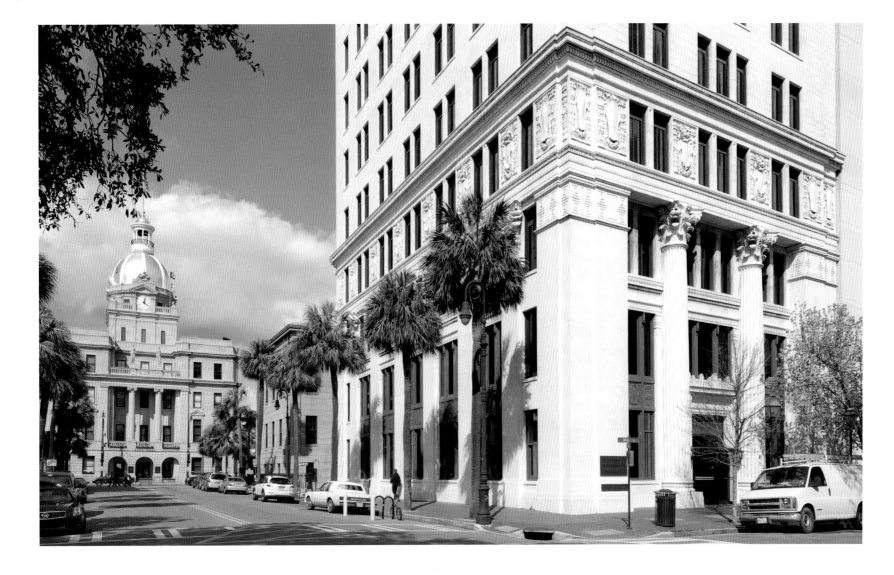

SAVANNAH BATHS

A fine place to get a Victorian wash and scrub

Left: This photograph, taken in 1867, proves the existence of Custom House Baths on Johnson Square behind the Custom House. It can only be assumed that the baths provided a convenient location for ship captains and crew to clean up after a long voyage once they moored their ships along the wharves of Savannah. This image views the Custom House from the back. The selection of John Norris as designer of the U.S. Custom House established his reputation as the most important architect in Savannah during the prosperous 1850s. The stately Greek Revival masterpiece was constructed of New Hampshire granite in 1852, with a distinctive Tower of the Winds portico and six fluted columns.

Above: Wachovia Bank now resides where the baths used to be on the northeast corner of Bull and Bryan streets. Designed by the architectural firm of Mowbray and Uffinger, it was completed in 1912 as the state-chartered Savannah Bank and Trust Company. The fifteen-story building, Savannah's oldest existing "skyscraper," was occupied on the first four floors by the bank, and the remaining eleven floors held various businesses. In the center of the picture on Yamacraw Bluff is the highly visible City Hall with its gold dome, which looks down Bull Street over the five squares—Johnson, Wright, Chippewa, Madison, and Monterey.

HAMPTON LILLIBRIDGE HOUSE

Supposedly haunted, despite a switch in locations

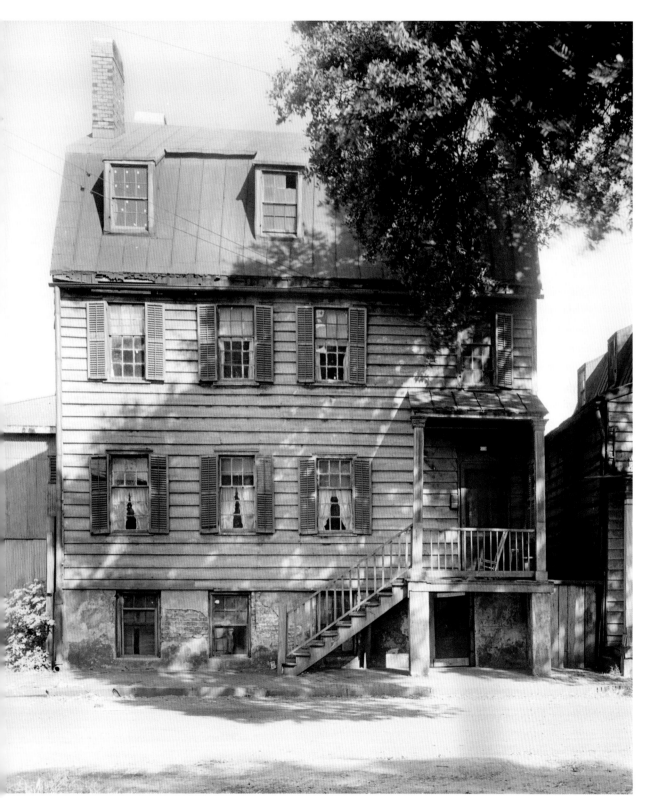

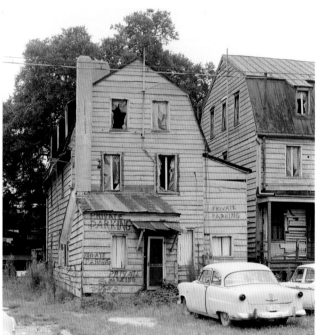

A Dutch gambrel roof was not common in Savannah in the eighteenth century, so this wooden frame house, built for Hampton Lillibridge from Rhode Island in 1796, must have been an attraction even then. It was constructed in true New England fashion, with its clean lines and rooftop widow's walk. The widow's walk—which had rotted away by the time of this photo—was placed on the east end of the roof, which is closest to the entrance of the Savannah port, where a widow might anxiously wait for her husband returning from sea. Even before it was completed, stories of unexplained events drew people to walk by and stare into its windows. Tales were told of a sailor hanging himself in one of the rooms during its time as a boardinghouse, and of human forms walking through walls. After Hampton Lillibridge died, his wife remarried and the house was sold. These photos from 1962 show the main house, which was saved, and (in the inset) its neighbor at 312 East Bryan Street, which collapsed.

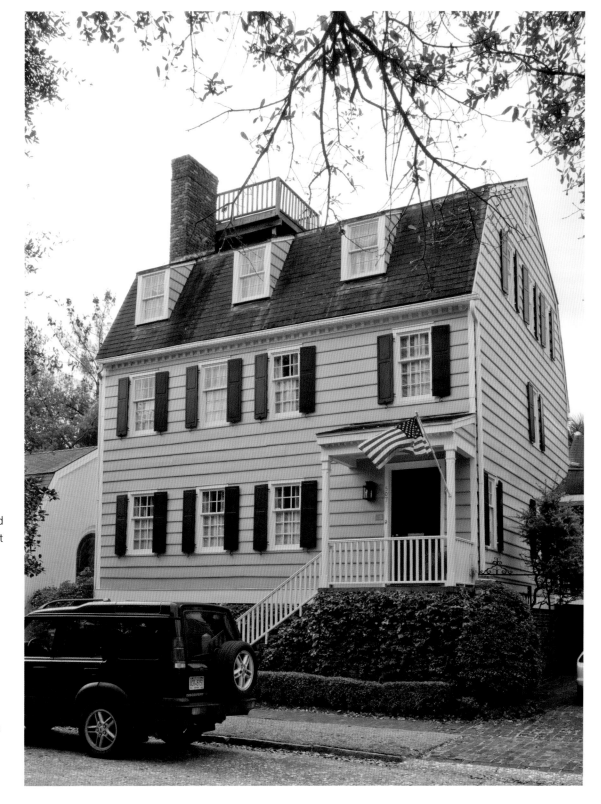

The house stood vacant for many years, causing decay and deterioration. Antiques dealer Jim Williams, a leader of the renovation movement, bought the house in 1963 and had it moved from its East Bryan Street address to its present location on Saint Julian Street. As part of his restoration work, Williams had the widow's walk rebuilt back onto the roof. Increased sightings and hearings led him to have a formal exorcism performed in the house by the bishop of Georgia. Williams also purchased the house next door to the Hampton Lillibridge House on Bryan Street, with the intention of restoring both at the same time. The second house tragically collapsed in the attempt to move it, killing a worker. In 2003 the American Institute of Paranormal Psychology named Savannah America's most haunted city. The Hampton Lillibridge House is singled out by many believers as the most haunted building in the city. Visitors craning their necks to see the widow's walk of the home tell of spotting spiritual presences in the form of orbs on the photographs they take with digital cameras.

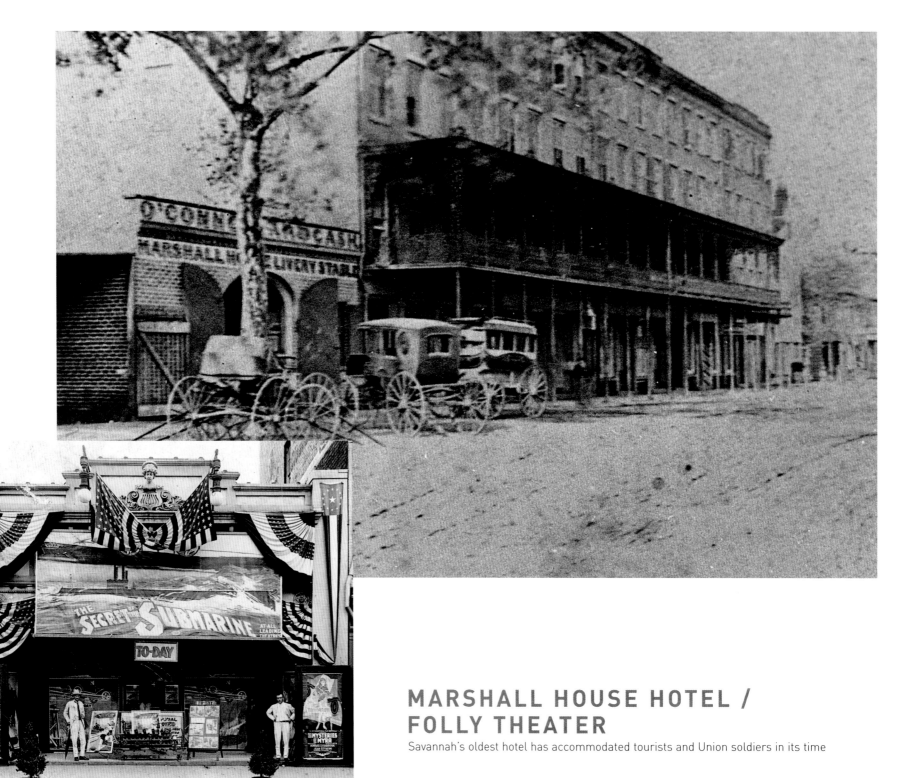

MARSHALL HOUSE HOTEL / FOLLY THEATER

Savannah's oldest hotel has accommodated tourists and Union soldiers in its time

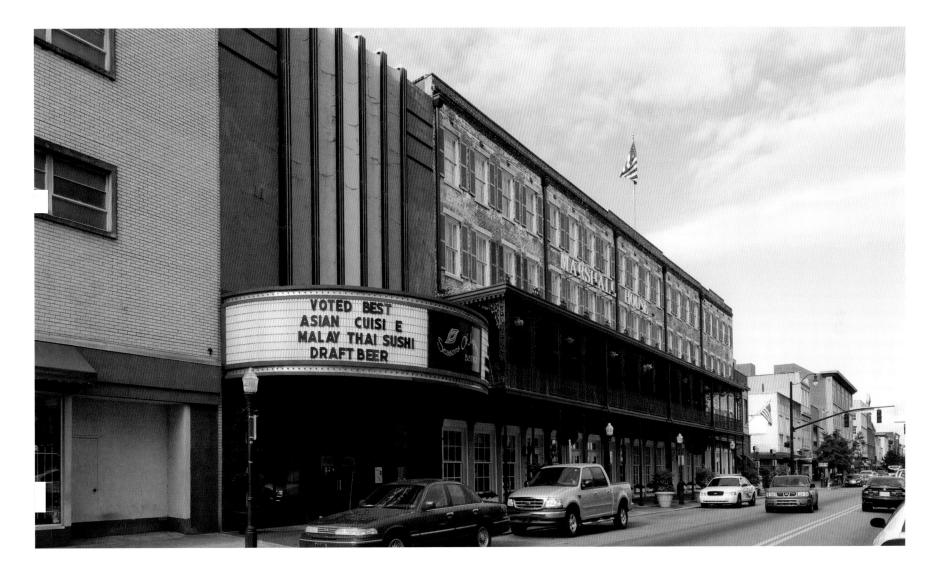

Left: In 1851 Mary Marshall built the first hotel in the city, the four-story Marshall House, on what had become the city's main street, Broughton Street. In 1857 an iron veranda was erected on the street side. The veranda became a signature feature of the Marshall House. The adjoining building, known as the Florida House, was annexed as part of the hotel, increasing its capacity by a third. In 1864 the hotel served as a hospital for wounded Union soldiers during the occupation of Savannah following the battle at nearby Fort McAllister. In the 1880s the Marshall House was home to Joel Chandler Harris, editor of the *Savannah Morning News* and author of the famous Uncle Remus tales. The Folly Theater (inset) grew from what had been the livery stable, adjacent to the Marshall House Hotel, and specialized in burlesque acts.

Above: Considering the history of this "grand dame," it has stood the test of time. It was a hotel for homeless pigeons in 1895, and reopened four years later with electric lights plus hot and cold baths. Herbert Gilbert, a businessman from Florida, leased the building and changed the name to the Gilbert Hotel, sold it in 1941, and it closed once again. By 1956 the hotel had closed and the first floor was used for businesses. In 2001 it was bought by HLC Hotels, a Savannah hotel company, and after more restoration, it was featured on the Travel Channel's *Great Hotels* program. Finally, it was named a National Historic Building in 1999 by the Georgia Trust for Historic Preservation. The Folly Theater, like so many, was remodeled to show movies as the Band Box Theater. With the decline of the inner city in the 1950s it closed its doors. A local theater company re-opened the old Folly as a venue for live theater, which thrived into the new millennium before moving to a bigger space. Today it is a popular Asian restaurant.

SPILLER HOUSE

An example of a "second wave" colonial cottage

Above: This colonial-style wooden clapboard home, originally belonging to Mr. Spiller, was similar to many built during the late eighteenth century. It was larger than the original colonists' single-story saltbox homes with two complete floors, so more sleeping space was available for larger working families. This "second wave" style was built slightly above ground, on blocks, which provided some protection from moisture and insects and, since floorboards were not always tightly placed and sealed together, offered fresh air flow. An outhouse and a cookhouse were located behind the house in the space shared with the garden and carriage house. Mr. Ballon, the builder of this house, also built the house to the right. This photo is from the mid-1970s.

Right: Atlanta banker Mills B. Lane took an interest in Savannah restoration in the 1960s and restored some of the squares in this area. His good works spurred homeowners to pursue their own restoration. Driving past the home today on East Congress Street, one would have no idea of its earlier deterioration. Today the house has two bedrooms, two and a half baths, a living room, a dining room, a kitchen, and an office with a courtyard out back. The house to the right is smaller, and it is believed that Mr. Ballon lived in it while constructing the larger one. The house to the left was built just recently on land once used as a parking lot for the Spiller House.

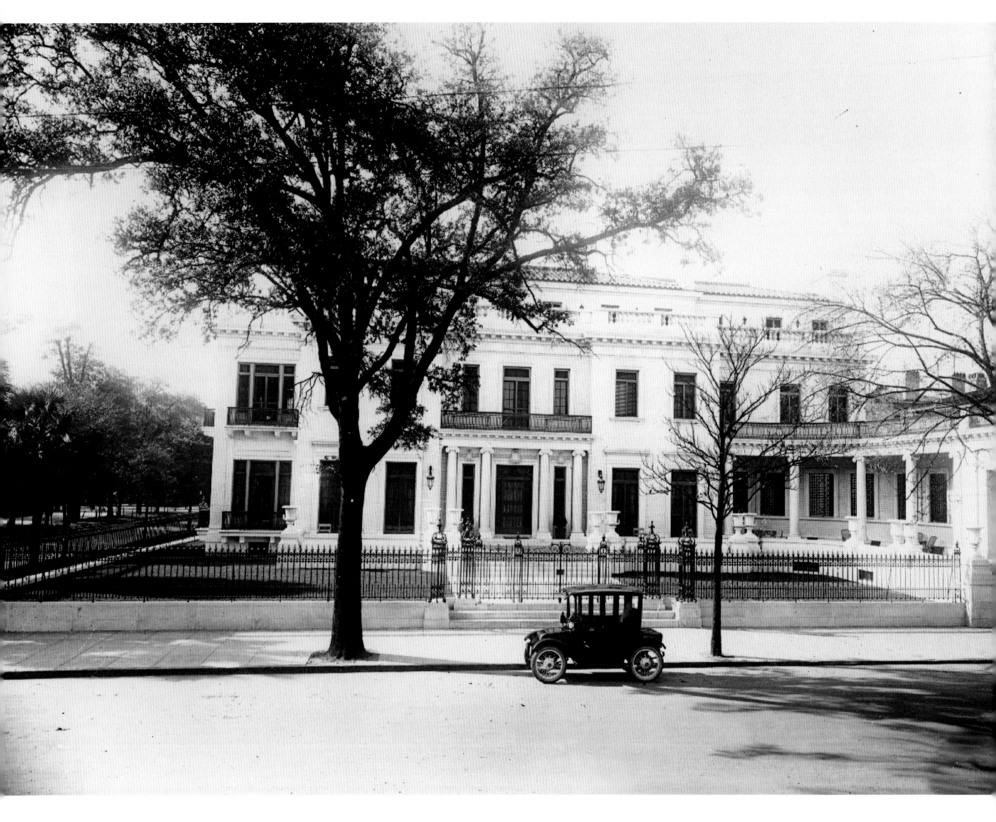

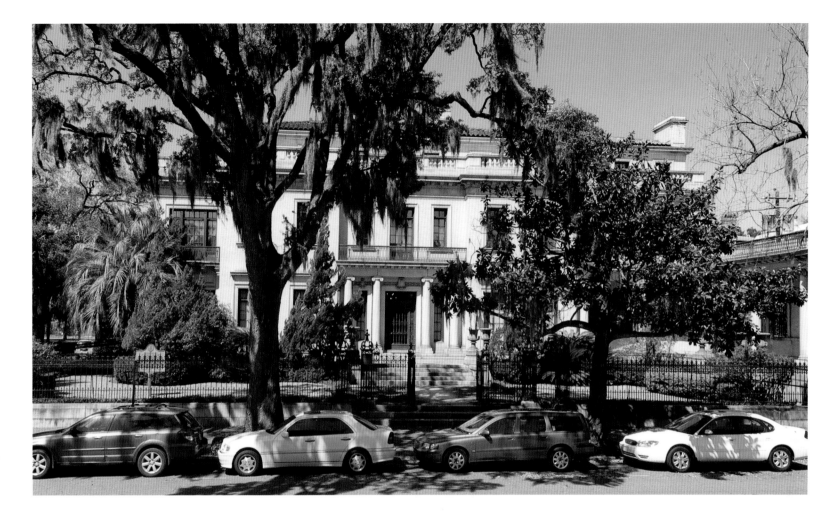

ARMSTRONG MANSION

One of the grand mansions built on the wealth of the Savannah shipping trade

Left: George Armstrong was born in 1868 in Guyton, a rural community just a few miles from Savannah. His maritime and shipping success during World War I at the Strachan Shipping Company earned him a national reputation and a personal fortune. Between 1916 and 1919, Armstrong, his wife Lucy, and their daughter saw the completion of their mansion on Bull Street across from Savannah's largest metropolitan green space, Forsyth Park. Architect Henrik Wallin used granite and glazed brick in his four-story Italian Renaissance design. The beautiful curving piazza at the north end of the front of the mansion was said to have been requested by Armstrong to block the view of the lane and whatever would become of the Monterey Square area to the north, and allow the family a sheltered view of the bucolic arboretum and the beautiful fountain of Forsyth Park to the south. This photo dates to about 1920.

Above: The city-supported Armstrong College was first housed in this mansion in 1935 after the building was gifted to the city by the family of George Armstrong. The college expanded into six additional buildings nearby. In 1966 it moved south to its present site, a gift of considerable acreage from Donald Livingston and the Mills B. Lane Foundation. The Armstrong House was bought in 1970 by the law firm of Bouhan, Williams, and Levy and was thrust into the limelight when the book *Midnight in the Garden of Good and Evil* shook the city to its foundations. Visitors to Savannah hope for a glimpse of one of the book's characters, William Glover, who supposedly walked an invisible dog in Forsyth Park, or even the bulldog called Uga, the mascot for the University of Georgia's football team, who is occasionally seen being walked in the park. Directly across Bull Street is the oldest gentlemen's club in Georgia, the Oglethorpe Club, which started in 1870.

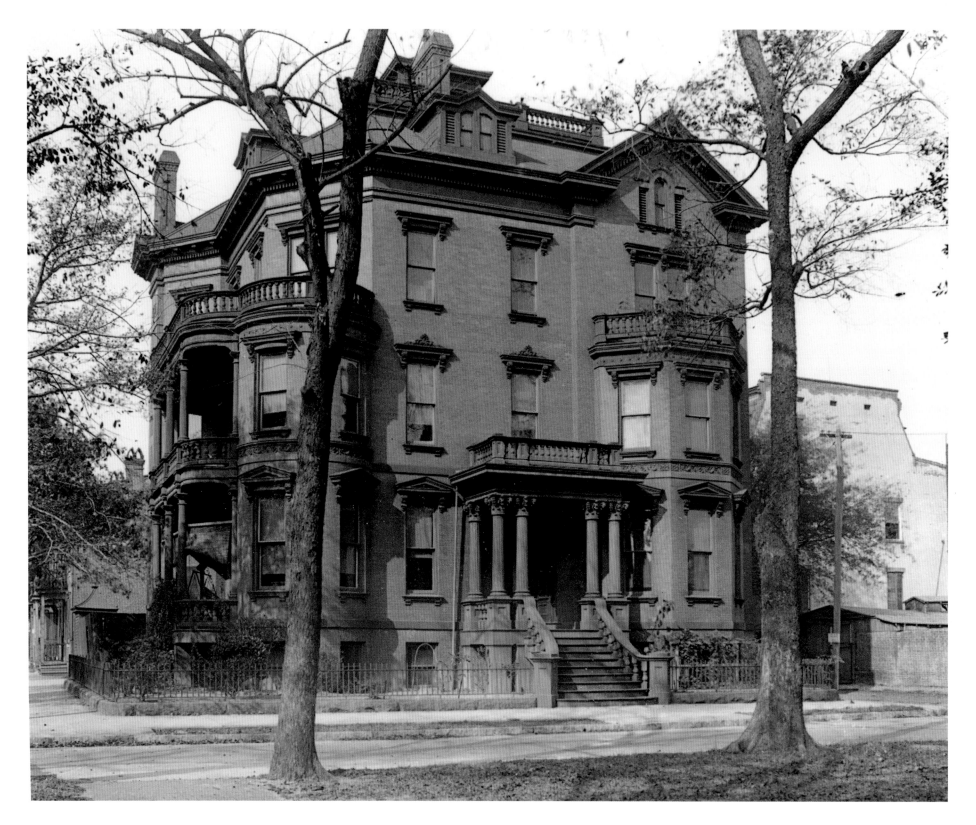

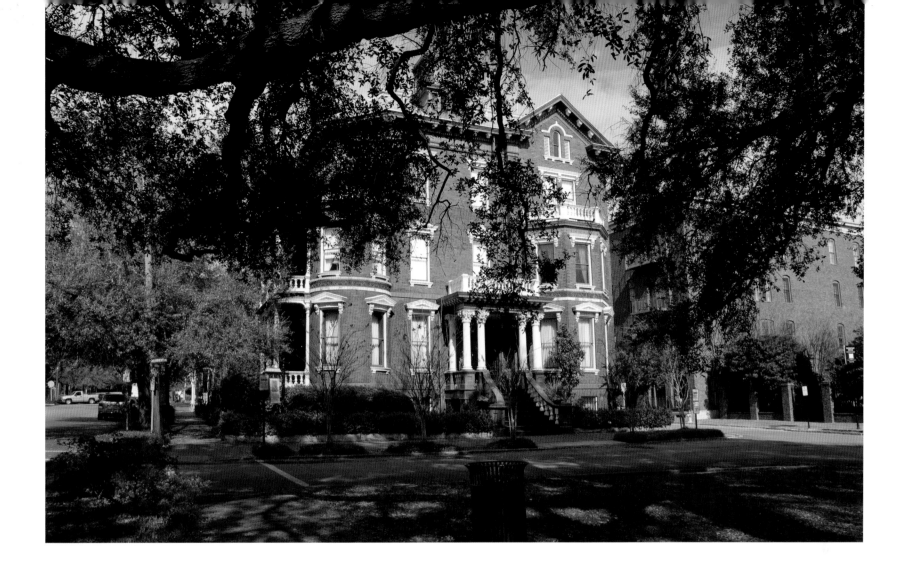

KEHOE HOUSE

William Kehoe's house was a fine advertisement for his iron foundry

Left: A number of ironworks were founded in Savannah in the nineteenth century. William Kehoe worked his way from apprentice to owner of the company that eventually bore his name. During the Victorian period, architectural styles favored elaborate decorative detail. Savannahians were easily convinced that in their semitropical climate, where rot and insects quickly destroyed wood, such embellishment should be made of iron rather than wood. Kehoe earned a fortune accommodating these preferences. His Queen Anne–style four-story masterpiece of brick and iron was built in the 1880s. Almost all the detail on the home was of iron—window adornments, porches, balustrades, piazza floors, railings, and stairs. It served as an effective advertisement for his product. The photo shows the Kehoe House in 1923.

Above: Kehoe's fondness for cupolas (he had one put on his home, his cottage on Tybee Island, and his foundry) might be explained by the fact that he had ten energetic children. He often packed up his rosary, folded his newspaper, and climbed up to the cupola of his mansion for respite. Kehoe's heirs sold the house in 1930. Over the next sixty years, it was a boardinghouse and the Goette Funeral Home. In 1980 it was owned for a short while by football star Joe Namath and a group of investors. In May 2000, it was purchased by HLC Hotels and extensively refurbished. Many well-known celebrities have been guests here, including Tom Hanks, Melanie Griffith, Samantha Brown, and Demi Moore. Guests staying here often comment on the size of the elevators, which reflect the home's past as a funeral home, which required the elevators for moving caskets from floor to floor.

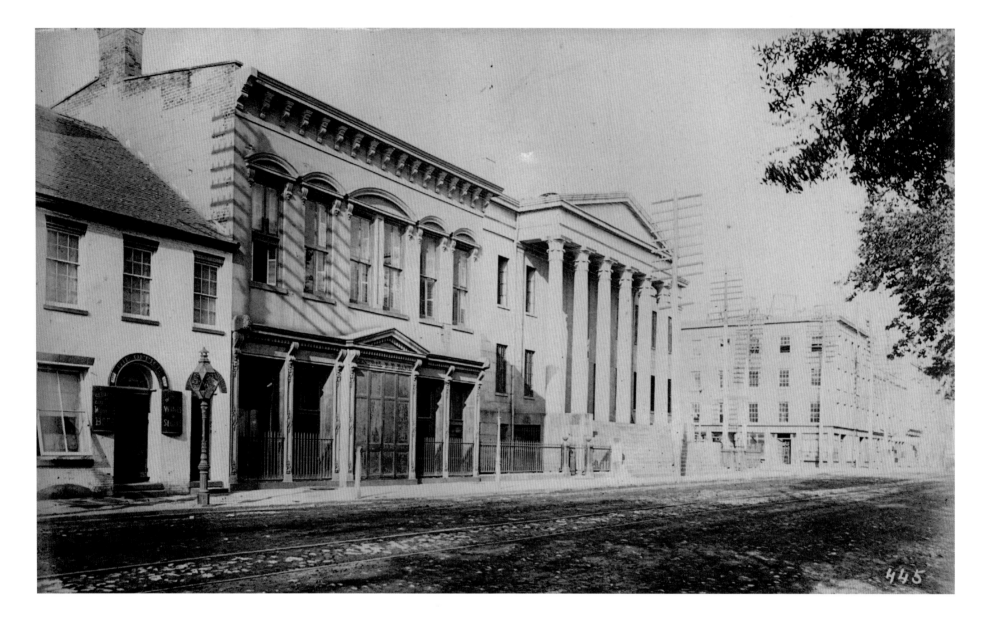

GEORGIA RAILWAY BUILDING

Built in the heyday of the railway boom

Construction of the Central of Georgia Railway began in 1845. The records of the Georgia Historical Society show that this building (just to the left of the Custom House in this photo taken in 1892) was built in 1853 for the railroad's banking and financial business. During the Civil War and the occupation of Savannah by Union troops, the building was commandeered by General William T. Sherman's Union army forces as the military headquarters of the post commandant, General John White Geary. General Geary was a lawyer, politician, and the first mayor of San Francisco. He oversaw the surrender of the city of Savannah and briefly served as the city's military governor. He also distinguished himself in many battles, including those on General Sherman's March to the Sea.

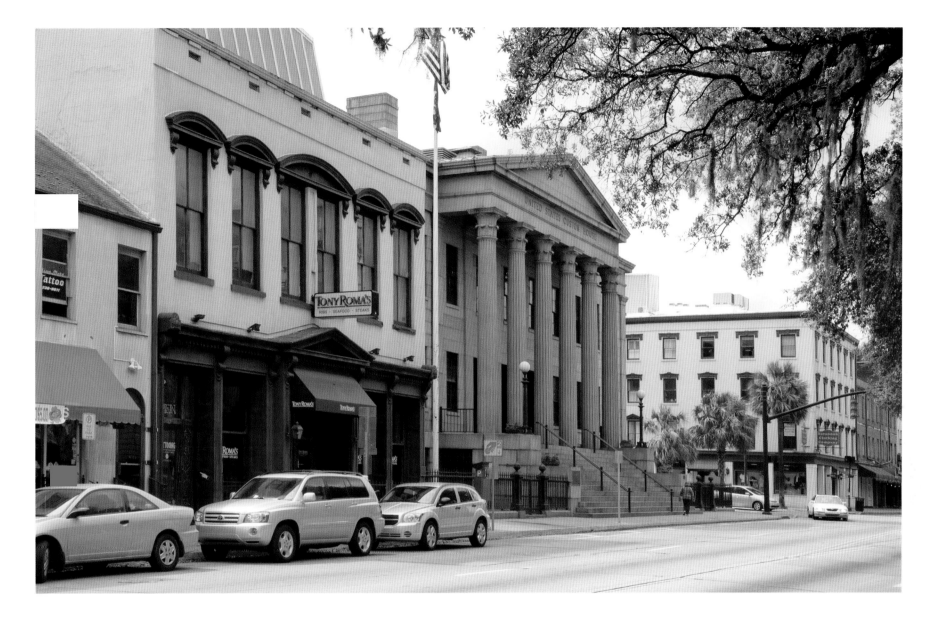

The building that once housed the Central of Georgia Railway's bank has known a number of tenants since the railroad went into receivership and was bought and sold a number of times before 1900. For a good part of the twentieth century, the building served as a tavern and restaurant under various owners and names. The narrow building was purchased by Tony Roma's restaurant chain in the late 1990s. The first floor was kept as it was for the railway offices, with original windows and wooden washboard-style wainscoting skirting the walls. Although the second floor is used for offices today and is not open to the public, the rooms have changed little since they were used for his land-development business in the early decades of the twentieth century by George Mercer.

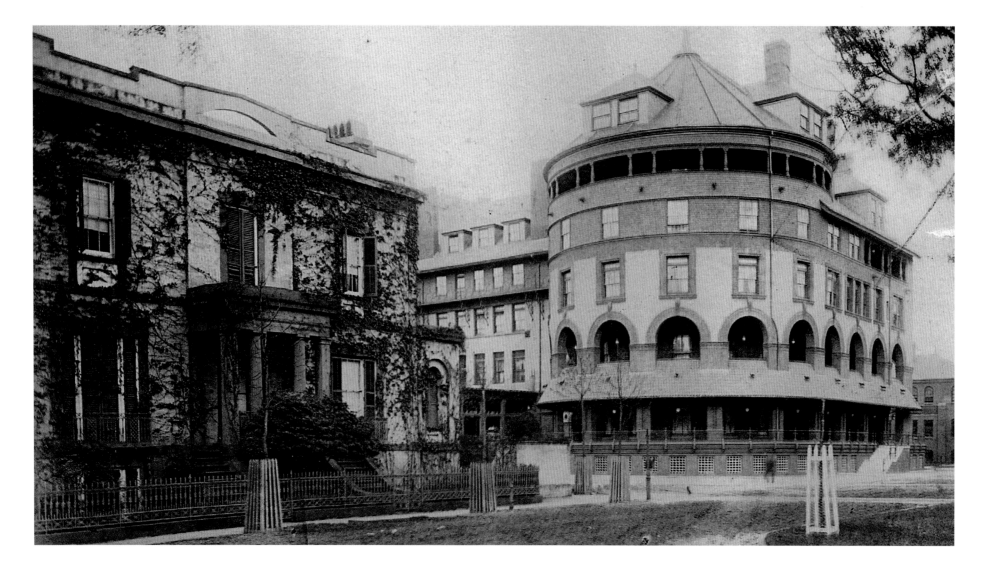

DeSOTO HOTEL / SORREL-WEED HOUSE

One of the classic Savannah buildings that preservationists could not save

The gem of elegant hotels in Savannah, the DeSoto (on the right in this 1892 photograph) was built in 1888 on the ten city lots previously occupied by Confederate barracks, which were demolished after the Civil War. Its circular southwest corner was skirted with graceful wraparound verandas lined with tall rocking chairs. The massive structure surrounded a courtyard—a refuge with an Olympic-size pool, cabanas, palm trees, and a fully landscaped miniature golf course. The Sorrel-Weed House on the left,

a fine example of Savannah's beautiful Regency-style homes, was built in 1841. Gilbert Moxley Sorrel, a Confederate soldier who served under General James Longstreet and reached the rank of brigadier general by the end of the war, was born and raised in the house. His journal of his war years is considered by many to be one of the most revealing of the Confederate mindset. Henry Davis Weed, a merchant in the hardware business on Broughton and Barnard streets, purchased the house in 1859.

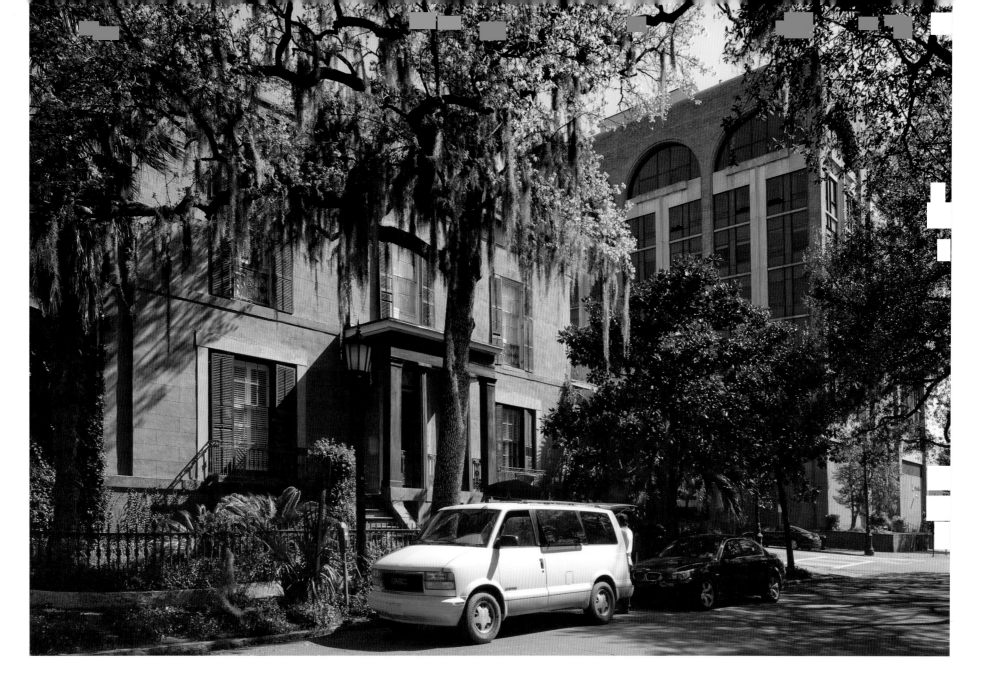

Until the 1960s, the DeSoto Hotel was the site of many of Savannah's major functions and the meeting place of national and international figures, including a succession of presidents. This grand hotel was demolished in the 1960s. A new hotel was built on the same site and called the DeSoto Hilton. The German Heritage Society holds its annual banquet here, and two Rotary Clubs use the facility. The ghost society GhoStock was drawn to Savannah with its reputation of being so richly haunted. Every March the hotel bursts with guests decked out in green for the St. Patrick's Day parade. In the 1950s, the owners of the Sorrel-Weed House operated an adjacent store, an attractive ladies' dress shop called Lady Jane. The Sorrel-Weed House is a private residence today with the reputation of being one of Savannah's famous haunted houses. The orange color of the house, which is known locally as the "Pumpkin House," was analyzed, and it was determined to be the original color.

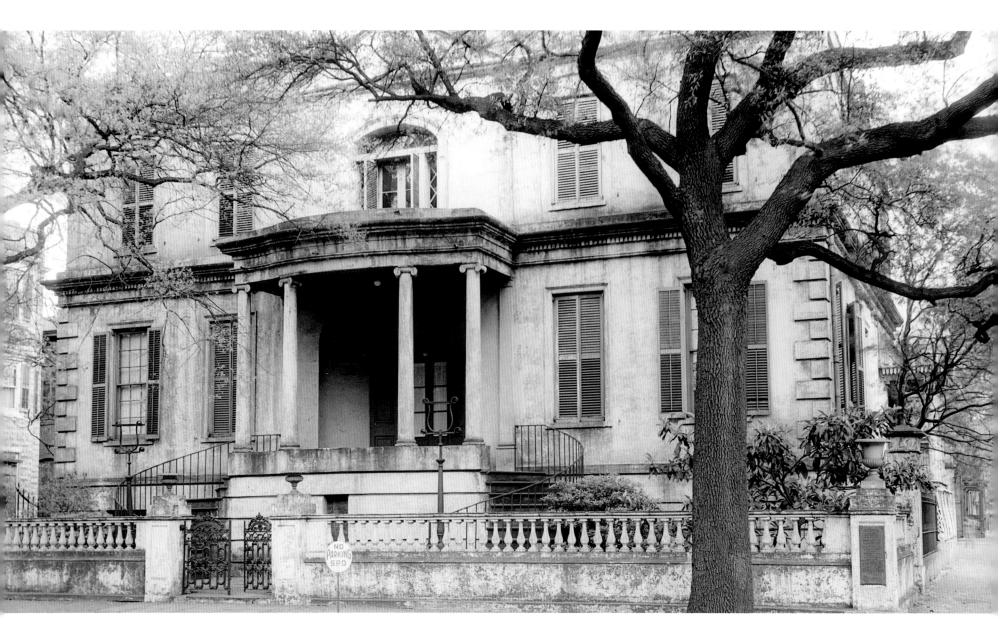

RICHARDSON-OWENS-THOMAS HOUSE

Said to be the finest Regency house in America

The Richardson-Owens-Thomas House, recognized as the finest example of Regency style in America, was the first design of architect William Jay to be built in Savannah. In 1817 cotton broker Richard Richardson brought Jay from England to Savannah to supervise construction of his house, but lost it through bankruptcy. The house bears the name of the second owners, George Owens and his granddaughter Margaret Thomas. The house had unique and dramatic elements, including a gradually ascending, embracing staircase; a cantilevered bridge stairway; a rectangular parlor giving the illusion of a round ceiling; a flat dining room wall that appears to be curved; and a frame of brilliant orange-and-blue stained glass around the doorway in the vestibule.

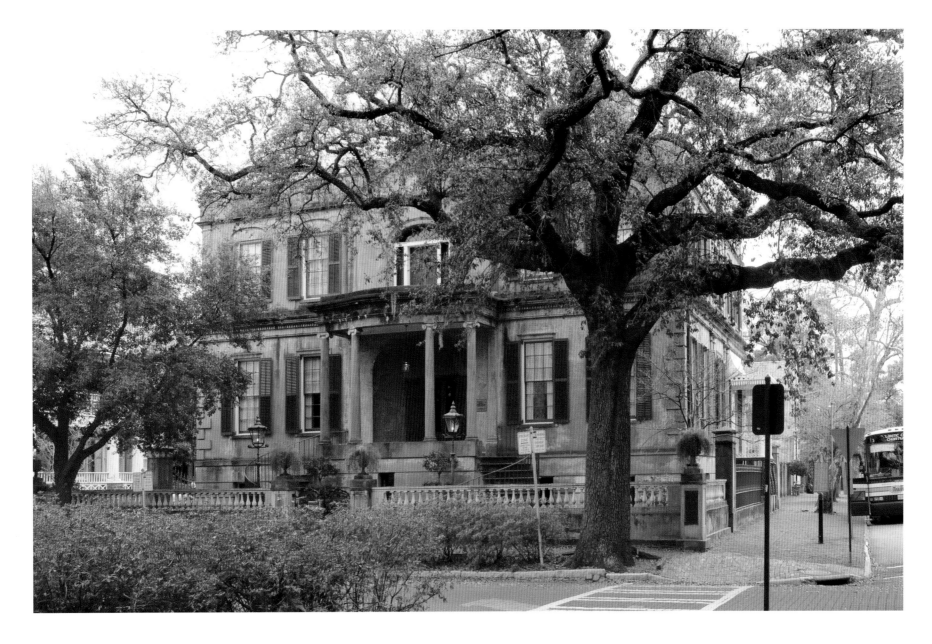

Since the house and the family furnishings were willed to the Telfair Academy of Arts and Sciences by the last of the Thomas family in 1951, the wrecking ball that tore through more than fifteen of Savannah's architectural treasures never had a swing at the Richardson-Owens-Thomas House. Standing proudly on Oglethorpe Square, it is one of the lucky ones that survived into the twenty-first century. The house has become one of Savannah's finest house museums today. The house and kitchen below have period furnishings. The preserved slave quarters still have original furniture and haint blue paint formulated by early occupants. There are many gray areas when it comes to explaining the origin of haint blue. Some cultures held the belief that haints, or haunts, could not cross water. This color resembled water and was painted on doors, sills, windows, and ceilings to jinx spirits from entering a dwelling. On the President Street side is the balcony on which the Marquis de Lafayette stood while addressing a crowd in 1825. The occasion was the dedication of the Nathanael Greene monument in Johnson Square.

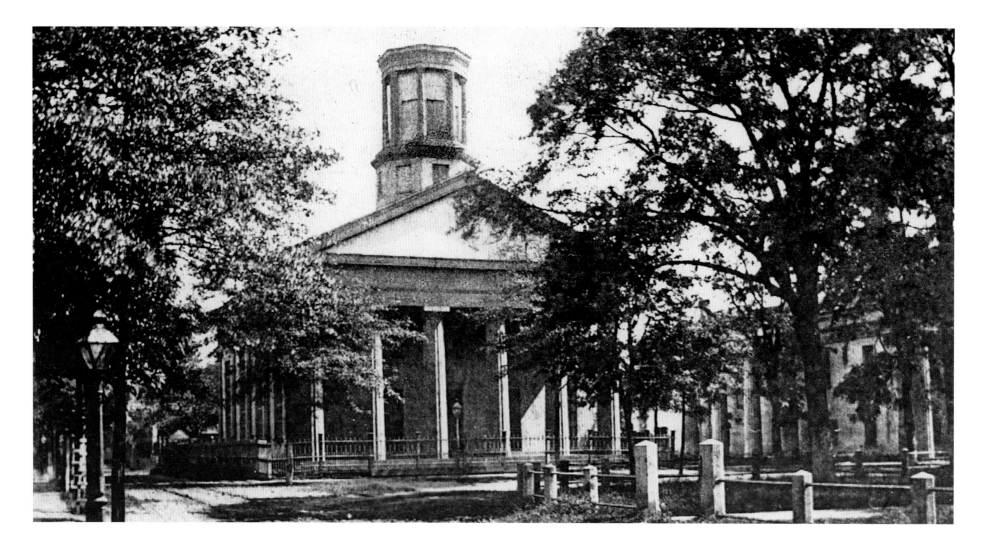

LUTHERAN CHURCH OF THE ASCENSION

The old church building was rolled onto the site using the trunks of pine trees

Above: When Austrian Salzburgers arrived in Georgia in 1734, they built the first church in Ebenezer, where they settled, upriver from Savannah. Its brick replacement, completed in 1770, remains the oldest church building in the state. One of the first structures to serve as the Salzburgers' Lutheran Church in Savannah (on Wright Square) was moved on rollers (pine tree trunks) from the neighboring trust lot. This structure had been the redundant courthouse, which was no longer large enough to serve the growing community. The pew cushions of the 1844 Greek-style Lutheran Church on Wright Square were used as beds by General William T. Sherman's Union troops during the occupation in 1864, and some pews were used for firewood.

Right: A renovation in 1875 resulted in the current Gothic appearance of the church, which became the Lutheran Church of the Ascension in 1878. That was the same year its stained-glass window depicting the ascension of Jesus was installed. When the sanctuary on Wright Square is open, it is a memorable experience to take refuge from the noise and summer heat of the Historic District and enter this haven of peace and tranquility, accented by lovely old stained glass.

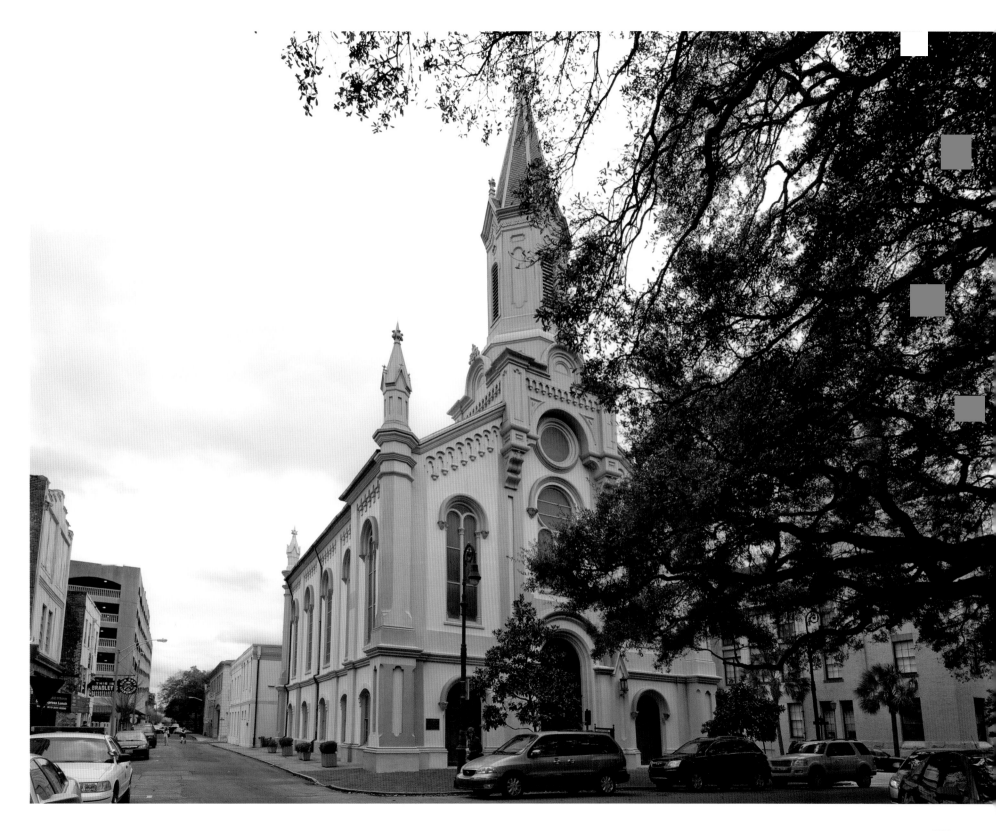

AVON HALL

The original house may be gone, but music is still being made at Avon Hall

Left: The first known owner of the house that overlooked the Vernon River in the village of Vernonburg was Reverend Benjamin Burroughs, who started a school for boys in his home. When William Neyle Habersham and his wife Josephine bought the red-tin-roofed house in 1854, her love of music and Shakespeare was the inspiration for naming their new summer home Avon Hall. William Habersham was head of the family cotton and rice business, founded by his great-grandfather, James Habersham, in 1737. Habersham made a number of changes to the house in 1870, including adding a widow's walk on the roof. In 1970 a fire destroyed the home, right from the widow's walk to the handsome, fourteen-inch-wide floorboards in the entrance hall.

Above: Avon Hall has remained in the family and today is owned by the Habershams' great-great-granddaughter. The present house was built in 2000 on the footprint of the original plantation-style home. With design suggestions from the owner, the smaller home was built to include a number of architectural elements reminiscent of the original family house. Two Southern magnolias that grew by the old homestead and a live oak well over 100 years old that shaded the home from the back are still thriving. In keeping with the spirits of the music-loving Habershams, the owner, a longtime member of the "Crabettes," a local group of musicians, is seen with them in the photograph practicing on the porch of the present-day Avon Hall.

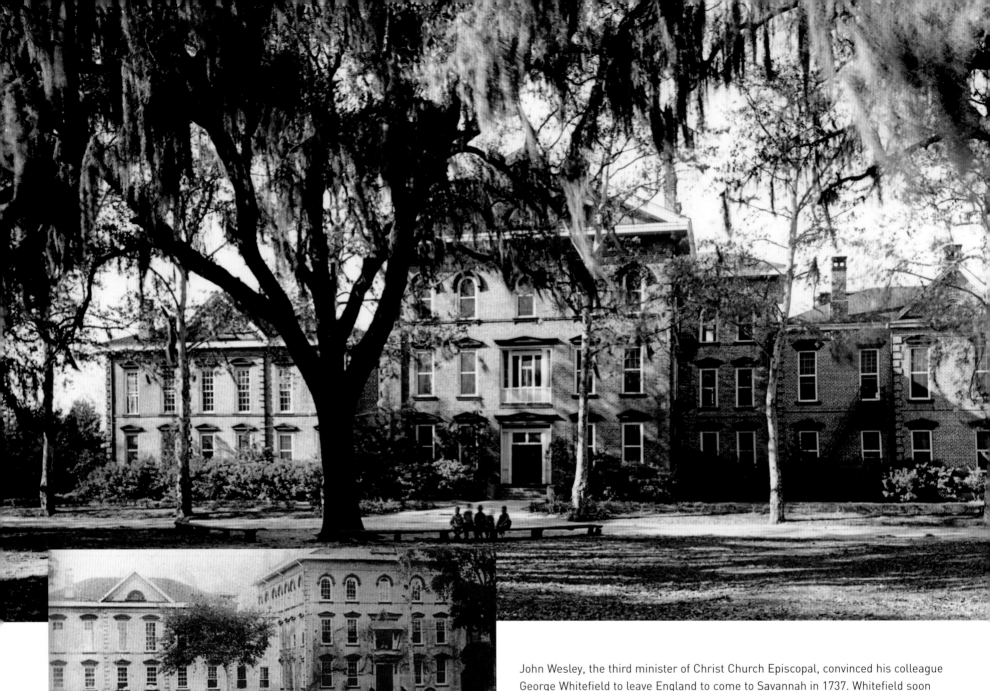

BETHESDA HOME FOR BOYS

The first orphanage in America was started on the banks of the Moon River

John Wesley, the third minister of Christ Church Episcopal, convinced his colleague George Whitefield to leave England to come to Savannah in 1737. Whitefield soon replaced Wesley as spiritual leader of the church. With his friend James Habersham, Whitefield started the first orphanage in America in 1740, on the banks of the Moon River. They gave it the name Bethesda, meaning "house of mercy." Reverend Whitefield's persuasive sermons, delivered up and down the East Coast and across the Atlantic, brought the support of such luminaries as Lady Huntingdon and Benjamin Franklin, who eventually became a trustee of Bethesda. The original building was struck by lightning and destroyed by fire in 1770, the year Reverend Whitefield died. Within brick buildings that replaced it on the same campus, Bethesda maintained its charge to meet the needs for family, education, and faith.

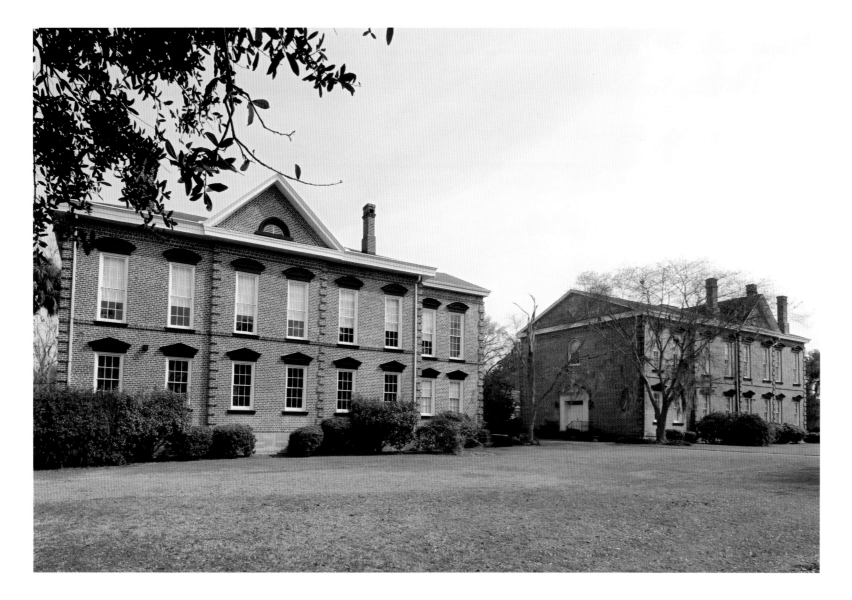

Many Bethesda alumni return with their fiancées to be married in the Whitefield Chapel, given by the Colonial Dames in the state of Georgia. The outdoor theater was funded by the Trustees' Garden Club. A new Christian-oriented school was opened on the property recently, which accepts commuters as well as boys living on campus. The traditional school program is offered, leading to a high school diploma and higher-education opportunities. All students participate in events to raise money for improving the campus. Antique car shows and art fairs are a few of the activities at Bethesda. This image shows the buildings that house the library and administrative offices.

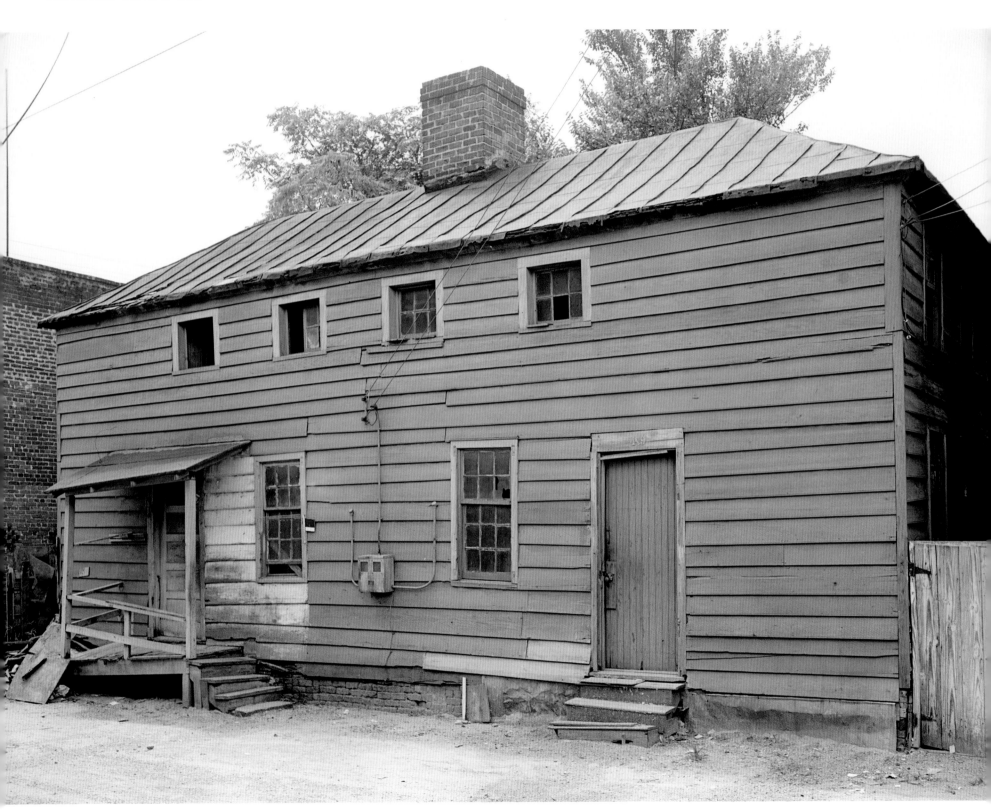

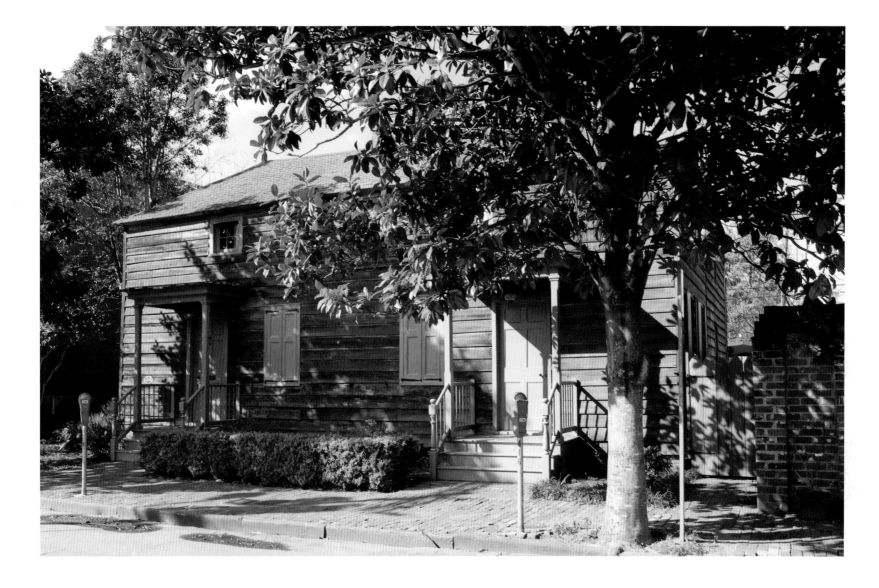

TIMOTHY BONTICOU HOUSE

A small gem on a road less traveled in the Historic District

Left: The Timothy Bonticou House was a duplex cottage of a style commonly built for the working-class in the late eighteenth and early nineteenth centuries. Constructed on a narrow lot, it was one room deep, with additional rooms directly attached, avoiding the wasted space of halls. With a rough, unpainted clapboard exterior, it was the most basic living accommodation of its time. Records indicate that around 1800, the Barie family, descendants of refugees from the French Revolution, lived in the house. As built, the home originally faced the East Broughton Street lane and accommodated two families.

Above: After owners moved the Bonticou House on its lot in 1971 for renovation, it took an East State Street address. A small house on Greene Square owned by an African American woman named Laura, was moved to State Street beside and slightly behind the Bonticou House. Together the two houses are one of Savannah's little secrets tucked away on a road less traveled in the Historic District. Laura's House is today a tiny inn.

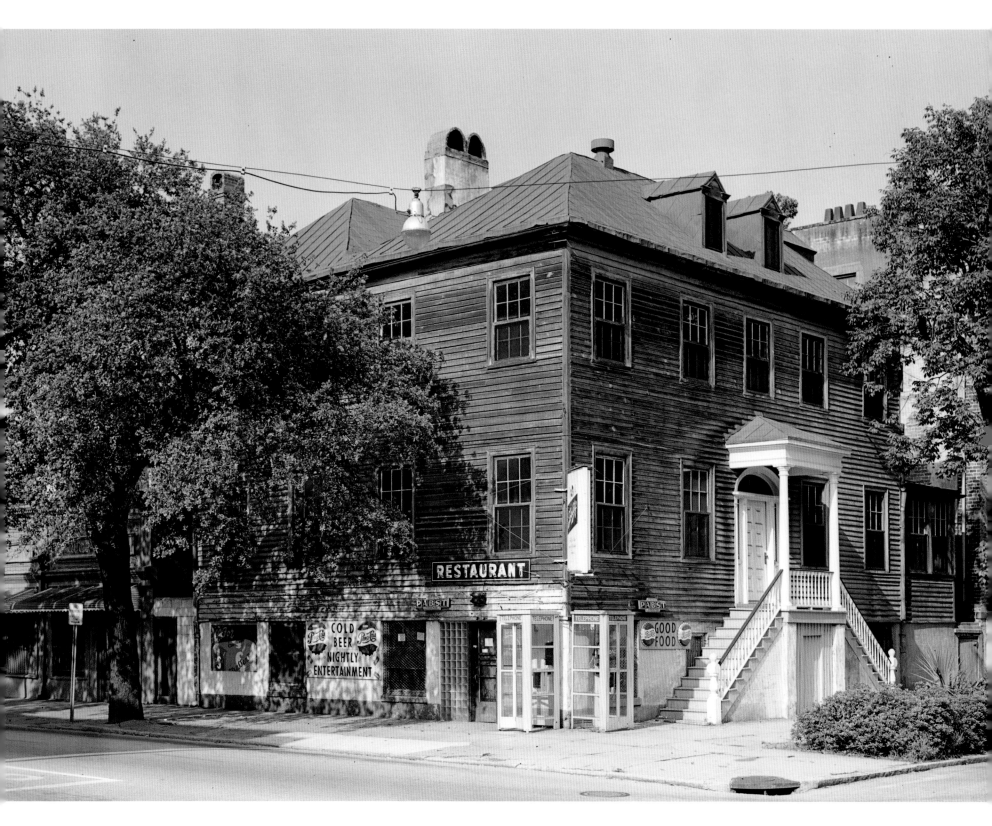

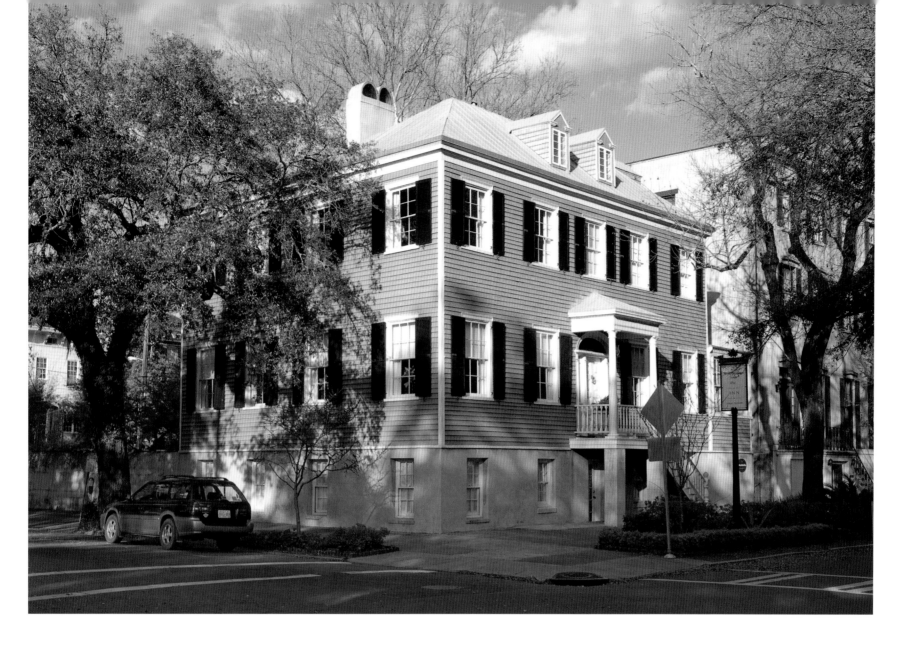

STEPHEN B. WILLIAMS HOUSE

The largest Federal-style wooden house to avoid the wrecking ball

Left: The Stephen B. Williams House, built in 1834 entirely of Georgia longleaf heart pine, was first occupied by William Thorne Williams, six-term mayor of Savannah. A leading merchant and postmaster of the Confederacy, Solomon Cohen bought the house in the 1850s. It remained in the family as the home of his daughter and her husband. The decorative Victorian style in vogue in the 1870s prompted the family to replace the original floors of the home with narrower pine boards. The building was sold in the 1930s and began a decline into disrepair, becoming a boardinghouse and then a tenement. This photograph is from 1966.

Above: Thought to be the largest Federal-style wooden house to avoid the wrecking ball in the Historic District, the Stephen B. Williams House has survived devastating fires and hurricanes, urban decay, and tenant abuse through the years. Dr. Albert Wall, to whom the house was sold in 2001, put nearly half a million dollars into a thorough restoration effort, giving attention to every minute detail. His goal was to return the house as closely as possible to its original plan and style. Today it serves as an inn, with antiques from around the world and a Steinway grand piano in the parlor.

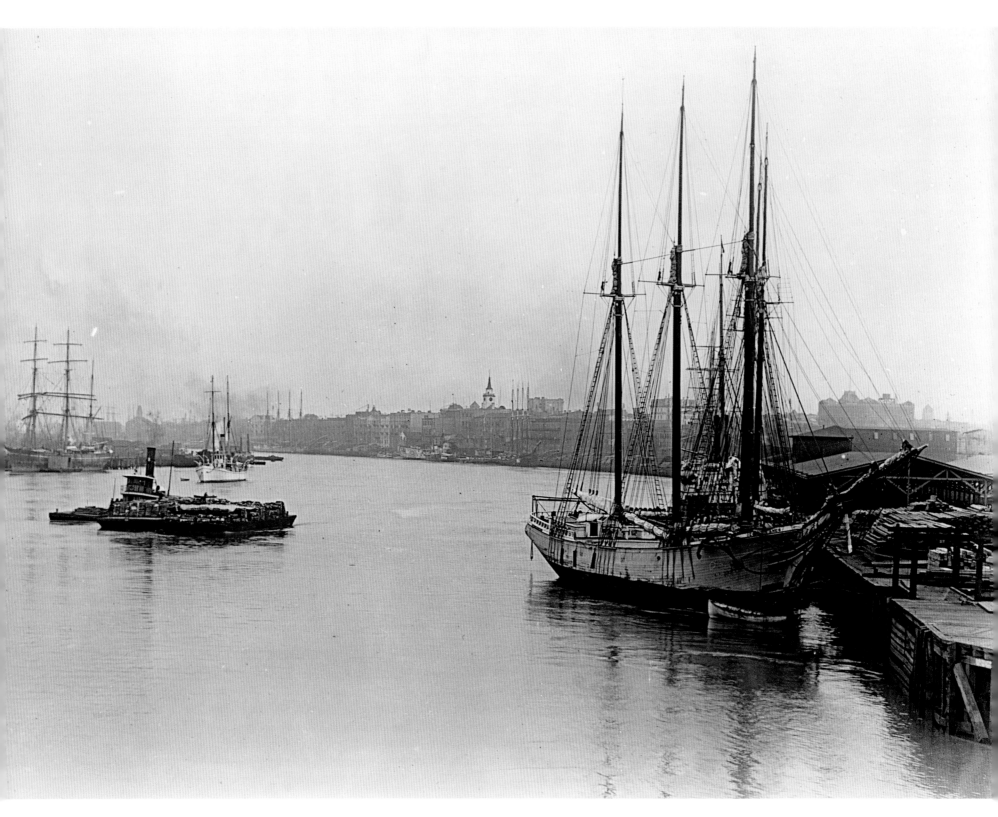

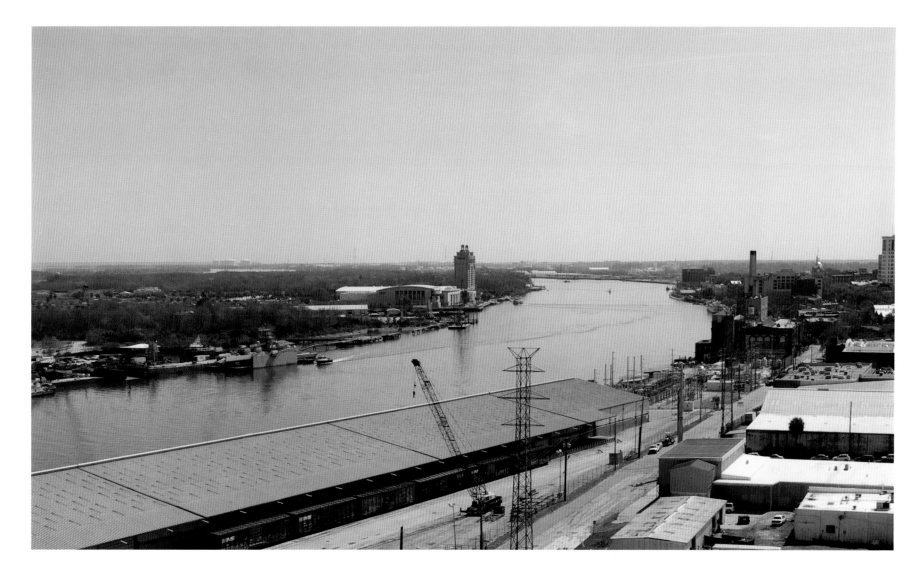

SAVANNAH WHARF

Trade has not diminished on the Savannah River, but it has moved upriver

Left: The Savannah River was the lifeline to the world for the fledgling settlement of Savannah. It was the outlet to the Atlantic Ocean seventeen miles to the east, the avenue along which the first forts were built, and the trade route to England. Within a year of the English landing in 1733, settlers came up the Savannah River from Portugal then Austria. Subsequently, the river served as the road to a new life for immigrants from all over the world. Within twenty years of the founding of the colony, Georgia's ban on the importation of slaves—unique among the thirteen colonies—was lifted and the Savannah River became the last leg of the disorienting, frightening trip from Africa for thousands of slaves.

Above: Although Savannah has recently taken the position of third-most productive port in the United States, the river still surprises visitors, who can see massive container ships from all parts of the globe slowly slide by in the deep channel en route to the Georgia Port Authority's terminals upriver. Yachts, sailboats, and dinghies are docked all along Rousakis Plaza while passengers stretch their legs and enjoy the park and the art, food, and festival atmosphere that have replaced cotton in the old stone-and-brick warehouses that line the narrow cobblestone street along the base of the bluff. Paddleboats, ferries, and cruise ships tie up at city docks to gather passengers for a relaxing trip down the river or a quick commute to Hutchinson Island.

ROGERS' GROCERY

An archetypal corner store that couldn't stem the tide of progress

A midtown neighborhood of Savannah grew with the extension of streetcar lines in 1888. It was a heterogeneous community—a working-class suburb of residential, commercial, and community buildings. In the Thomas Square District, examples of diverse architectural styles could be found. The cluster of neighborhood businesses on Bull Street, in the center of the area, was called Starland; the Starland Dairy at the core of this busy little center. Of the same Art Deco style at the north end of the block was Rogers' Grocery, which served the neighborhood around the little hub. During the Great Depression, the working-class neighborhood of primarily wooden homes suffered the pains of poverty and neglect. The area became a slum in the late twentieth century. Crime rates were high, and homes and stores were vacated and boarded up. The little grocery store on the corner didn't survive.

Where Rogers' once was, on the 2400 block of Bull Street, between Bull and Whitaker streets, is the Back in the Day Bakery, an artisan bakery that makes small batches of cupcakes all day. Loft apartments with glass walls designed by Savannah College of Art and Design alumni John Deaderick and Greg Jacobs, along with several nice art galleries with working artists and curio shops, add interest. A Saturday morning market once held here, where farmers and craftsmen sold their wares, is now in Forsyth Park. Shoppers buy fresh melons, squash, tomatoes, sunflowers, honey, dog treats, crepes, and more. The market is supported by SCAD, the Coastal Organic Group, and Georgia Organics.

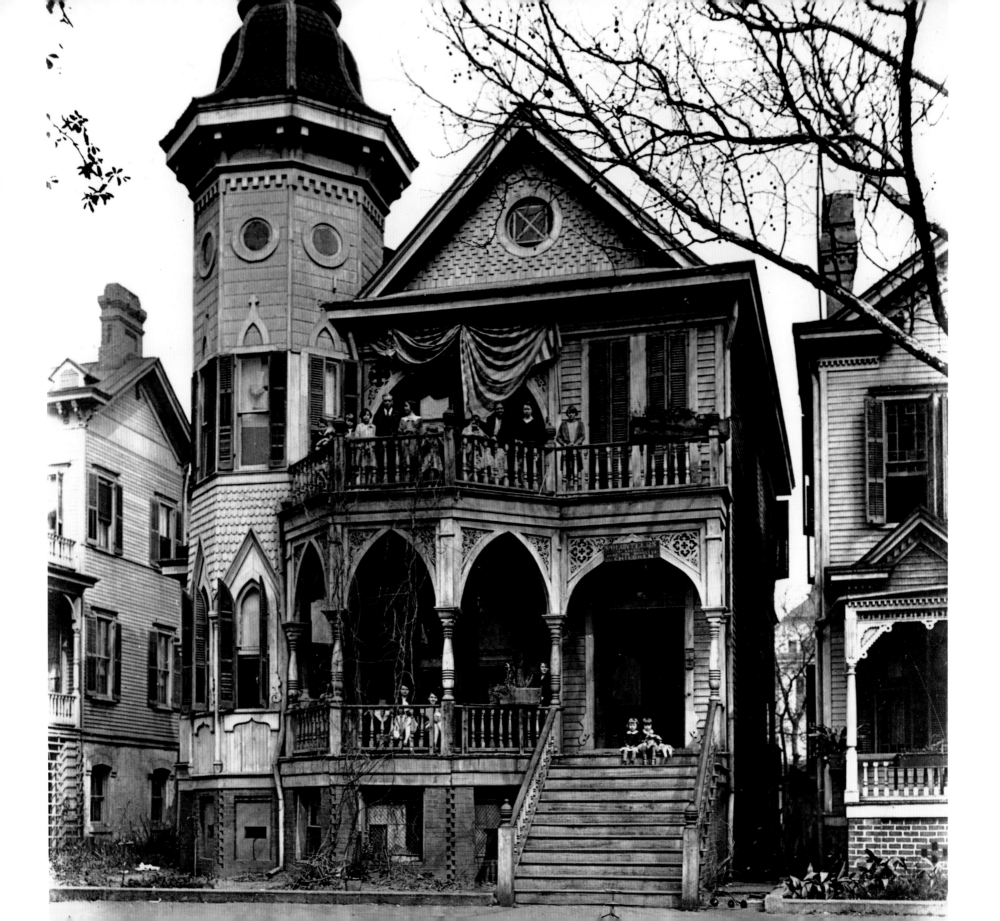

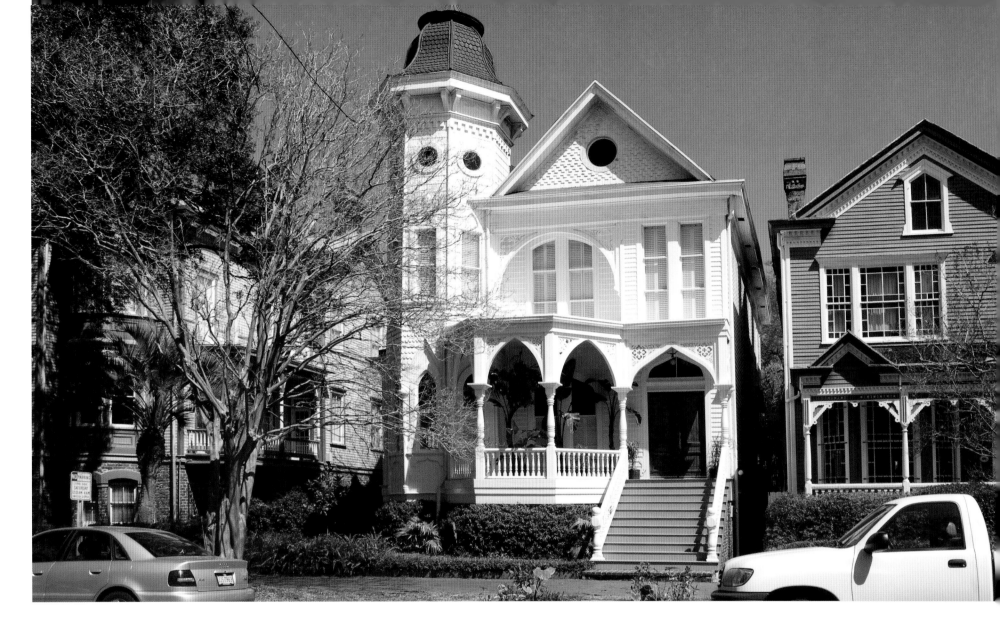

408 EAST GASTON STREET

Boasting an eclectic mix of arch styles

Left: As Savannah grew during the late nineteenth century, development moved to the south, to Gaston Street and beyond. Houses became more eclectic in their design, with new architectural styles reflected in the elaborate curves, arches, turrets, and wide front porches—embellished with the fancy detail of gingerbread. This part of town, surrounding Forsyth Park and spreading beyond, is known as the Victorian District. The Tom Crites home, built in 1892 at 408 East Gaston Street, is a blend of elements from the Queen Anne and Gothic Revival styles. The house has four different types of arches—lancet, Tudor, rounded, and arrow point, in addition to the reverse-ogee arches and candle-snuffer peaked crown.

Above: After a fire destroyed several blocks in this neighborhood, the house was rebuilt. Gaston Street is the northern border of the Victorian District. Many spectacular homes south of Gaston Street can be seen; some are pristine, but others are waiting for someone to roll up his or her sleeves and get to work. The present owner of 408 East Gaston Street has spent several years restoring the property, which is recognizable from the archival image, except for one major difference—the absence of a railing along the upstairs balcony. The house has six bedrooms, six fireplaces, four kitchens, and a colorful interior.

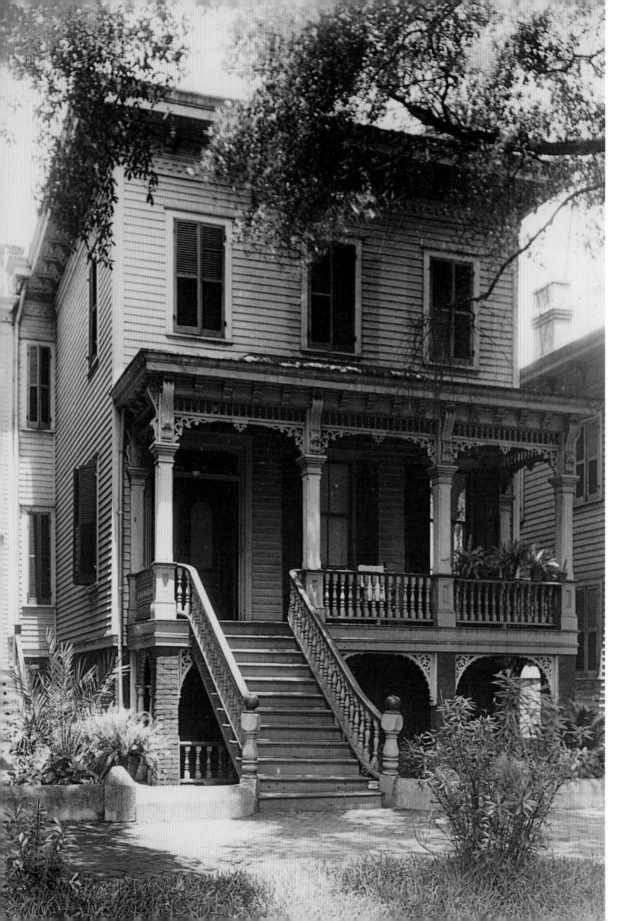

CATHERINE WARD HOUSE

A Victorian house with every convenience

Following the Civil War and Reconstruction period, large numbers of Irish immigrated to Savannah seeking opportunities that the New South would offer. Captain James Ward came hoping to capitalize on the potential labor force his countrymen could provide. He and his wife Catherine were prominent in the Irish community in Savannah, and active members of the new grand Cathedral of St. John the Baptist. He stood as a standard-bearer in Savannah's chapter of the historic Irish Hibernian Society. The Italianate carpenter design of the home James Ward built for his wife is a unique union of traditional Savannah architecture with the modern conveniences of the Victorian age—gas for cooking and lighting, as well as indoor plumbing. After Captain Ward's death in 1891, Catherine continued to live in the house. She took in two boarders to occupy her home during her frequent visits to her second home in New York City. The photo was taken in 1953.

The Trapani family lived here until 1965, having purchased it from Michael Gainey, who owned the Cosmopolitan Hotel. In 1983 the Historic Savannah Foundation bought the Catherine Ward House and sold it to Alan Williams, who converted it into an inn. Its new owners updated it once again. This inn is on Waldburg Street in Savannah's Victorian District. The Victorian District is a residential area of 162 acres sectioned into sixty blocks. It extends from Gwinnett Street on the north to Anderson Street on the south, and from Martin Luther King Boulevard on the west to East Broad Street on the east. Most of the large wood-frame houses were built between 1870 and 1910. Many streets are bricked and shaded with large magnolias, sycamores, and oaks. Guests take pleasure in wandering through the neighborhood, admiring the intricate "gingerbread" wooden patterns adorning these large frame buildings. Just a few hundred yards away is Forsyth Park.

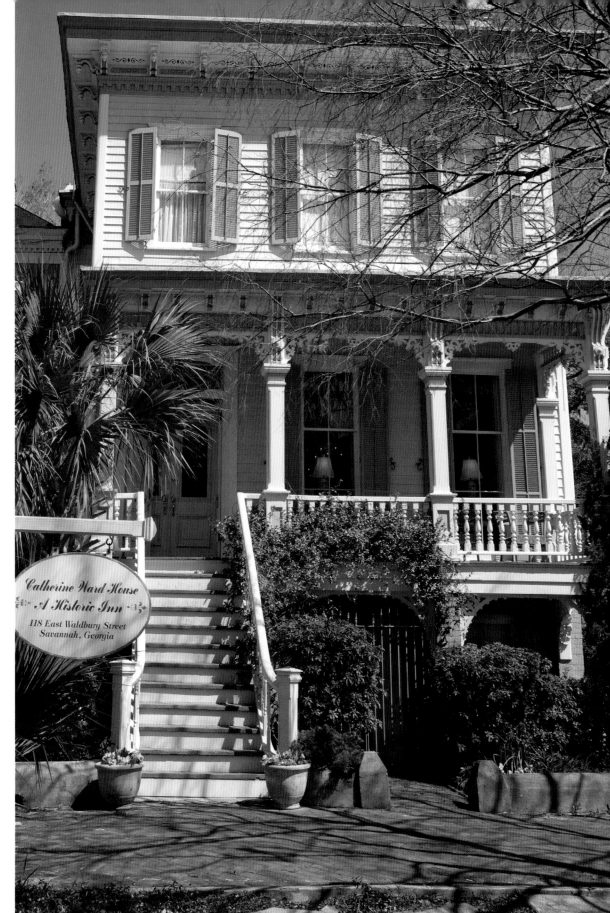

Catherine Ward House
A Historic Inn
118 East Waldburg Street
Savannah, Georgia

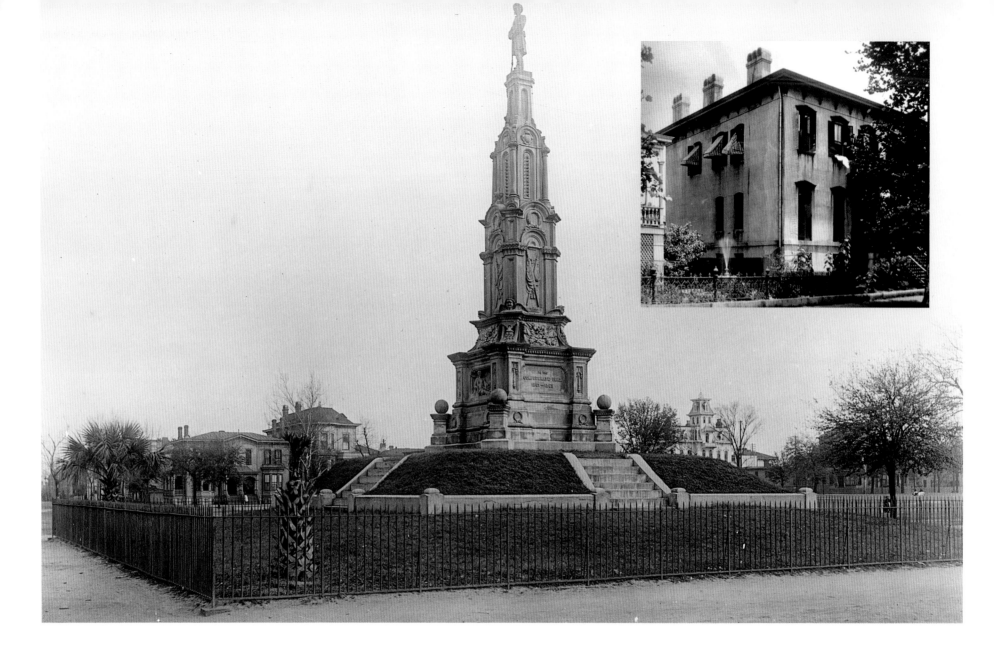

CONFEDERATE MONUMENT

The centerpiece of a moving annual remembrance ceremony

This monument in Forsyth Park commemorates the soldiers who fought and gave their lives for the lost cause of the Confederate States. Completed in 1878, the bronze soldier in Confederate uniform faces north, following the tradition of military statues facing their enemy. Based on his gallantry and devotion to the cause of the South, Major Albert S. Bacon was chosen in 1878 to be the real-life model for the monument. Albert Bacon began his service in the Civil War in 1861 at just seventeen years of age, as a private in the Oglethorpe Light Infantry. In 1881, the home at 314 E. Huntington Street was constructed for Major Bacon (see inset) with building materials from his own lumberyard, Bacon & Brooks, located on Liberty and East Broad Streets. A raised relief carving depicting a grieving widow sitting under a weeping willow tree, surrounded by four winged angels, adorns the sandstone base. Savannah Ladies Memorial Association collected $10,000 in donations over six years for the memorial. The script carved on the base reads: "Come from the four winds, O breath, and breathe upon these slain, that thee may live."

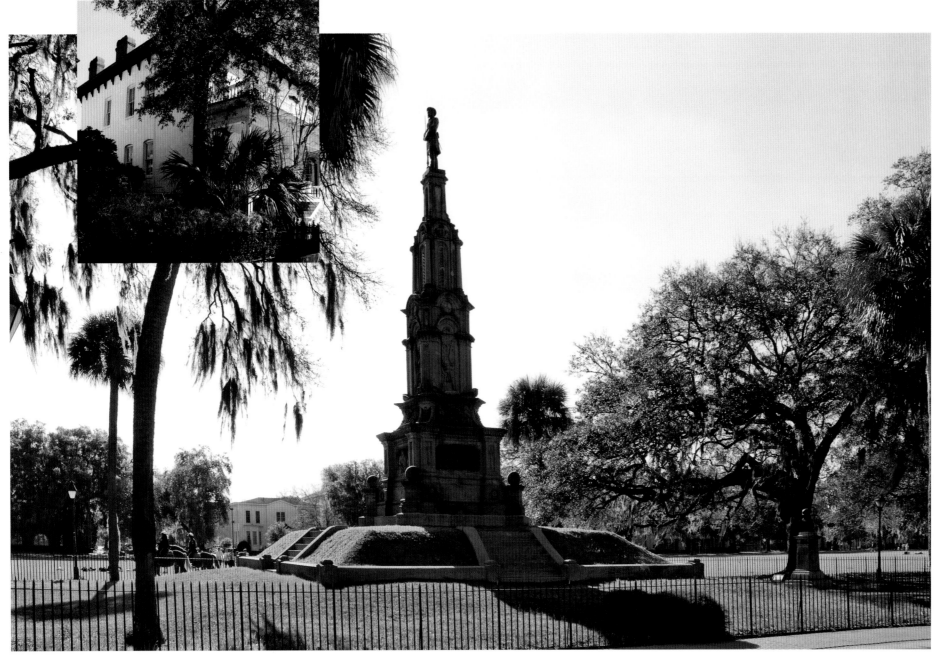

An observance beginning in 1866, when women decorated graves of men who died in the Confederate Army, continues today. Held on the Sunday nearest April 26th, when General Joseph Johnson surrendered the last Confederate army in Greensboro, North Carolina, it is a moving experience. Ladies in black Victorian dress and veils covering their faces, silently place flowers on the base of the monument. Speeches honor our forefathers who fought valiantly. A rag-tag unit of re-enactors fires rifles and cannon. Fife and drums play with a follow-up ceremony in Laurel Grove Cemetery among graves of more soldiers killed in the war. The inset photograph shows Major Bacon's home as it looks today, in which many original details remain. It is among the few homes left in Savannah, built for and owned by a former Confederate officer of the Civil War.

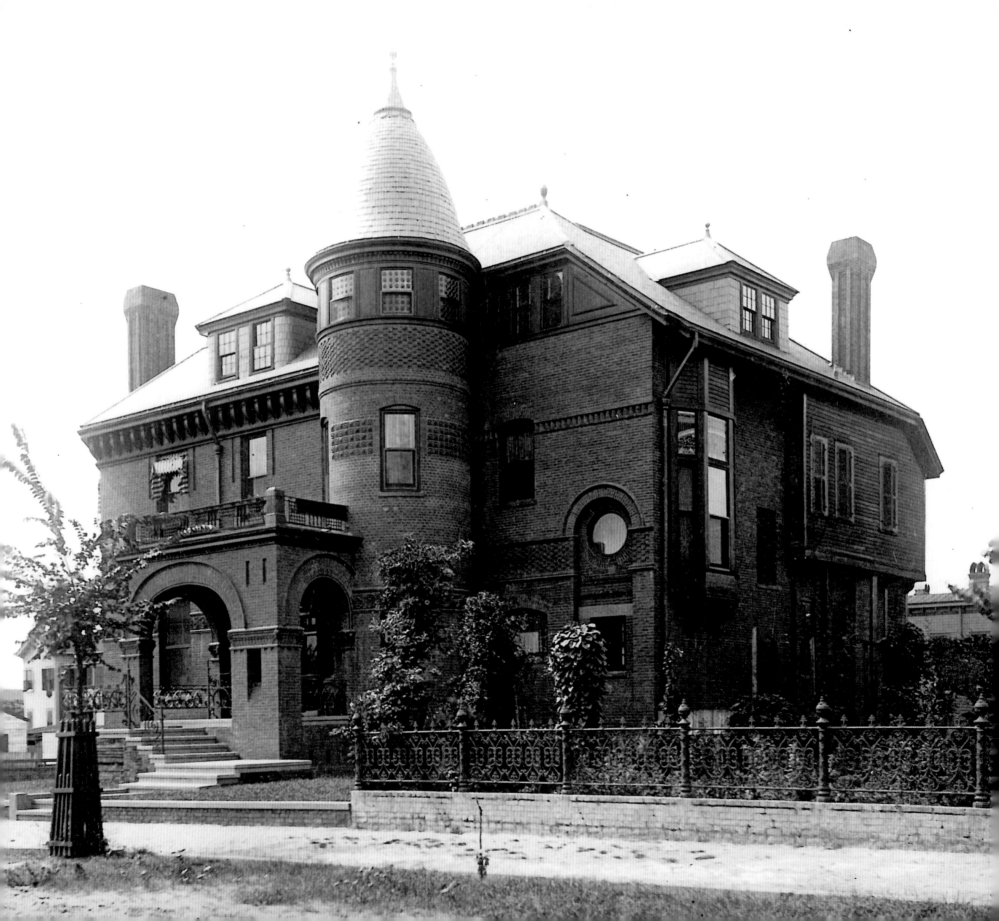

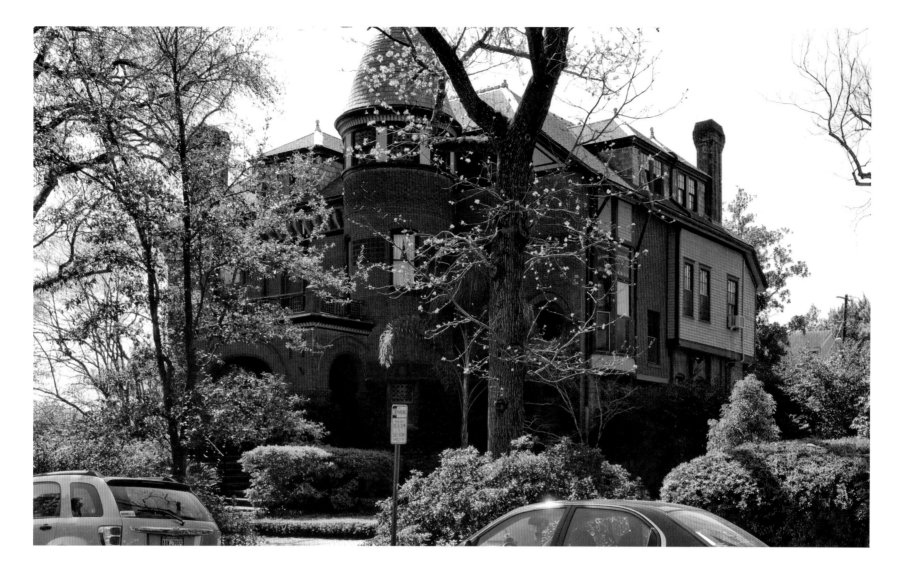

BALDWIN HOUSE

An innovative house commissioned by one of Savannah's business pioneers

Left: George Baldwin was born and raised in Savannah. After earning an engineering degree at the Massachusetts Institute of Technology, he returned home in 1879 to join the firm of Baldwin and Company, which dealt in fertilizers, cotton, and naval supply stores. He married Lucy Hull of Atlanta and soon began planning a home on Hall Street with architect William Gibbons Preston. In the 1890s Baldwin was the organizer and first president of the Savannah Electric Company, and later designed the electric rail systems for Savannah and other southern cities. In 1889 when the Baldwins moved into their completed home, they hosted a traditional Savannah housewarming gala with 350 guests, complete with food catered from New York. This photo dates to circa 1900.

Above: The original 1888 radiators still bring heat in winter and the original pipes still provide water. It can be said with certainty that George Baldwin and William Preston's careful planning and attention to detail have stood the rigorous test of time. The style of the house is a mix of Richardson Romanesque and Queen Anne Revival. Hall Street, with its magnolias, wisteria, oaks, and azaleas, is a charming wide street surfaced with red bricks. The fifth and present owner, Alvin Wilkins Neely Jr., bought the house in 1973 and brought in furnishings from his own ancestors.

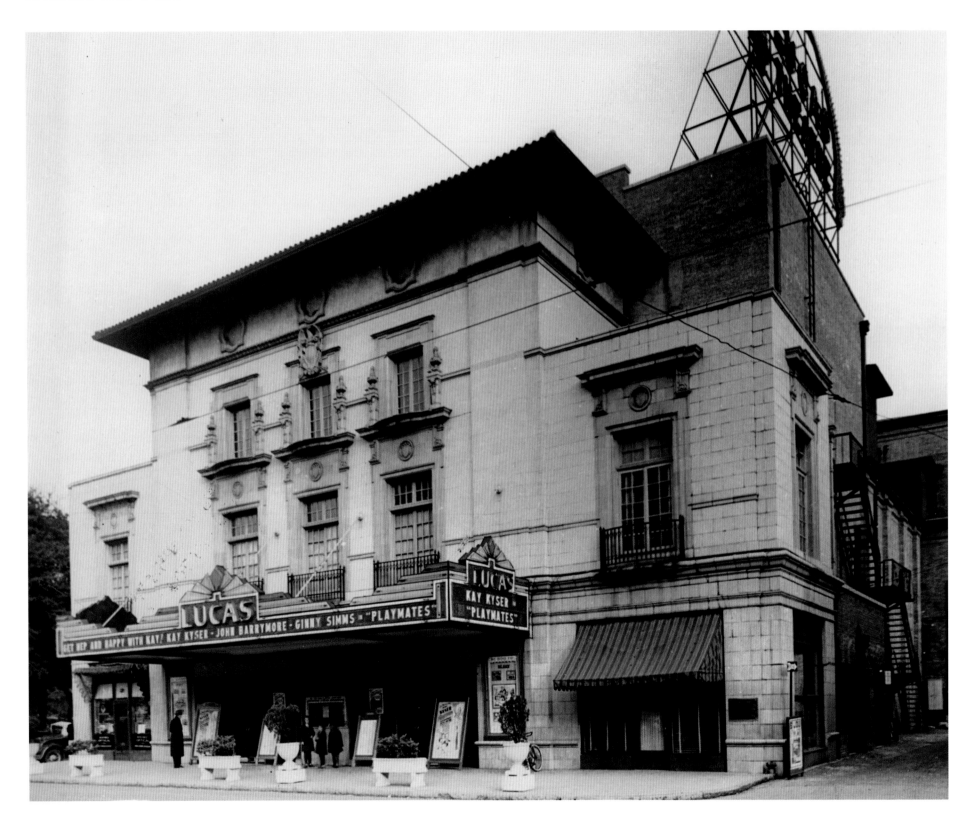

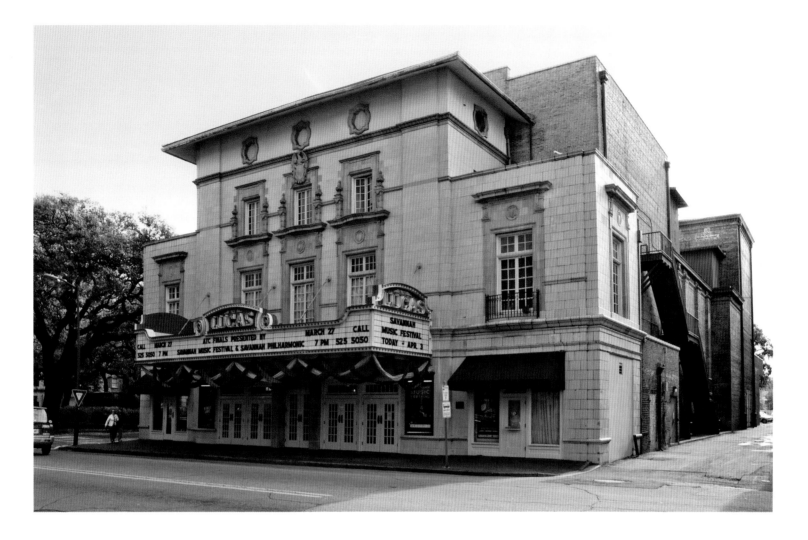

LUCAS THEATRE

Enjoying a new lease of life with the Savannah College of Art and Design

Left: Arthur Lucas sent birthday cards with coupons for free admission to his movie palace in 1921, the year the Lucas Theatre opened. He scoured the newspaper for wedding and birth announcements so he could offer his own form of congratulations—tickets. Lucas's favorite details—Greek Revival, Art Deco, neoclassical—were combined in the building's design, and he was the first in Savannah to add air-conditioning in 1923. This was reason enough to buy tickets during Savannah's sultry summers. For the next forty years Savannahians flocked to movies, vaudeville acts, plays, and musicals. But by the 1960s, people had moved to the suburbs and the islands nearby. Television became the screen of choice. When the Lucas Theatre closed its doors in 1976, it seemed fitting that the last film shown was *The Exorcist*, and it played to an empty house.

Above: Several attempts to convert the space to an alternative use failed. It was a dinner theater for a while, and also a comedy club. The all-too-familiar wrecking ball loomed. In 1986 a group of caring citizens pooled their resources, bought the building, and created the Lucas Theatre for the Arts. After a fourteen-year campaign and a $14 million restoration, the future was bright. Supported by Savannahians and celebrities such as Kevin Spacey, and the cast and crew of *Forrest Gump*, the Lucas had a grand opening in 2000. The future of this opulent movie palace is assured because of its relation today with the Savannah College of Art and Design. The college carries overhead expenses and uses it for events such as the Savannah Film Festival. The Lucas presents opera tours from London and Italy, European orchestras, country music stars, traveling repertory companies, and films.

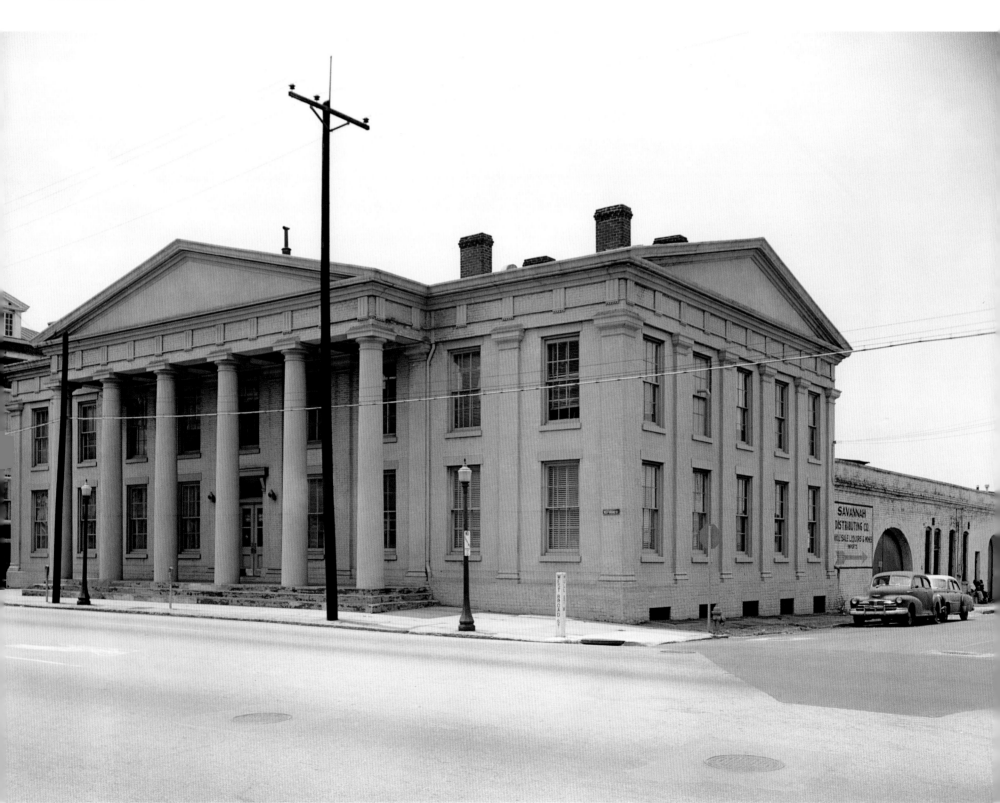

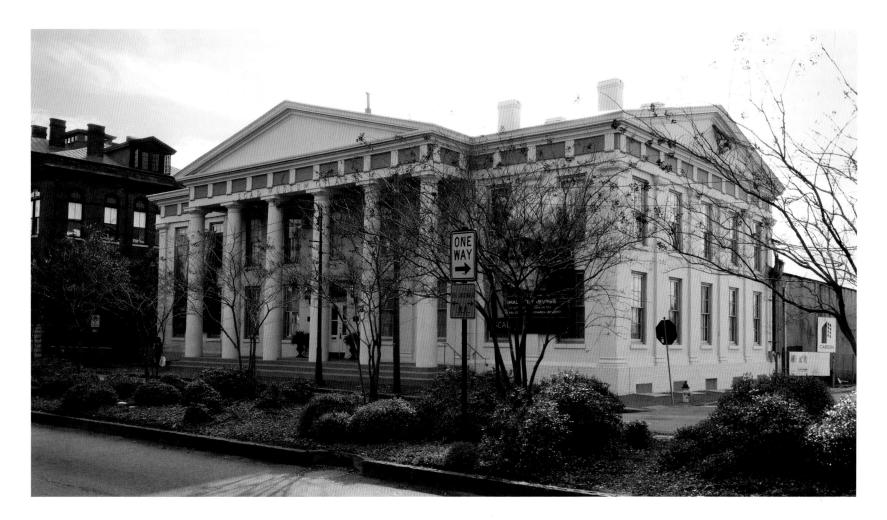

CENTRAL OF GEORGIA RAILWAY BUILDING

The elegant railroad station now houses architecture and design classes

Left: Former president Millard Fillmore was welcomed to Savannah at the Central of Georgia Railroad depot in 1854. The railroad office building, the oldest surviving such building in the United States (with a record 130 years serving that function), would be fully completed in little over a year. The six handsome Doric columns lend the building a grace that defies its strength. In 1855 a writer for *Colburn's Railroad Advocate*, a national journal, described it as "the most complete and elegant railroad station in the country." It withstood earthquakes, hurricanes, and the ravages of the Civil War, when Federal troops destroyed numerous Southern railroad complexes. Somewhat surprisingly, it even escaped the wrecking ball that took down so many of Savannah's historic buildings in the mid-twentieth century. The depot attached to the rear of the railroad office building served as both freight and passenger stations; the complex included its own machine and repair shops.

Above: The Savannah College of Art and Design (SCAD) owns the building on Martin Luther King Boulevard today. It is called Eichberg Hall and houses the classrooms for architecture, interior design, and urban design. Across the parking lot to the south is the old passenger terminal for the Central Railroad and Banking Company, later the Central of Georgia Railway. When SCAD purchased Eichberg Hall, the big challenge was repairing the enormous roof. The same technology selected by NASA for its projects was used on this massive structure. The art college occupies approximately 2.5 million square feet of facilities throughout the Historic District and Victorian District.

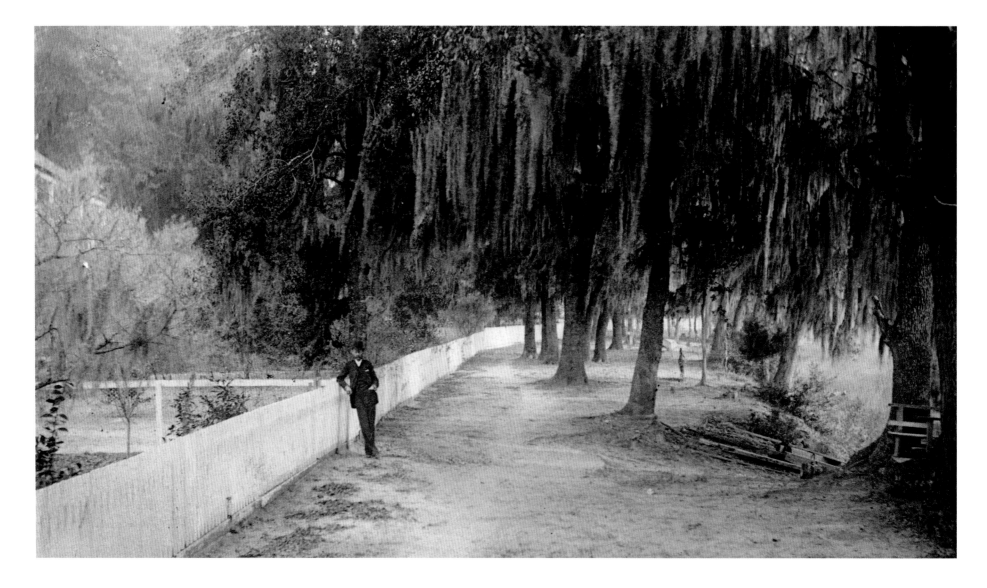

ISLE OF HOPE

Fiercely resisting the march of the condominiums

Charmingly situated in a horseshoe on the banks of the Skidaway River, the Isle of Hope was settled in 1737. Wormsloe, the plantation of one of Georgia's earliest settlers, Noble Jones, and the ruins of his first fortified residence, remain. In the eighteenth and early nineteenth centuries, many Savannahians fled the city each summer, attempting to avoid contracting malaria and yellow fever. There were years when hundreds would succumb to these diseases of then-unknown origin. The belief prevailed that inhaling salty breezes or "taking the salts," served as a preventive and cure for the body and soul. By horse and buggy, townsfolk would pack up and leave for such retreats as the Isle of Hope. Barbee's Pavilion on the Isle of Hope eventually became the terminus of the main line of the city and suburban railway, six miles from Savannah. By 1870 trains brought families to the resort daily. Many large cottages were built by well-to-do Savannahians for their families.

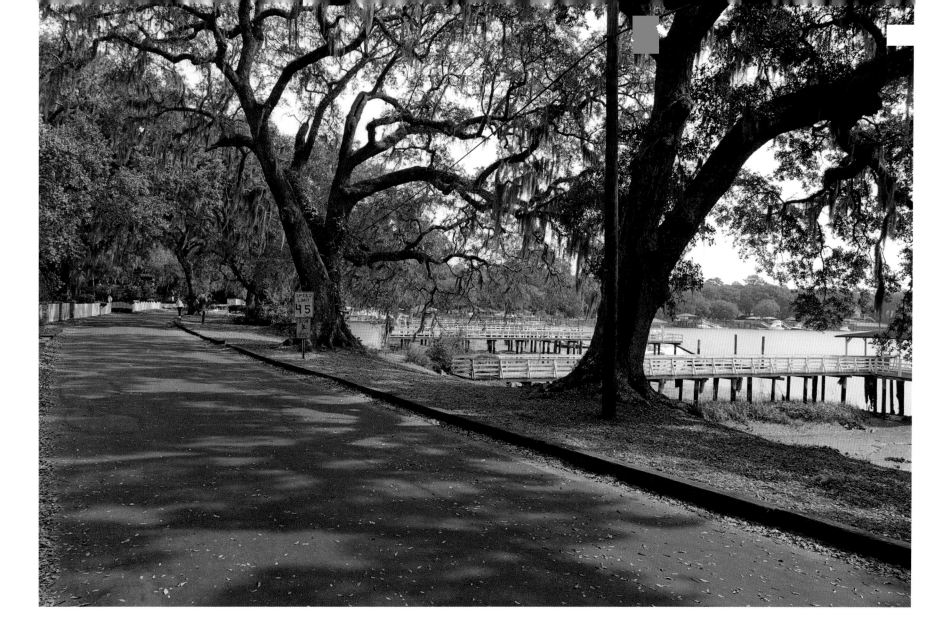

Locals are fiercely protective of the island. Condominiums are not welcomed in this special community. Outspoken locals have waged—and won—intense battles to preserve the charm of this area. The architecture is a mixture of Greek Revival, Victorian, and neoclassical. Tidy white fishermen's cottages line the bluff. Hundred-year-old live oak trees shade the gardens and protect the bluff from eroding. Yachts heading south for the winter tie up at the marina while their owners find their way downtown to explore the Historic District and have a meal ashore. Bluff Drive is active with joggers, walkers, and tourists. The Isle of Hope today has churches, a school, a swimming pool, and residents who take much pride in their community.

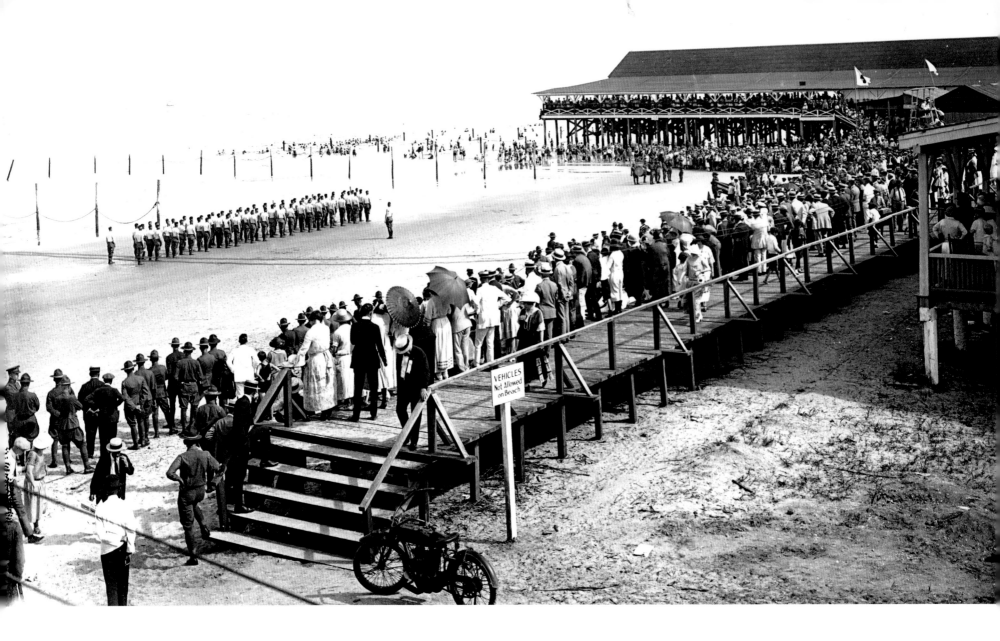

The Tybrisa Pavilion, built in 1891 on Tybee Island, was a landmark on the Atlantic Ocean. Day-trippers boarded trains hourly from downtown Savannah for the eighteen-mile ride to Tybee. Laden with stuffed picnic baskets, children, and money to rent woolen bathing suits, passengers enjoyed the forty-five-minute ride as they anticipated the relief of cool, foaming breakers. Musicians such as Tommy Dorsey's band, Guy Lombardo, and Ted Weems played regularly and locals crowded around to hear Dewey Holm's band, the Savannahians, play "Tybee, Where the Georgia Peaches Go." The next generation danced in bare feet to the sounds of a jukebox. This photo was taken in the 1930s.

TYBRISA PAVILION AND BEACH

A popular destination for Savannahians and tourists alike

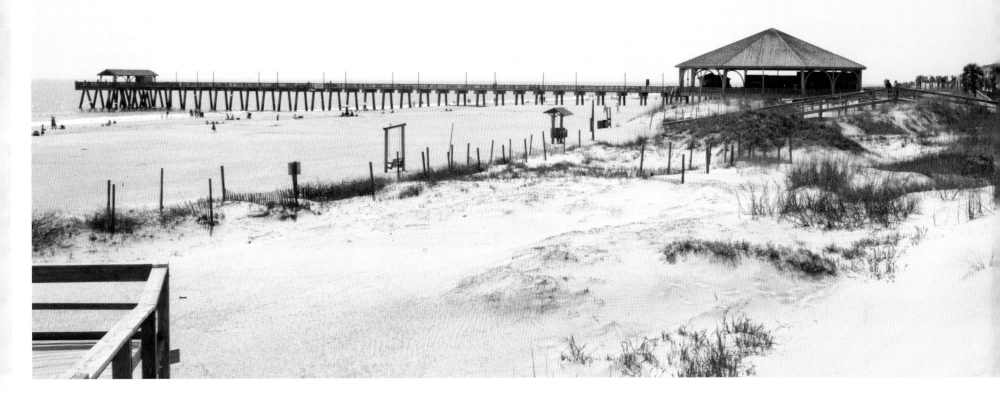

In 1967 a devastating fire was ignited by a disgruntled employee. Flames rapidly engulfed the pavilion. A colorful way of life vanished in heavy smoke, leaving behind charred pilings, burned-out shells of hangouts, and the stench of needless destruction. For twenty-nine years, the site of the old pavilion remained desolate. Finally, led by the efforts of the people of Tybee, Chatham County built Tybrisa Pavilion II and dedicated it on August 9, 1996. Following a major beach renourishment, the Tybee Island Rescue Squad has seen visitors to the island increase yearly. Inner-city children continue to come to the Fresh Air Home for two-week sessions in the summer. The Tybee Island lighthouse complex handles thousands of visitors each year, many of whom climb to the top of the lighthouse. Tybee's small cemetery near the city hall was restored in 2005.

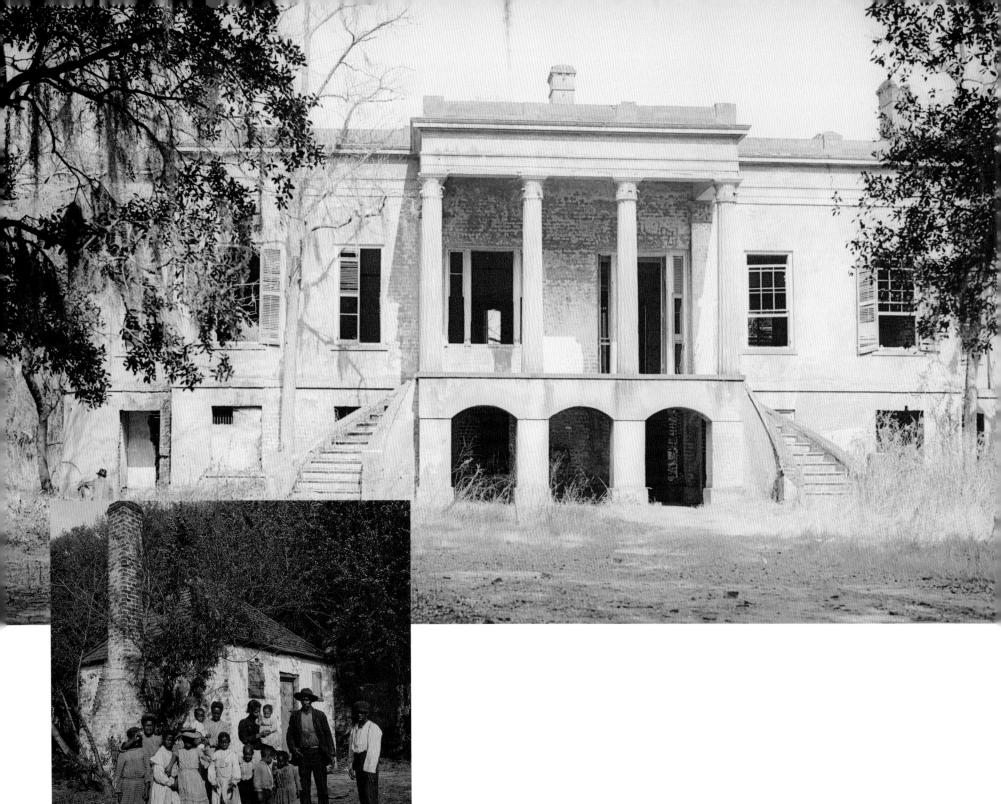

THE HERMITAGE

The old plantation house may be gone, but two slave dwellings live on in Michigan

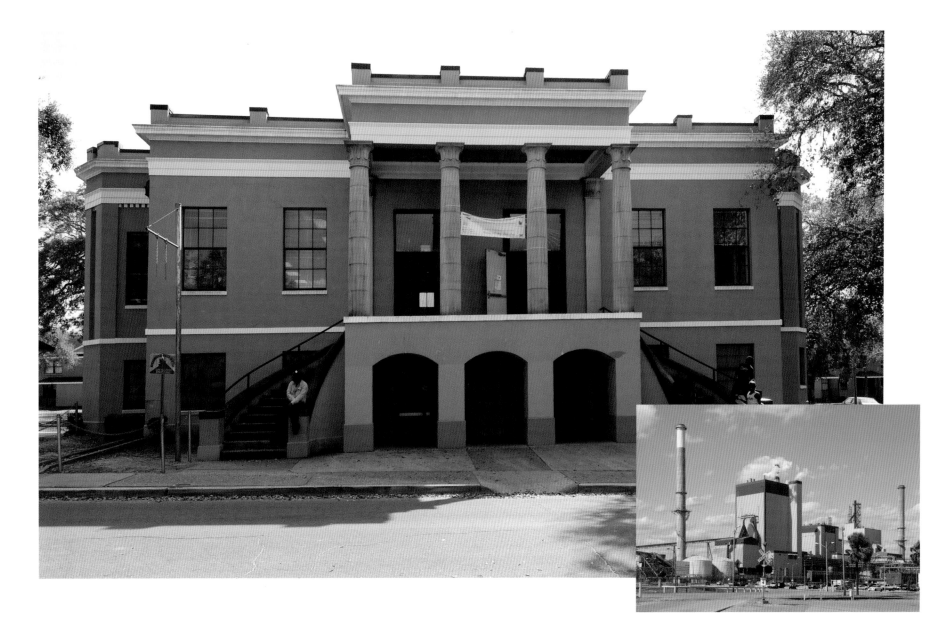

Left: Built on the Savannah River in 1820, the Hermitage Plantation house was of classic Greek Revival design. The front and back facades were identical. Porches were reached by gracefully curving, embracing stairways—a Savannah trademark. In addition to an iron foundry, sawmill, and rice mill, Henry McAlpin developed brickworks on his 400-acre plantation. After a devastating fire in the 1820s, laws were passed prohibiting building with wood in town. McAlpin amassed a fortune as a result of the great demand for his "Savannah gray bricks," so named even though the Savannah River's mud fired to a handsome, rich, reddish color. By 1850 more than 60 million Savannah gray bricks had been produced. The main house and the fifty-two cabins that housed slave families (inset) were built with Savannah grays by slaves on the plantation.

Above: Industry encroached on the plantation lands along the river; railroad yards and a chemical plant were built on what had once been fields. A way of life was passing. Henry Ford acquired the plantation for $10,000, demolished the main house, and had the bricks shipped to Richmond Hill, to build his home. They have also been used to re-create two slave houses, identical to the one in the archival photo, in Greenfield Village, Michigan. In 1935 the land passed into the hands of the Georgia Ports Authority; Union Camp built a pulp and paper mill on what had been the site of the Hermitage Plantation house. Three replicas of the Hermitage house exist in Savannah; the one seen here is used as a community center and is located in the Yamacraw Village public housing project.

BONAVENTURE CEMETERY

A Gothic resting place among the live oaks

The title stated with pride by those born in Savannah has always been "Savannahian." Many Savannahians of note are buried among the ancient live oaks, mounds of azaleas, and camellia bushes of the former Bonaventure plantation, perched on a bluff at a bend in the Wilmington River. Among those buried here are colonist Noble Jones, famed composer Johnny Mercer, and Pulitzer Prize–winning writer Conrad Aiken. The story lingers that the plantation house, built in 1760 by Colonel John Mulryne, was given to his daughter Mary and her husband Josiah Tattnall as a wedding gift, and had

live oaks planted in a pattern that entwined their initials, M and T, along the lanes. At a family ball given in 1801, a spark ignited an oriental rug and was noticed too late; those gathered saved only the bottles of champagne, ran a safe distance from the conflagration, toasted, and threw their empty glasses into the fire as the house burned to the ground. The property was thereafter purchased to develop a cemetery of legendary beauty—Bonaventure.

Nature and wise neglect by man have created a picturesque sanctuary. Bonaventure was exposed to the world when it was featured in John Berendt's 1994 book, *Midnight in the Garden of Good and Evil* and the movie of the same name directed by Clint Eastwood. *Bird Girl*, a 1936 sculpture by Sylvia Shaw Judson, stood here on an old Savannah family plot. A photograph of it by the late Jack Leigh graced *Midnight*'s cover. Tourists visit Bonaventure not only for its beauty but for photos of the sculpture, which was moved to the Telfair Museum for its own security. Some well-known people interred are Confederate General Hugh Mercer and little Gracie Watson—daughter of the manager of the Pulaski House Hotel and subject of numerous tales of the spirits of Savannah. The inset photo shows the tomb of Johnny Mercer, songwriter and descendant of General Hugh Mercer.

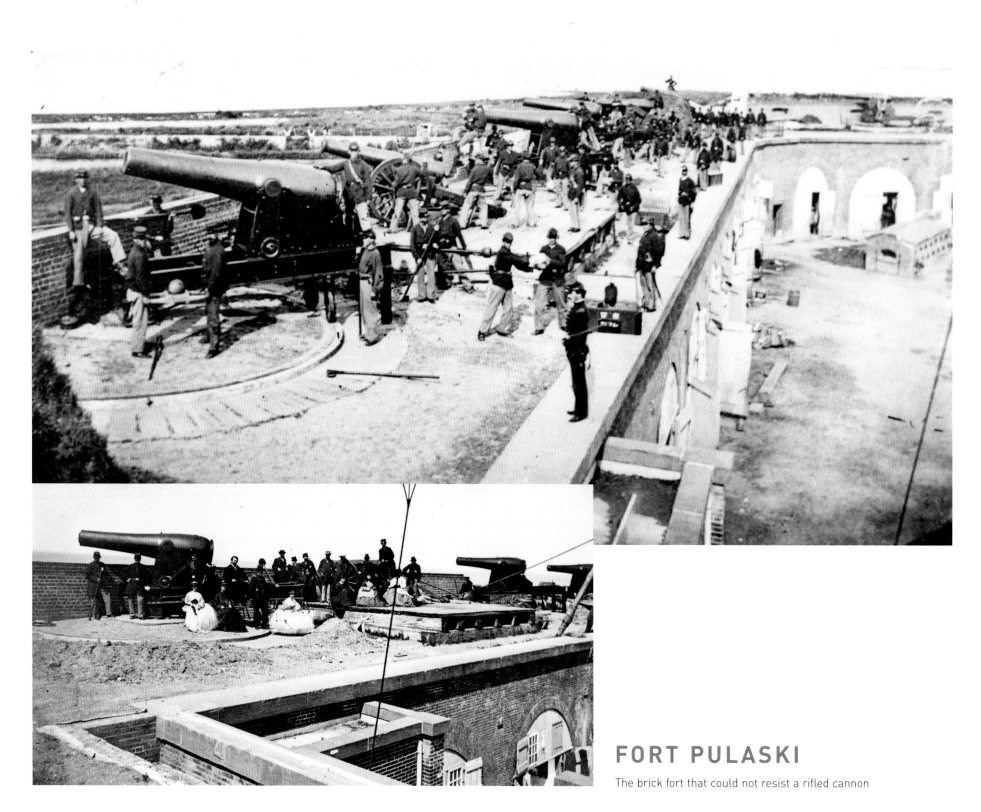

FORT PULASKI

The brick fort that could not resist a rifled cannon

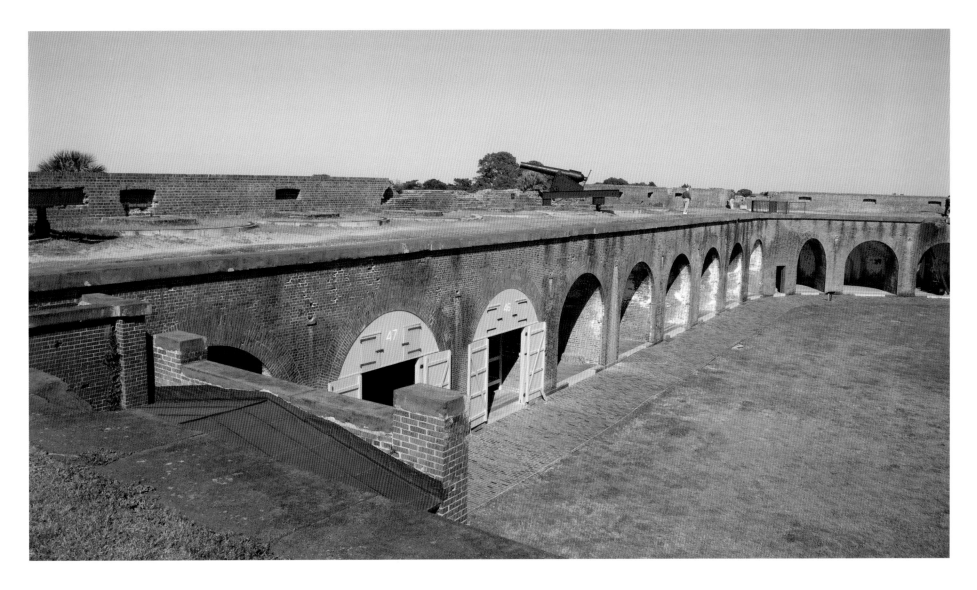

Left: Following the War of 1812, building a fort on Cockspur Island, at the mouth of the Savannah River, was considered crucial for the defense of the growing city. The charge to design a drainage system for this low-lying, swampy location and to oversee construction fell to a recent West Point graduate, Robert E. Lee, who spent seventeen months at the fort before leaving in 1831. After accepting his Confederate army commission, he was the engineer of choice to make recommendations for the fortification of river entrances along the Southeast's coast. He was confident that no Union troops could breach the walls and capture Fort Pulaski. Those defending were shocked when the walls were breached and stored gunpowder was suddenly vulnerable. Surrender was the unanimous choice of the officers in charge. The Battle of Fort Pulaski was over in less than two days. A new weapon in the arsenal of the Union—rifled cannon—had been used for the first time. Savannah was isolated for the remainder of the war.

Above: Today the fort is an important stop for Civil War buffs and tourists alike, who can enter the fort through the "sally port," then through a massive gate into a tunnel where a cannon aims directly at visitors. This demonstrates what attacking soldiers confronted. Most meaningful is the handwriting put by soldiers on the walls, and the battered wall, twice breached, through which Union forces were about to attack when the Confederates waved the white flag of surrender. The firing of Civil War cannons makes the whole experience dramatic. One can explore the casements where artillery was kept and walk on the ramparts for a clear view of Tybee to imagine what the Confederates saw as the Union army fired on them.

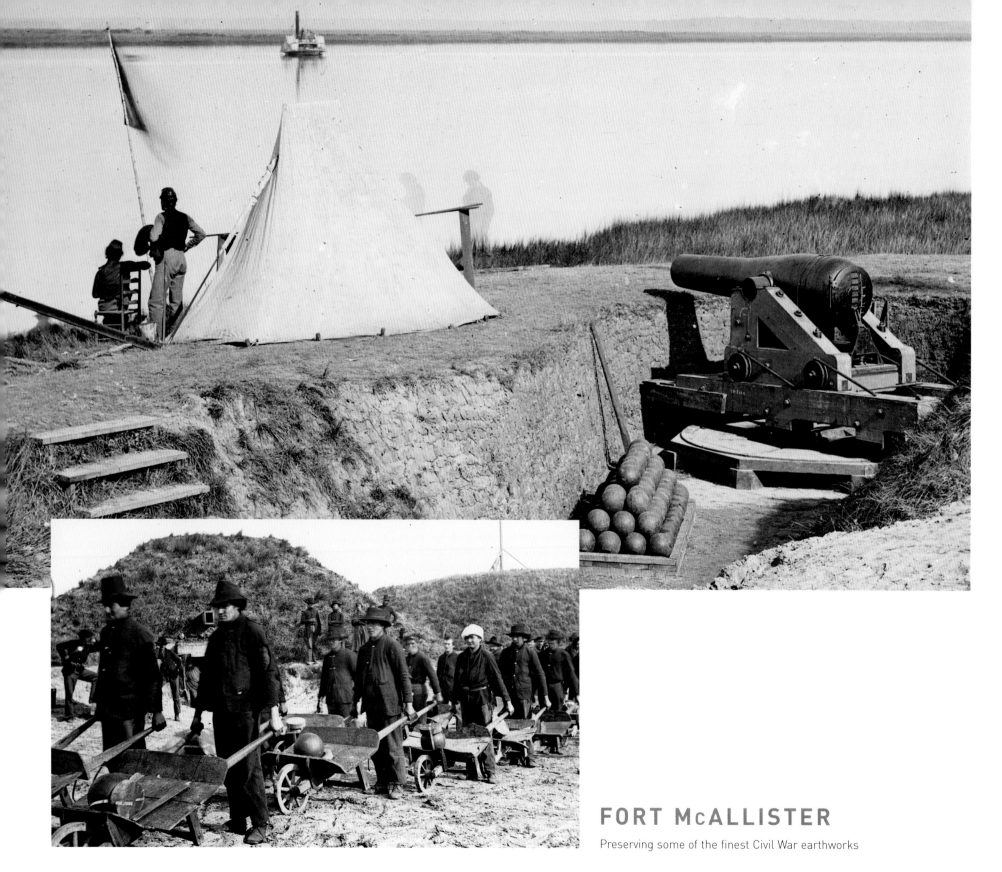

FORT McALLISTER

Preserving some of the finest Civil War earthworks

Left: Fort McAllister was constructed in 1861 on the banks of the Ogeechee River, southeast of Savannah, as a simple earthwork fortification to guard the railroad line, Ogeechee River rice plantations, and the southwestern approaches to the city. When General Sherman marched his Union troops along the critical rail lines of the Deep South toward Savannah, Fort McAllister was the last barrier between the Union troops and the U.S. Navy, waiting at the mouth of the Ogeechee with much-needed supplies. Union forces had unsuccessfully tried to take Fort McAllister at least six times, bombarding it from warships on the river. It had become a frustration that General Sherman was determined to address. They skirted Savannah and, on the night of December 13, 1864, the general and 1,500 of his soldiers paid a call on Fort McAllister—this time from land. A brief, fierce battle ensued and, once Sherman captured the fort, he turned his sights on Savannah.

Above: Fort McAllister State Park displays the best-preserved earthwork fortifications of the Confederacy on the banks of the Ogeechee River in Bryan County. Union ironclads attacked the earthworks seven times, but were unable to succeed in capturing the fort until Sherman attacked from the land side. Visitors are told of the bloody combat and the 300 casualties. After the war, the fort fell into ruin and remained a habitat for sand crabs, lizards, and snakes until the late 1930s, when it was restored as an historic site using funds from Henry Ford, who owned the property. The fort is now operated as a state park by the Georgia Department of Natural Resources and includes a museum and tours.

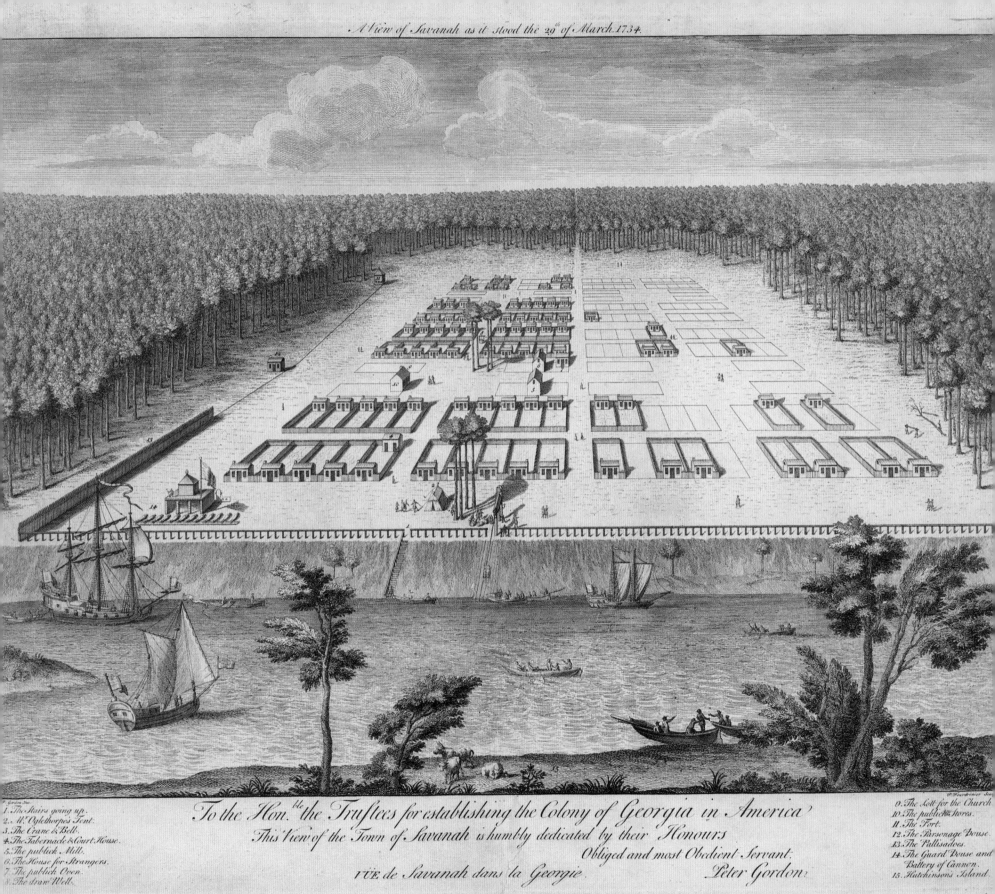

A View of Savanah as it stood the 29ᵗʰ of March. 1734.

P. Gordon Inv. P. Fourdrinier Sculp.

1. The Stairs going up.
2. Mʳ Oglethorpes Tent.
3. The Crane & Bell.
4. The Tabernacle & Court House.
5. The publick Mill.
6. The House for Strangers.
7. The publick Oven.
8. The draw Well.

9. The Tott for the Church.
10. The publick Stores.
11. The Fort.
12. The Parsonage House.
13. The Pallisadoes.
14. The Guard House and
 Battery of Cannon.
15. Hutchinson's Island.

To the Honᵇˡᵉ the Trustees for establishing the Colony of Georgia in America

This View of the Town of Savanah is humbly dedicated by their Honours

Obliged and most Obedient Servant.

rUE de Savanah dans la Georgie. Peter Gordon.